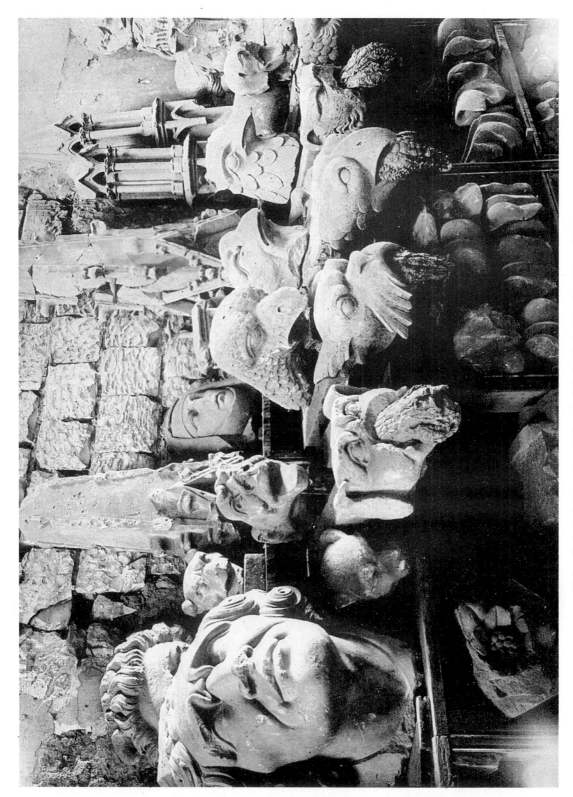

Reims Cathedral Gargoyles (After the War) Choked by Lead from Roofs

THE *GARGOYLE* BOOK

572 EXAMPLES FROM GOTHIC ARCHITECTURE

LESTER BURBANK BRIDAHAM

Introduction by
RALPH ADAMS CRAM

DOVER PUBLICATIONS, INC.
Mineola, New York

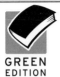
Bibliographical Note

This Dover edition, first published in 2006, is an unabridged republication of the work originally published in 1930 by the Architectural Book Publishing Co., Inc., New York, under the title *Gargoyles, Chimeres, and the Grotesque in French Gothic Sculpture.*

International Standard Book Number
ISBN-13: 978-0-486-44754-4
ISBN-10: 0-486-44754-5

Manufactured in the United States by Courier Corporation
44754503
www.doverpublications.com

TO:
JANET MERRIAM WOODBRIDGE
WHOSE HELP MADE THIS POSSIBLE

INTRODUCTION

AMONG the quaint superstitions that surround the popular legend of the Middle Ages, there is none more distorted and baseless than that this was a period gray, miserable and morose, and chiefly characterized by priestly tyranny, civil oppression, abysmal ignorance and a deplorably low state of culture. It is a matter of faith that in all respects any comparison between the twelfth to the fourteenth centuries, inclusive, and the subsequent Renaissance, shows the former period in a most unfavourable light, while there is no comparison whatever between the same and our own era of enlightenment under the beneficent influence of technological civilization.

Mr. Bridaham has made a book which ought to dispel at least one of these amusing "errors of mortal mind" and that is that the Middle Ages were centuries of gloom. His pictures should do more, revealing as they do the artistic sense, the creative inspiration and the technical mastery of the quite illiterate craftsmen of the time, points in which they far excel the workmen of today, even though the latter may have had the benefit of a complete public school education, are free of election to any political office however high (which they frequently fill) and are possessed of a radio, a motor car and the electoral franchise. Some of these sculptures in stone and wood are better as art than could be produced today by more than the smallest minority of professional sculptors with the best of Paris training behind them, yet none of their fabricators could read, none had any training except as an apprentice in a stoneyard, and all of them subsisted, and manifestly were sufficiently happy, on a wage that today would be considered the pittance of a pauper.

This by the way. The real point is that these "gargoyles, *chimères* and grotesques" gathered by Mr. Bridaham from every part of France, demonstrate that whatever else they may have lacked, the Middle Ages were a time when fun was "fast and furious," certainly in no respect behind our own day, the chief difference being that then it expressed itself in more comely and withal more really amusing ways than through the "comic strips," the radio humourists and the other dramatic outlets for contemporary joy in life.

Just because they were a sincerely religious people and involved in the sacraments, services and practises of their religion from the day of birth to that of death—and after— it is assumed that this must have knocked all the gaiety out of life and that they must have been sad, terror-struck and morose. Now so far as the people as a whole were concerned, and apart from a very few ascetics whose fancy took this turn, the reverse was the case and it was not until the sixteenth century that this degradation of the religious impulse took on such a peculiar form, finding its culmination in Calvinism and Puritanism. This was partly due to the fact that then for the first time, and as a result of the peculiar doctrines then evolved, religion and life began to separate, falling into two quite distinct categories, marked by six days in the week on the one hand, and one day—Sunday—on the other.

In the Middle Ages religion was a natural and a companionable and a familiar thing, laughter was not averse from it, nor was joking, even sometimes of rather a broad sort, out of the question in relation to what we should consider "serious matters." Hence churches, as these pictures show, broke out into delightful gaiety here and there under the hands of high spirited or waggish workmen, and they, and the religion they expressed, were the better for the wholesome sense of life.

It takes a fertile imagination to be really funny, but this imagination that gives these old grotesques such vivid life, was not always humourous in its nature. It was an imaginative age and men were fancying all sorts of fantastic things in the face of a world that was (and still is for that matter) so baffling in its ways and generally incomprehensible. As the Greeks peopled air and water, fields and woods with myriad mysterious little creatures and strange personifications, so did the Mediaeval man, and he took the greatest joy in working out their semblances in stone and wood. This book is a sort of "Bestiary" of apocryphal beasts as well as a sculptured satire on the very common foibles of fellowmen, whether clerical or secular.

As is of course well known, during the Middle Ages every stonemason who had passed from being an apprentice and become a journeyman, worked out his own ideas in his carving. He was, in a sense, an independent artist and he was free to do pretty much what he liked. Today every piece of carved ornament of any sort has to be made in an architects office, the modeller following the full sized detailing as well as he can, the carver copying the model with all the exactness possible. Indeed, it is not seldom that all he has to do is to direct a pneumatic tool. This is one reason why it is so hard to get Gothic vitality into the revived Gothic architecture, also incidentally, why so much labour is an irksome task instead of a creative joy. These gargoyles and grotesques show very plainly the complete freedom under which the old craftsmen worked and the immense originality and variety that were the result. Here are hundreds of spontaneous creations, each as individual as possible, and not only this but many of them show a brilliancy of space composition and a fineness of line that would not shame a great sculptor. Craftsmen these, but also creative artists.

Sacheverel Sitwell has recently in "The Gothick North" shown new and veritable aspects of Mediaevalism through the minor arts of the time, rather than through the cathedrals and great sculptures that usually are chosen as the avenues of revelation. In the same way, by means of these "unimportant" gargoyles, *chimères* and grotesques, Mr. Bridaham has cast an added light on a great but, until recently, much misunderstood and maligned epoch; a light that, if you will, pierces deeper into the soul of the time than the surface of artistic beauty which was its invariable accompaniment.

RALPH ADAMS CRAM.

AUTHOR'S INTRODUCTION

I. GOTHIC PERIOD

THE natural tendency to ignore what cannot be understood explains the lack of attention given to the study of mediaeval grotesque sculpture. It has been easier to disregard it than to educate ourselves to the innocence of mind of the twelfth and thirteenth centuries. This sculpture offers an exact measure of the difference between our own day and the time when the great Gothic cathedrals were erected. To understand such sculpture we must put ourselves back into the state of mind of the late Middle Ages when it was created. In spite of the destruction of this grotesque sculpture by the Puritan hammer, the French Revolution, and the World War, the exteriors and interiors of the Gothic churches still preserve an abundance of it.

Since France is the birthplace of the Gothic style, it is the logical place to begin the study of this sculpture. In France, the finest Gothic cathedrals were built during the twelfth and thirteenth centuries by the individual effort of every person in the liberated communes. To these people of powerful faith no task was too arduous for the glory of God, the beauty of the Virgin, and the divinity of Christ. The cathedral was the crystallization of this force. In it was housed everything beautiful produced in the community. It was the town museum. Those citizens who could give no gold to build the cathedral contributed labor, harnessing themselves to the great carts, dragging the large stones from the quarries to the building site. To be prohibited from working on the cathedral was one of the greatest punishments of the time.

The sculptor was important as an ornamentor of the architectural fabric, and he was also a preacher in stone. The Pope ordered the illiterate to be taught by sculpture. The stone workers told for them stories of the Virgin, of Christ, and the Apostles, and of Heaven and Hell. They also found inexhaustible inspiration in the world about them, in the leaves and buds of plants, in the forms of animals, in the faces of men. A passionate intensity forced them to create vast quantities of beautiful sculpture often with small technical knowledge.

Events of daily life influenced carvers in the choice of grotesque *motifs*. There were the religious processions, the mystery plays, such feasts as the Feast of Fools. They heard folk tales and fables from childhood, and saw animals commit the same crimes as men.

II. THE RELIGIOUS PROCESSIONS

The people of the Middle Ages were accustomed to see the effigies of monsters carried through the streets on feast days in religious processions.

The origin of such beliefs goes far back into antiquity when the awesome phenomena of Nature associated with fountains, springs, lakes, or the sea were personified by some

monster of horrible aspect. In some cases this beast controlled the flow of water from springs. In folk lore we read of annual sacrifice sometimes of a virgin offered up to appease the beast. These pre-Christian earthy beliefs colored the mediaeval mind and often bore strange fruit on cathedral facades.

Most of the Gothic cathedral towns as Amiens, Reims, Beauvais, Sens, Rouen, Metz, Tarascon, and Poitiers were famous for their processions which took place on definite Saint's days.

The most spectacular of these processions of monsters was the great Fierte of Saint Romain of Rouen. Once a huge dragon lived in the waters of the Seine, threatening the inhabitants of the countryside, swallowing ships and men. Saint Romain, in setting out to destroy the monster, asked for help. No one would go with him but a criminal condemned to death. The dragon was soon conquered by the sign of the Cross and led to the public square where it was burned with much rejoicing. To commemorate this act an annual fête was held until ended by the French Revolution. A criminal condemned to death was set free each year and given high honors. A wicker effigy of the monster called the "*Gargouille*," holding a live animal in its mouth such as a young fox, a suckling pig or a rabbit, was carried in the procession attended by the Brotherhood of Gargouillards.

At Amiens similar dragons, called "*Papoires*," were paraded through the streets. The size allowed men to be hidden inside who operated a mechanism for moving the jaws to take off the hats of persons so irreverent as to remain covered while the procession passed.

Dragons were used at Noyon until 1739, when they were suppressed because a woman spectator gave birth to a child which resembled the *papoire*.

At Poitiers, The "Grande 'Goule," formerly carried in processions, may be seen today in the Musée of the Hôtel de Ville, see page 1. One of the most famous dragons is the Tarasque of Tarascon, which is large enough to house several men who shoot out fireworks. Other monsters were, the "Graouilly" of Metz, "La Chair Salée" of Troyes, "Le Dragon" of Louvain, and "Le Dou Dou" of Saint George of Mons.

III. THE MYSTERY PLAYS

Numerous subjects for grotesque sculpture originated, as Emile Male has shown, in the religious and semi-religious plays which were enacted inside the church to teach morality and to amuse the laity.

The Devil was variously represented in certain scenes of these plays. In the Temptation and Fall of Adam and Eve, the Devil was a serpent, for, it was said that, "Satan went into a worm and told Eve a tale." One mystery play speaks of the Devil as actually entering Judas; for, Jesus gave Judas a morsel of bread, and with that morsel the Devil entered into him. This symbol of evil actually entering a man in concrete form is widely used by means of toads in the scenes of sculpture of the Last Judgment. After Judas had killed himself by hanging, the Devil hurled him into Hell. Thus the carrying off of souls of sinners was a specific

function of the Devil. In the stonework at Urcel, page 17, one may see a demon smiling gleefully for having captured a soul.

The form of the Devil was varied. Some describe him as a hunter in darkness. He was also a serpent, a fox, or wolf. He was usually black in color, but sometimes invisible. A stench was associated with him, shoe leather was burned to provide it.

Often Christ and the Saints had vigorous physical encounters with the Devil; in the legend of Sainte Catherine, Jesus overcame the fiend and shaved his head.

IV. THE FEAST OF FOOLS AND OTHER FETES

Ceremonies of extreme licence were performed inside the cathedral at definite dates on the church calendar which have no counterpart today. The meaning of such old fêtes is sometimes difficult for us to understand. Such services as the Feast of Fools, the Holy Innocents, and the Feast of the Ass, which existed in the ritual of the Church from the eleventh century to the Reformation came from the Roman Saturnalia held at the end of the year.

Such follies and licences as the Feast of Fools taught in symbol that the superiority of the rich would not last forever. There would be some day of compensation when the clergy and laity would be equal. In this fête a pope or archbishop of fools was elected, who presided over a definite set of ceremonies which lasted several days. There were riotous dances in his honour. Grotesque and impious masquerades took place, obscene songs were sung. Games of dice were played on the high altar and sausages were eaten there. The priests disguised in grotesque masks, and sometimes as women, danced in the choir. The laity, disguised as monks or nuns, took part in the celebration. Shoe leather was burned for incense.

An animal was introduced into the church as part of the service during the Feast of the Ass. At Beauvais on January fourteenth, a girl rode an ass into the church illustrating the Flight into Egypt. The singers and congregation drank, the ass was watered and fed. The animal was then taken to the nave where the congregation danced around the beast and brayed like asses.

In all these ceremonies there was no idea of contempt. To the child-like mind of the Middle Ages the healthy man needed time for play. The clergy realizing this considered the church building to be the logical place for this to occur; there was but one house and that was the House of God.

The capitals in the crypt of Bourges Cathedral recall these fêtes exactly, and the church of Sainte Melaine at Morlaix possesses a nave cornice frieze of painted stone of monks in grotesque attitudes, and laughing fools with long ears.

V. THE MEDIAEVAL FEELING TOWARD ANIMALS

The mediaeval feeling for animals was so different from our own that it is interesting to recall.

Each race since the beginning has regarded animals with suspicion. Organic and physical eccentricities were ominous signs of alarm. A hen which crowed was the handiwork

of the Devil. Fowl of both sexes were always under suspicion, on account of their kinship with certain of the mystical animals of the Bible. In 1474 a cock was sentenced to death and burned with great solemnity at Kohlenberg near Basle for having laid the ill omened "cockatrices' egg." This egg was supposed to contain the most potent ingredient of witch-craft ointment. When hatched by a toad or serpent the deadly basilisk or cockatrice came forth, to hide in the roof of a house killing the inhabitants by its death-darting glance, see page 9.

A pig which had sacrilegiously eaten a consecrated wafer was hanged in 1394 at Mortaign. Pigs were especially open to suspicion on account of their association with witchcraft.

In the Middle Ages animals which had committed crimes were treated exactly as other members of a man's household, as his wife and servants were. A fair trial was demanded before the animal could be punished. There are records of animals being put on the rack to confess their sins. Officers of the law considered themselves able to read the confession in the cries and groans of the beast.

VI. SYMBOLISM

There is much symbolism in the sculpture of this period; but we must be wary of reading in too much meaning. The clergy regarded every stone in the fabric of the cathedral as a religious symbol. The sculptors chose subjects which everyone, even the ignorant peasants understood. Some subjects are obscure today because we have lost the unrecorded local tradition.

A definite distinction should be made here between the symbolic religious representations and the grotesque. Early Gothic sculpture was more symbolic than grotesque, as it dealt more directly with the awesome religious elements. For example, the Devil, at first, was a serious powerful figure, greatly to be feared, whose actual physical presence was seen, felt and described. Little monsters and *chimères* represent his likeness in many forms. With late Gothic sculpture the tendency is more wholly grotesque, when some of the old motifs had lost their deep religious meaning. Here the foibles of the human race are satirized by burlesques on daily life. The Devil and what he stands for is more comic and less to be feared.

There are many sources of these *motifs*. The classical source supplied such themes as the Lay of Aristotle and the story of Virgil Tied up in the Basket. The men of the Middle Ages delighted in these chronicles of the foibles of the great men of antiquity.

The Bible furnished a large number of subjects, as the animals in the signs of the Four Evangelists. There are many *motifs* used to denote Christ, some of which are based on mediaeval interpretations, such as the roaring lion, the lioness and cubs, the pelican and young, and the unicorn. The basilisk or cockatrice mentioned in the Bible is found on the portal of Amiens Cathedral, see page 9. This beast is half cock and half serpent, whose look was deadly. The only protection lay in placing a glass vessel in the line of sight to ward off the rays. The aspic of the Bible also found on the main facade of Amiens, see page 9, was

a deadly creature which could be charmed by music. It would cleverly defy its seducers by placing one ear to the ground, stopping the other ear with the end of its tail. This act was symbolic of the sinners who would not listen to the word of Christ.

The fables furnished many well known themes. On Autun Cathedral the story of the wolf asking the crane to remove the bone in his throat is carved in stone, see page 11.

The Bestiary books recorded current stories of mediaeval interpretations of moral lessons taught by animals. The Folk Lore of the period supplied other subjects, as the Story of the Fight for the Breeches, where the eternal struggle between husband and wife for the domination of the household is graphically depicted on a misericorde, see page 12. Another misericorde shows a couple blowing up a purse with bellows, illustrating the exaggeration of the human race in talking about money matters, see page 12. Monstrous beasts found under the feet of saints and bishops on the tombs or portals indicate the evil conquered by these men in their lives. On the towers of Laon Cathedral are stone oxen commemorating the help given by their kind in hauling the huge stones up the hill to the cathedral site, see page 12.

VII. TYMPANUM SCULPTURE AND THE LAST JUDGMENT

There are grotesque representations on the portals of cathedrals of the Last Judgment. The excellent example at Bourges, page 22, contains most of the elements common to all. In one part of the tympanum the condemned souls are led by devils to be plunged into the boiling cauldron heating over the jaws of Hell. The souls of the dead are always little nude figures, altho the nude was seldom used for any other purpose. The devils are men with deformed features and anatomy. Usually a massive head is found on the belly of a devil to show that the brain center has descended to the lower regions of the body. Female devils have animals heads as breasts; the wings of some have descended to the lower portions of the body to denote fallen angels. A toad vomited from the mouth of a boiling sinner denotes that evil entered him as a concrete element. The toad being suckled by a woman is a mark of her lewdness. The jaws of Hell are usually represented by the head of the monster Leviathan described in the Book of Job.

VIII. GARGOYLES

Gargoyles came early into Gothic architecture from the practical need of eliminating corrosive rain water from the foundations of churches. Viollet le Duc considered the initial date of gargoyles as about 1220 in Paris. The first gargoyles in stone were few in number and resembled the former bulky wooden ones. When the decorative value was realized the quantity was increased until finally there were many merely ornamental gargoyles which never carried water.

The *motifs* used are countless, such as dogs, pigs, sheep, cows, lions, horses, bears, foxes, panthers, birds, among the animals; and monks, nuns, knights, wild men, and pilgrims, are the commonest human subjects.

Gargoyles may be divided roughly into two classes, the simple types consisting of a single animal's head or body, and compound types which may include several figures, or one figure with a carved bracket for support. Usually the channel to feed the gargoyle is cut through the flying buttress.

The use of animals' heads as water spouts did not originate in the Gothic period, but there reached its highest development. They are found in Greek and Egyptian architecture, as well as in Pompeii. A gargoyle dug up at Alesia dating from 160 A.D., (see page 23), shows a plain channel with a human head as spout.

There is a great deal of controversy about the symbolism of gargoyles. Springer sees their conception in an exact Bible reference in Psalms XXI, and XXII, and in Isaiah XI-8. Mrs. Jameson believes the origin lay in the prehistoric Silurian remains of monsters dug up in the Middle Ages. Some see their origins in the constellations. Emile Male finds no symbolic origin, but rather a birth in the imagination of man from tales told by housewives during the long winter watches. The Abbé Auber, to whom every stone in the cathedral had an exact meaning, considered them as representations of devils conquered by the Church and made her slaves to perform the menial tasks.

We cannot feel that gargoyles always represent evil, for such subjects as pilgrims walking with their staffs could have no evil intent.

The Renaissance, while desirous of freeing itself of all taint of the "vulgar" Gothic, could not resist adopting gargoyles into its style.

IX. CHIMERES

These fabulous monsters include the imaginary animals found on the cathedrals which are not water carriers. They may be found perched on the pinnacles of buttresses, or intwined with the leafwork of portals.

The reason for their being is closely allied to the animals carried in processions. They symbolize the great awe-inspiring forces of Nature, or the animals of ancient lore which stood guard over treasure, such as the griffons of the East.

The most complete group of Gothic *chimères* is on the towers of Notre Dame de Paris. Many travellers consider them to be exact, old, original work, but most were entirely the products of the imagination of Viollet le Duc, in the nineteenth century. The idea was suggested by the row of *chimères* at Reims Cathedral.

X. HEADS

Reims Cathedral offered, before the War, a unique collection of heads scattered over the fabric of the edifice. As the sculptor was allowed to place whatever he made on the building, we find countless surprising designs. He made sarcastic heads of the men he saw in the market place, or of a monk that amused him, or of an imaginary animal. He cut the head of a monstrosity which might have been carried about by a troupe of minstrels; we see such lion-faced men in our circus today.

XI. WOODWORK

Wood was a very important material in the Middle Ages, due to the scarcity and difficulty of transporting stone. Most of the civilian houses were of wood. The rich burgher desired to have his house decorated on the exterior with carvings of heads, with little statues of saints, and other *motifs*.

There was an important use for wood in the choir stalls of the cathedral. The Flemish wood carvers finished the stalls with some of the finest sculpture the world has ever seen. The drollest subjects are found on the misericordes, those small auxiliary seats under the main bench which gave the monks a chance to rest while standing during the long church services. Being insignificant details they were carved with whatever *motifs* and fanciful designs the sculptors chose to use. Today they are invaluable historical documents giving a great deal of information about the customs of the times. It is seldom that the same theme is treated twice in the same manner.

<div style="text-align: right">

LESTER BURBANK BRIDAHAM.

</div>

INDEX TO ILLUSTRATIONS

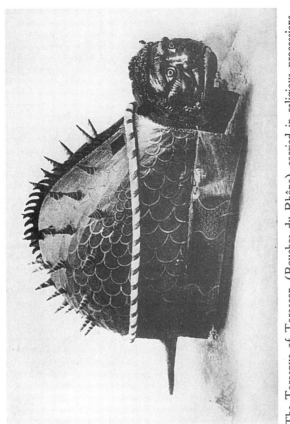

The Tarasque of Tarascon (Bouches du Rhône) carried in religious processions.

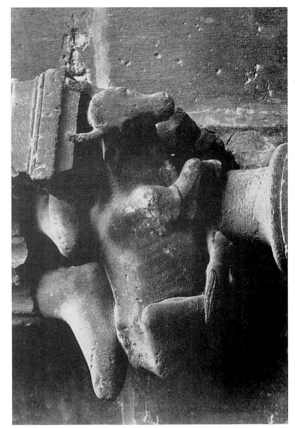

Reims, Cathedral (Marne) Ox St. Luke XIIIth Century.

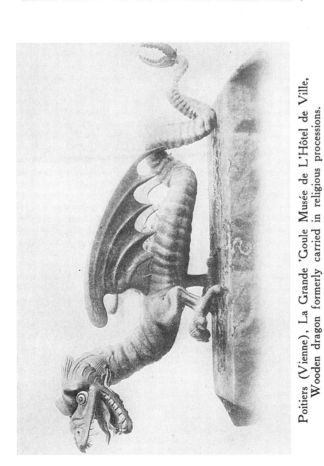

Poitiers (Vienne), La Grande 'Goule Musée de L'Hôtel de Ville,
Wooden dragon formerly carried in religious processions.

Chartres (Eure et Loire) Signs Of The Four Evangelists XIIth Century.

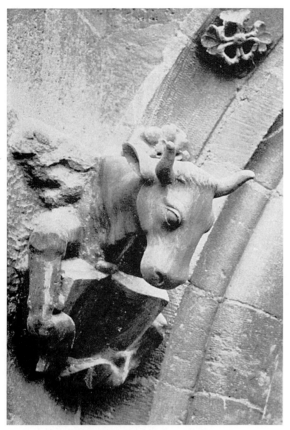

Ox of Saint Luke Reims (Marne)

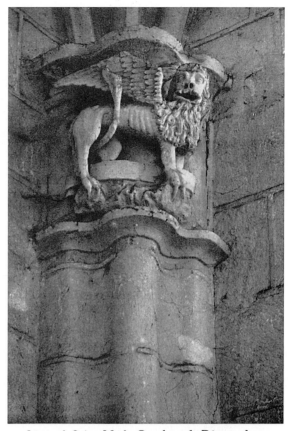

Lion of Saint Mark Castelnau-de-Pégueyroles
(Aveyron)

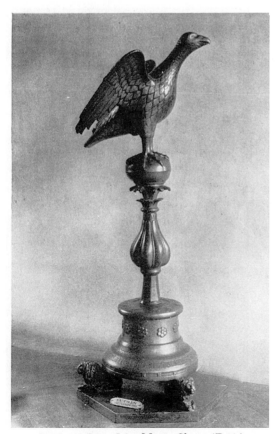

Lutrin of Saint John Musée Cluny (Paris)
XIVth Century

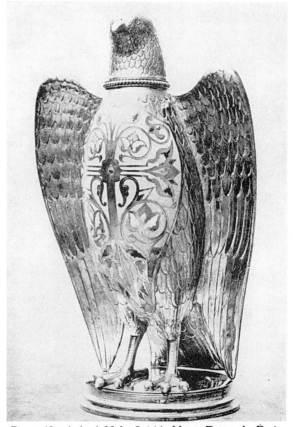

Dove (Symbol of Holy Spirit) Notre Dame de Paris
Vase for Holy Oil

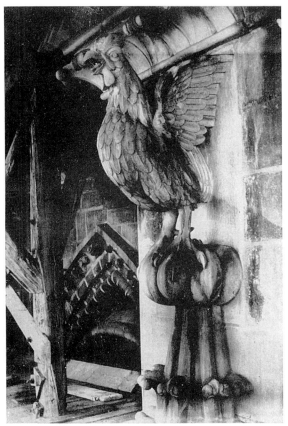

Reims (Marne) (Lead Work) Cock

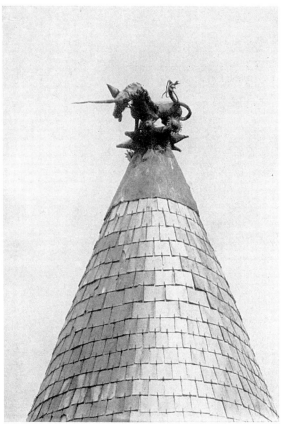

Symbol of Chastity—Unicorn in Lead
Poitiers (Vienne)

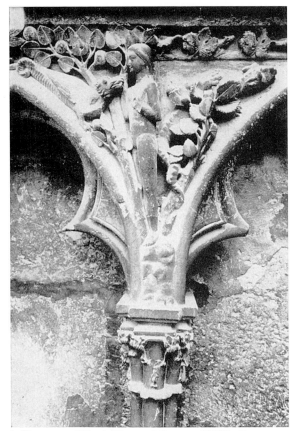

Bourges—(Cher) Eve and Serpent XIIIth Century

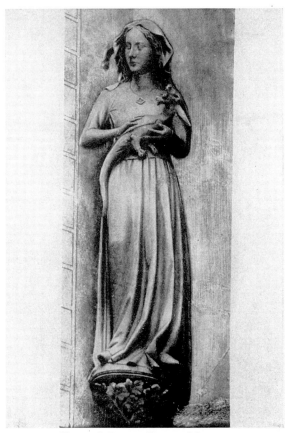

Eve and Serpent Reims (Marne)

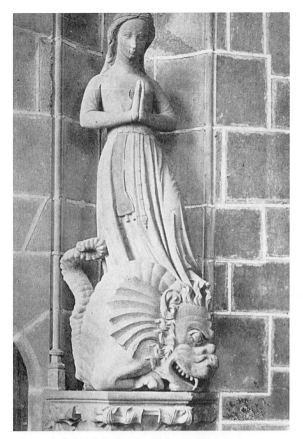

Sainte Marthe, Le Folgoët (Finistère)

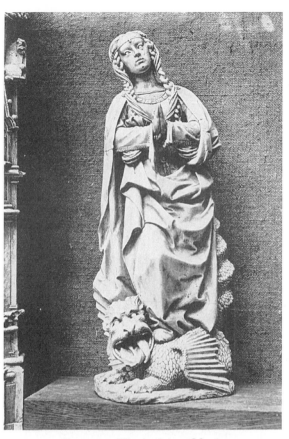

Bourges—(Cher) Sainte Marthe

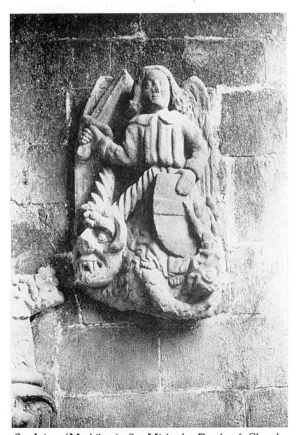

St. Léry (Morbihan) St. Michael—Porch of Church
Detail of Portal XIVth Century

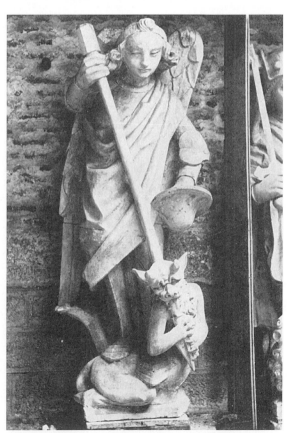

St. Michael and Devil Reims Cathedral—
XIIIth Century (Marne)

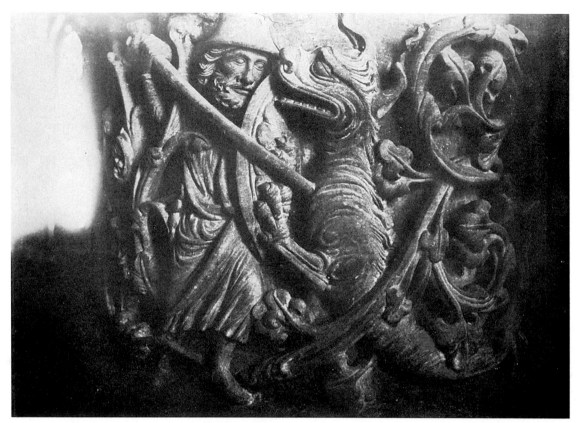

Saint George and the Dragon Reims

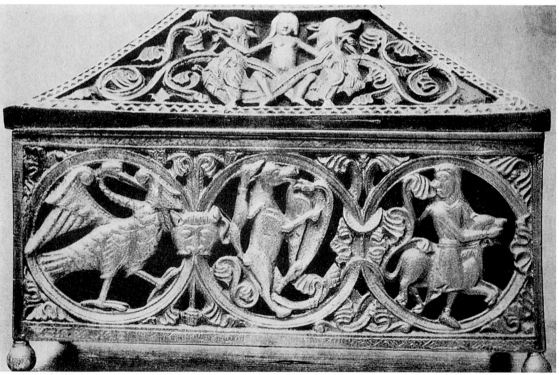

Paris, (Seine) Notre Dame, Treasury, Silver box said to Belong to Thomas of Becket,
showing the fable of the Ass and Lyre in the center, XIIth Century

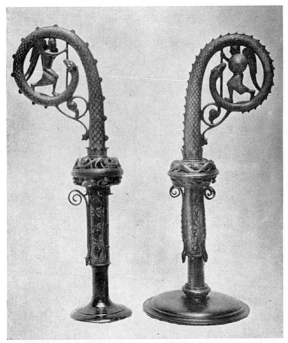

Crozier Symbolizing the Attributes of a Bishop's Power, Combining the Fearlessness of an Armed Angel with the Craftiness of a Serpent—Limoges Work, XIIIth Century

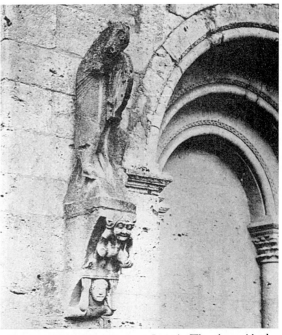

Chartres Cathedral (Eure et Loire) The Ass with the Viol South Bell Tower

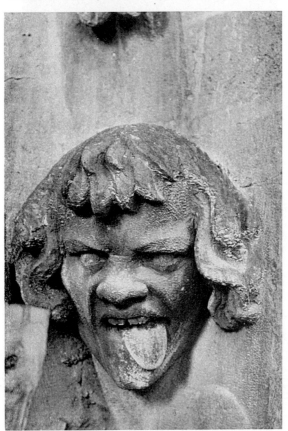

Blasphemy Reims Cathedral (Marne)

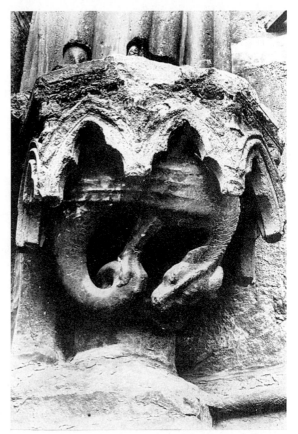

Chimere Represents Evil Conquered by Saint on Statue Above—Cathedral, Reims (Marne)

Paris—Notre Dame Symbolism of Dragons being
Trodden under Foot Shows Christ Triumphing Over Evil

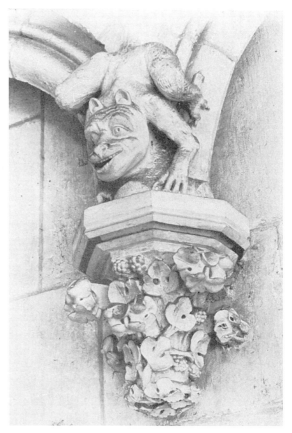

Toad—Symbol of Luxury (Lewdness) Auxerre Cath.
(Yonne) XIIIth Century

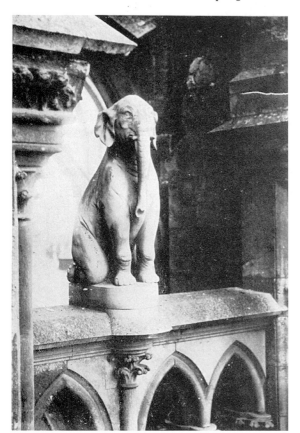

Elephant—Reims—Cathedral Symbol of Adam
XIIIth Century

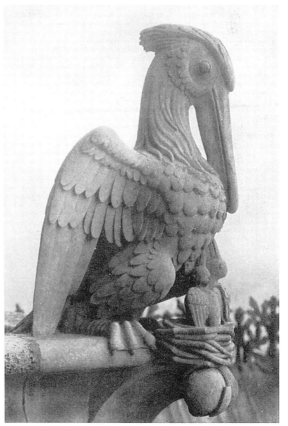

Notre Dame de Paris Pelican feeding her young with her
blood, symbolizing the sacrifice of Christ (Restored)

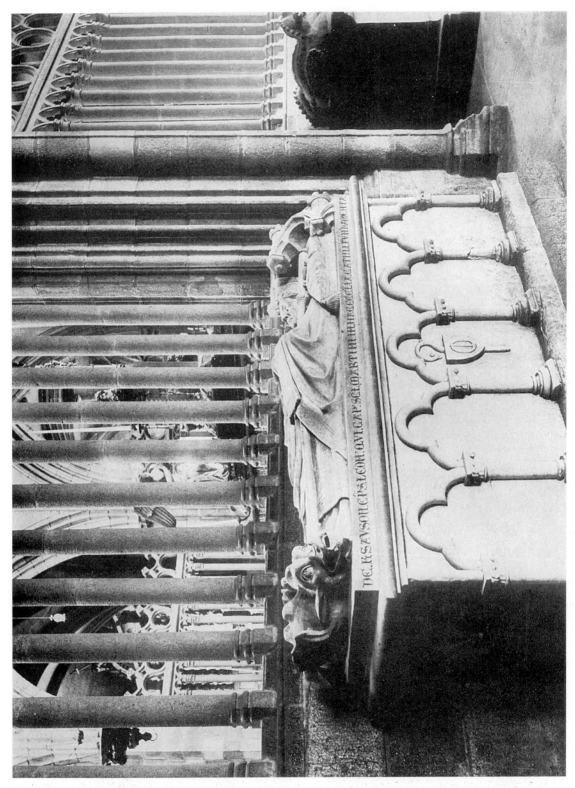

St. Pol de Léon, (Finistère), XIVth Century Tomb of Bishop, showing a dragon at the feet representing the evil conquered in the life of this man

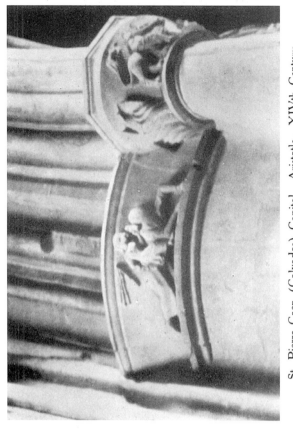

St. Pierre Caen (Calvados) Capital—Aristotle—XIVth Century

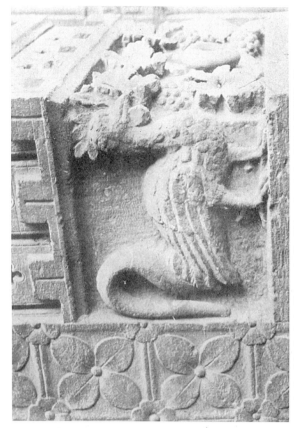

Amiens Cathedral (Somme) Basilisk—Symbol of Evil XIIIth Century—
Portal of Facade

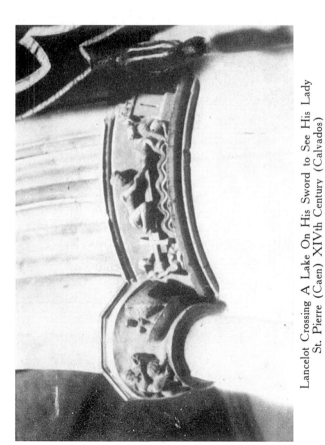

Lancelot Crossing A Lake On His Sword to See His Lady
St. Pierre (Caen) XIVth Century (Calvados)

Aspic (Amiens) (Somme) Used to Represent Sinners who Would not Listen to
The Word of God XIIIth Century—Main Portal Facade

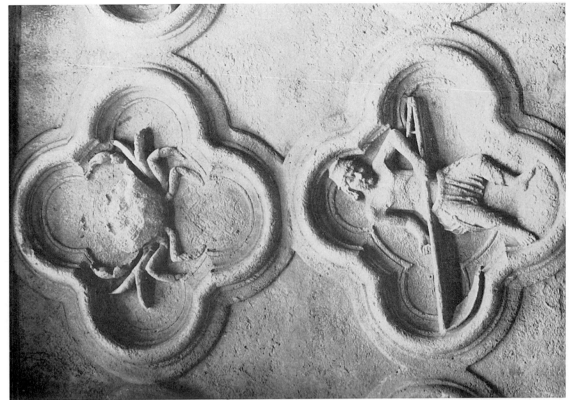

Amiens (Somme) Crab—Cancer—April Signs of Zodiac & Seasons
XIIIth Century

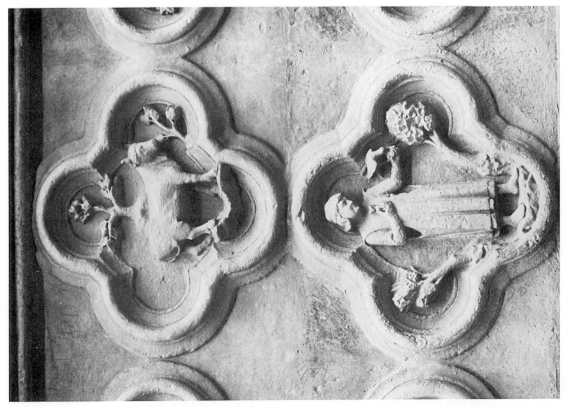

Amiens (Somme) Taurus—Bull—February Signs of Zodiac & Seasons
XIIIth Century

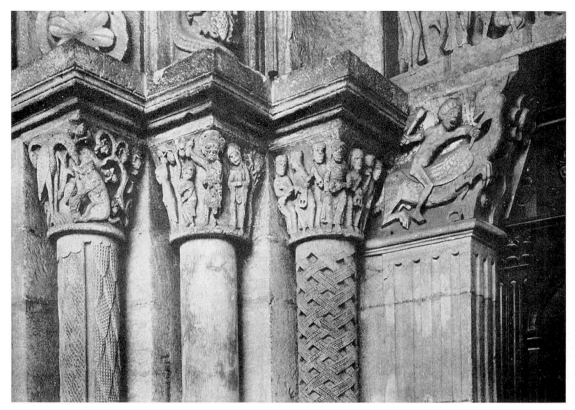

Autun Cath. (Saône et Loire) XIIIth Century—Capitals of Left Side of Portal—
Showing Stork Extracting a Bone from The Wolf's Throat (Left).

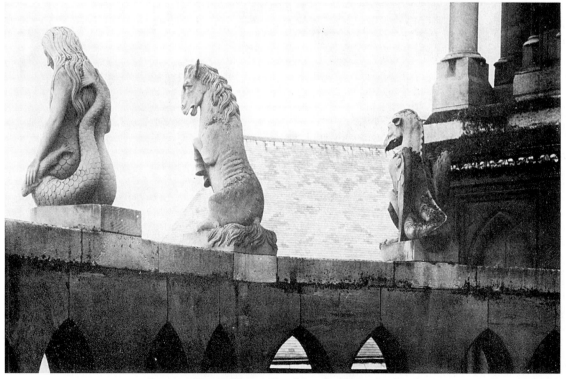

Chimeres Reims (Restored) (Marne) Mermaid (Siren)
Symbol of Enticements of the Flesh.

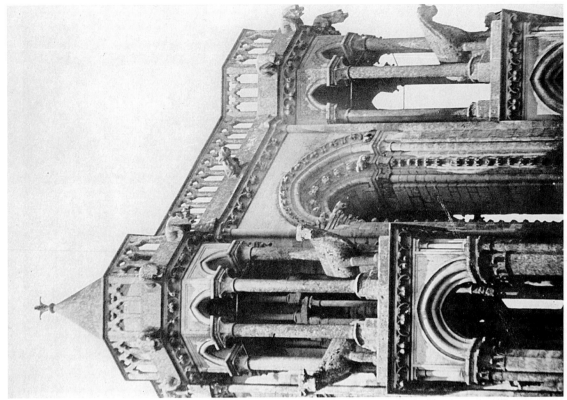

Oxen on Towers As Monument to Beasts which Carried up the Stones
Laon (Aisne) XIIth & XIIIth Centuries

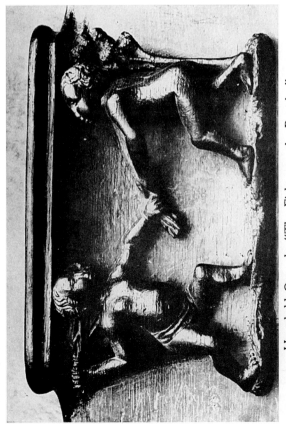

Household Quarrel—"The Fight over the Breeches"
Presles (Seine et Oise) XIIIth Century

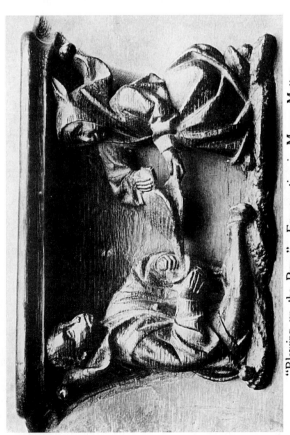

"Blowing up the Purse"—Exaggeration in Money Matters
Misericorde at Presles (Seine et Oise)

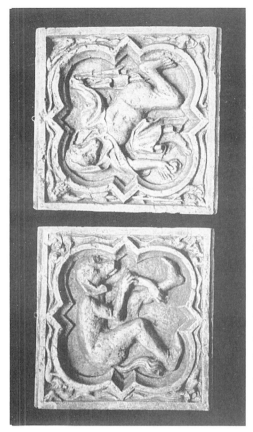

Imaginative Quatrofoils—Rouen—Cath. Portal of the Bookstalls
XVth Century (Seine Inférieur)

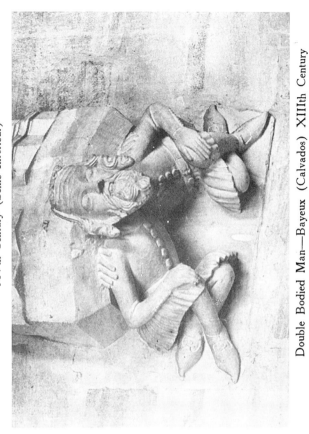

Double Bodied Man—Bayeux (Calvados) XIIIth Century

Bourges Cath. (Cher) XIIIth Century Showing How Mass Shape of Sculpture Would
Fit For Animal or Bird Forms

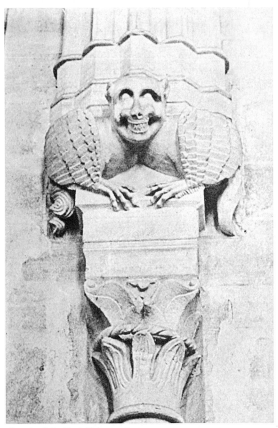

Single Headed Beast, Bayeux (Calvados) Cathedral
XIIIth Century

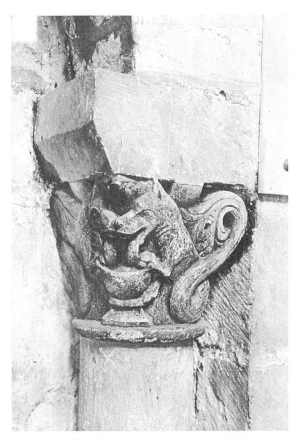

Animals Drink Out of a Jar, Poitiers (Vienne)
Oriental Motif

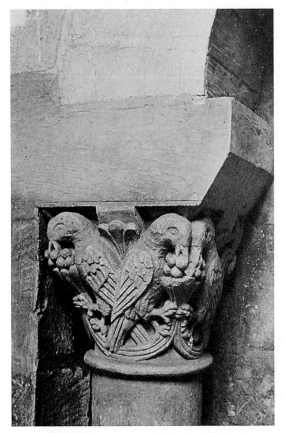

Birds Eating Grapes, Poitiers (Vienne)
Oriental Motif

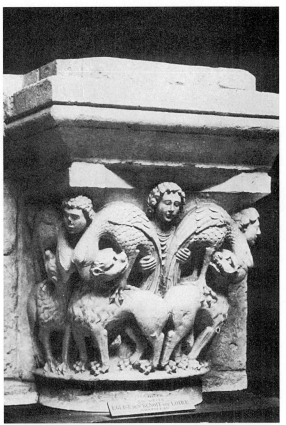

Animals Stand Upon Each Other, Saint Benoit-Sur-Loire
(Loiret) XIIth Century Oriental Motif

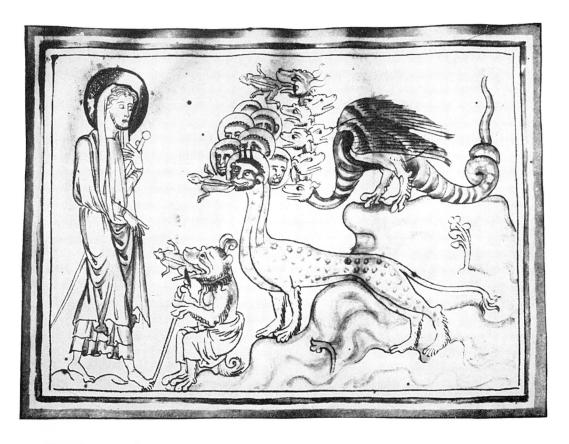

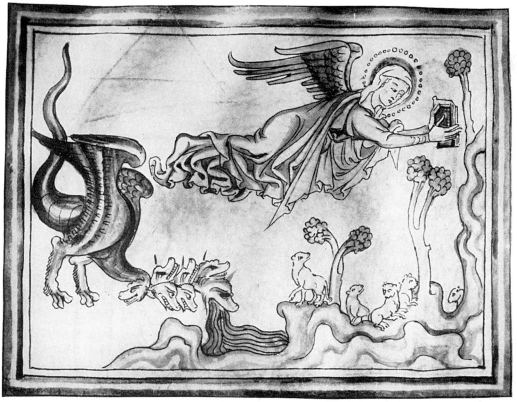

Cambrai Bible Illustrations XIIIth Century—Apocalypse

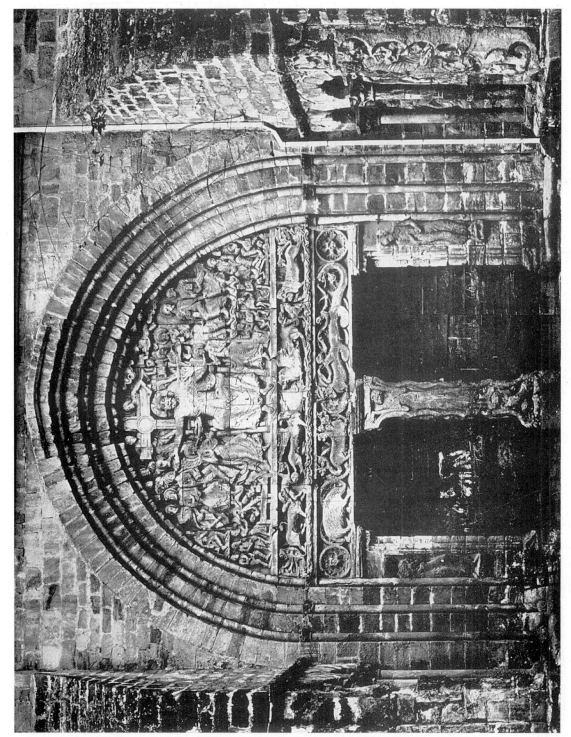

Beaulieu-sur-Dordogne (Corrèze) .. Twelfth Century, showing the seven-headed beast
of the Apocalypse on the lower band of the tympanum

Urcel, (Aisne) . . Smiling figure of the Devil Clutches a soul . . . XIIth Century

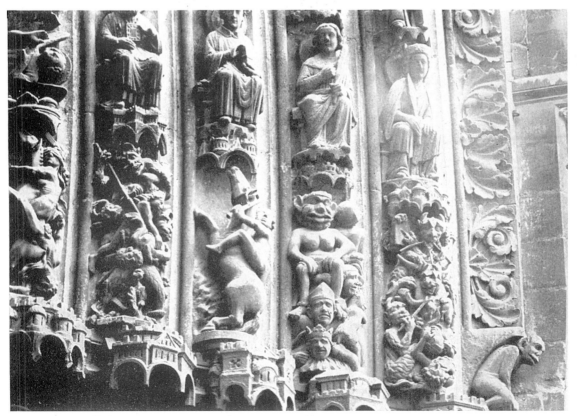

Riders of the Apocalypse and Devil Administering Punishment to the Damned
(Notre Dame de Paris) XIIth Century

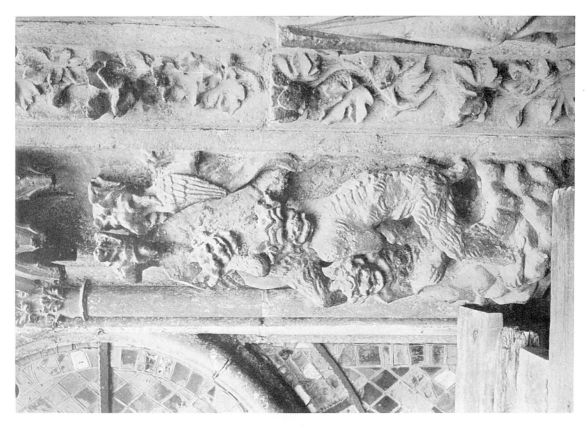

Reims (Marne) Devils—XIIIth Century

Notre Dame de Paris Rider of The Apocalypse—XIIth Century

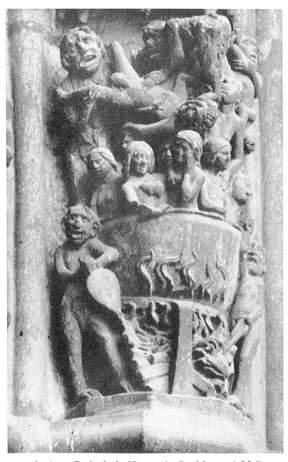

Amiens Cathedral (Somme) Cauldron of Hell
XIIIth Century

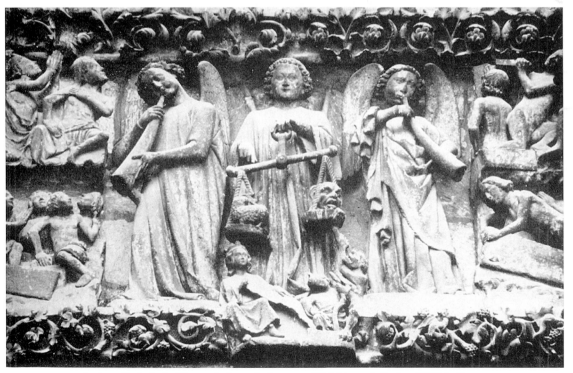

Amiens Cathedral (Somme) Last Judgment—Weighing of Souls—XIIIth Century

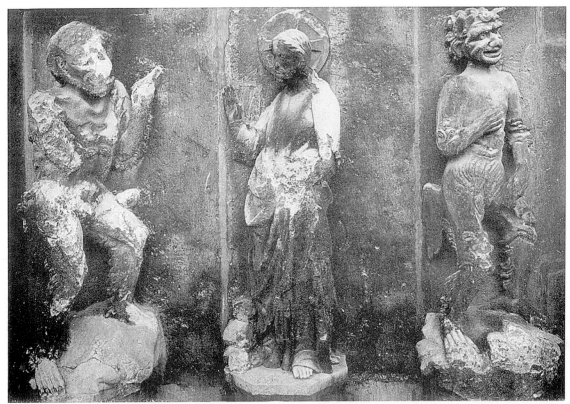

Reims (Marne) Devils with Christ

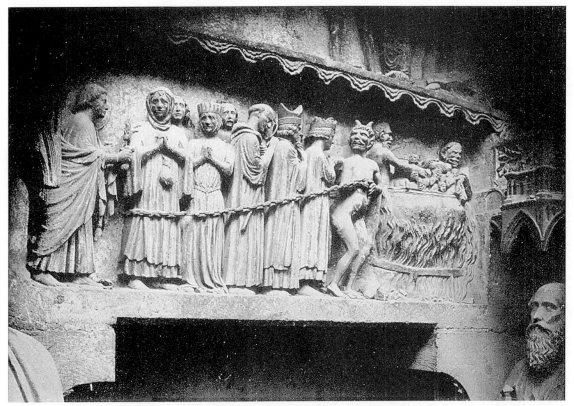

Reims Cathedral (Marne) Condemned Led Off

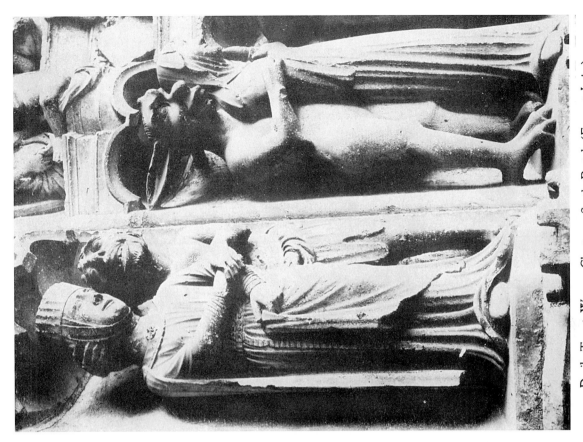

Devils Tempt Women Chartres—South Portal (Eure et Loire)
XIIIth Century

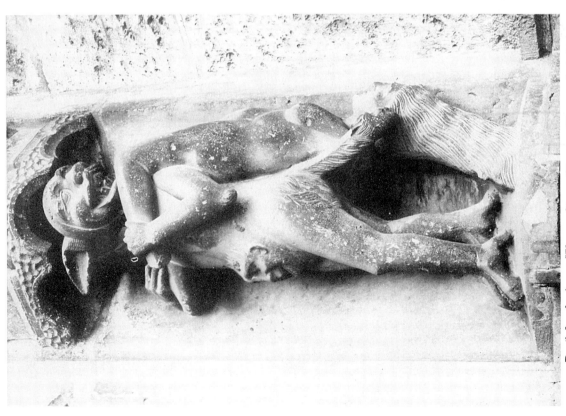

Devil Leads Away Woman Sinner Chartres (Eure et Loire)
South Portal—XIIIth Century

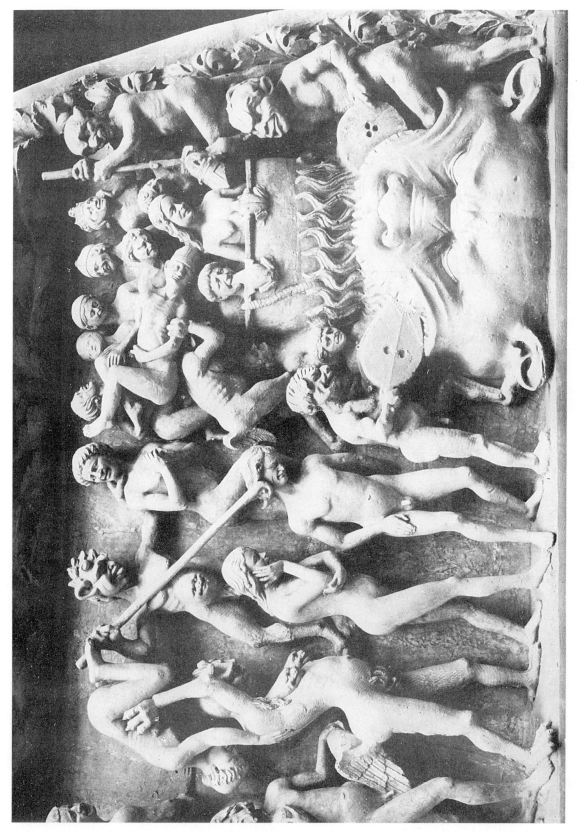

Bourges Cathedral (Cher) Last Judgment XIVth Century

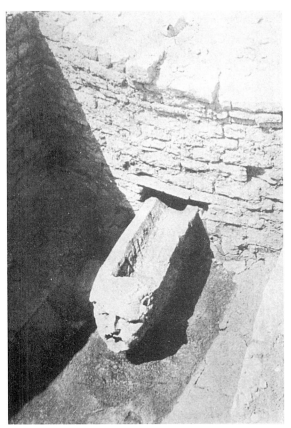

The Excavations of Mount Auxois (Côte D'Or)
A Gargoyle of 160 AD

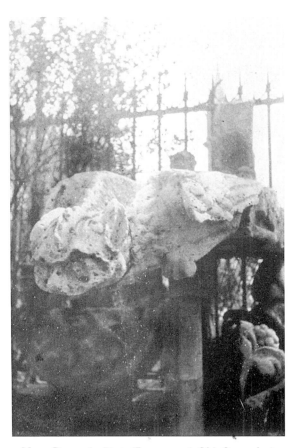

Notre-Dame de Paris Fragment of Old Gargoyle in
Garden—XIIth Century Showing Large Bulky Size

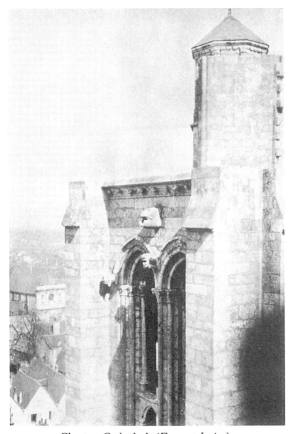

Chartres-Cathedral (Eure et Loire)
North Portal—Tower

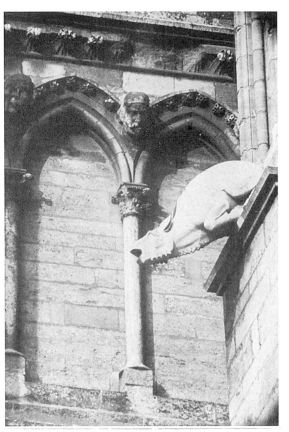

Reims Cathedral (Marne) North Side

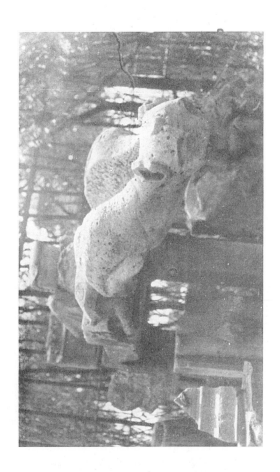
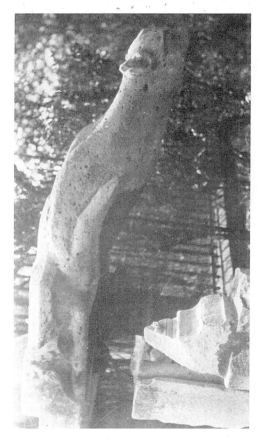

Notre Dame de Paris Ancient Fragments of Gargoyles in Garden (Apse)

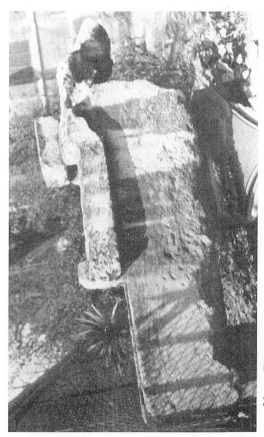

Notre Dame de Paris Ancient Types Now in Garden Behind Apse—
Showing Box Setting for a Gargoyle

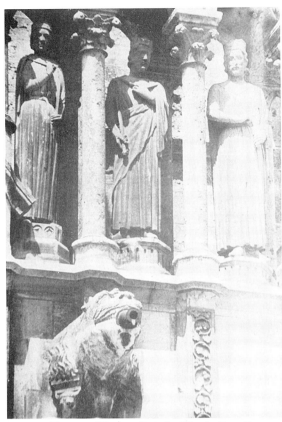

Chartres (Eure et Loire) (South Portal)

Musée de Cluny Garden Dog Clutches Small Animal
Paris (Seine)

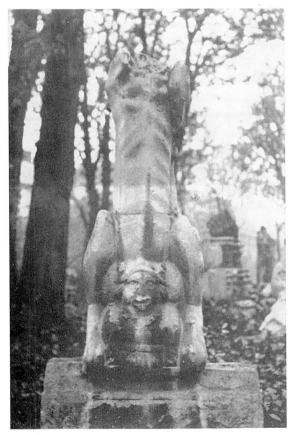

Musée de Cluny Garden Paris (Seine) Animal Gargoyle
with Relief of Man at Base

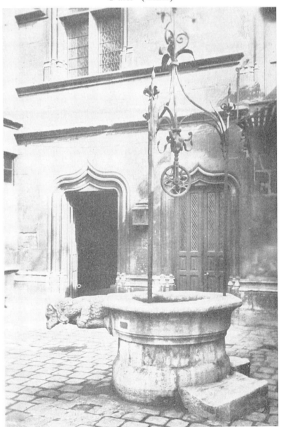

Well-Spout—XVth Century Musée de Cluny
Paris (Seine)

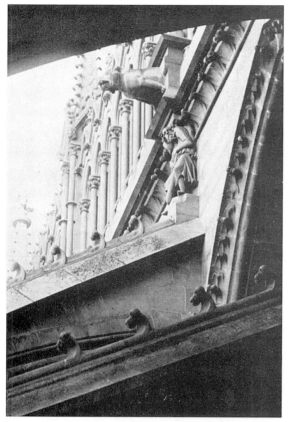

Reims Cathedral (Marne)

Musée de Cluny Garden Paris (Seine) Hooded Man

Musée de Cluny Garden Paris (Seine)
Woman as Gargoyle

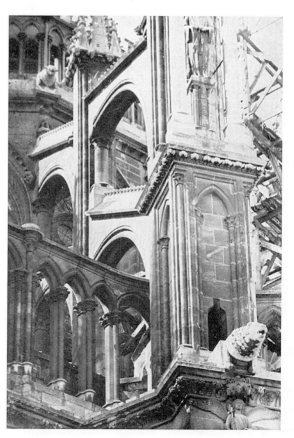

Reims Cathedral—(Marne) Apse Showing Line of
Gargoyles in Channel of Buttress

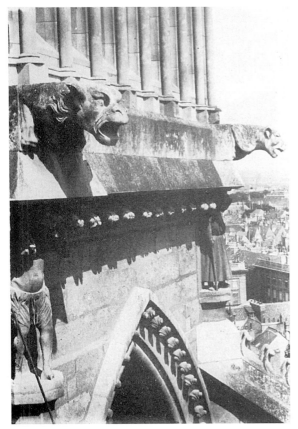

Reims Cathedral (Marne) Apse (Restored)

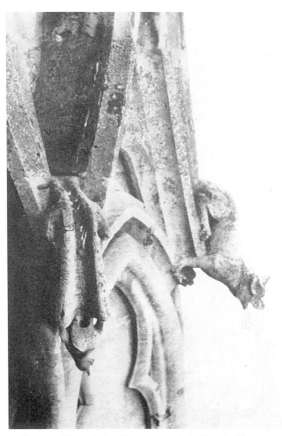

Chartres-Cathedral (Eure et Loire) North Tower
XVth Century

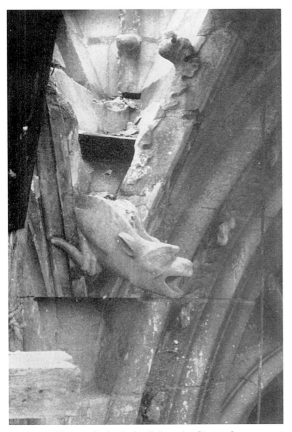

Reims Cathedral (Marne) Gargoyle

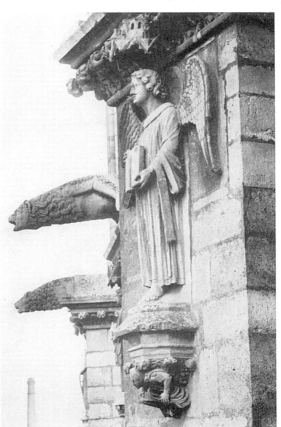

Reims Cathedral (Marne)

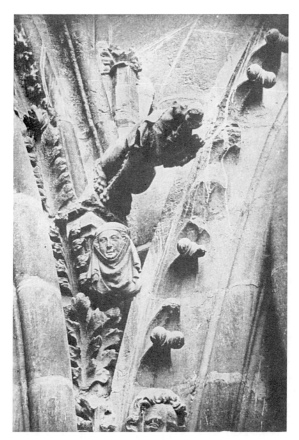

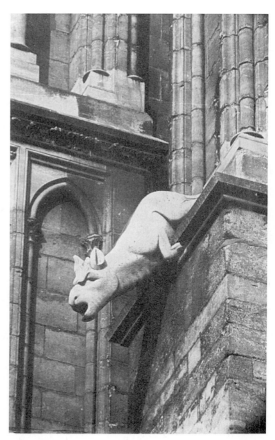

Reims—Cathedral (Marne)

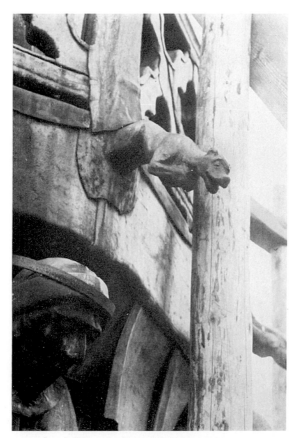

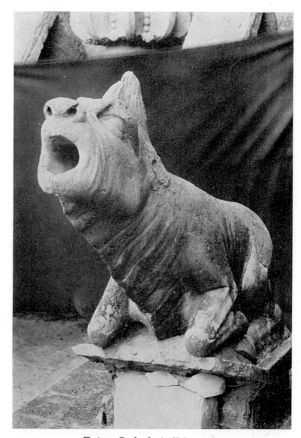

Lead Gargoyle Reims Cathedral (Marne) Reims Cathedral (Marne)

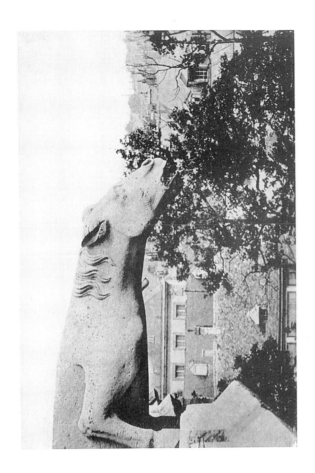

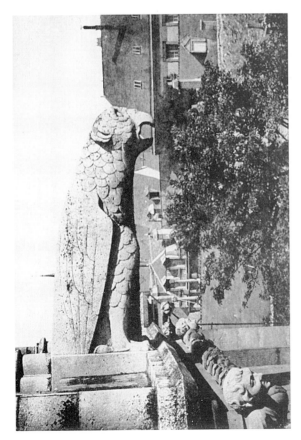

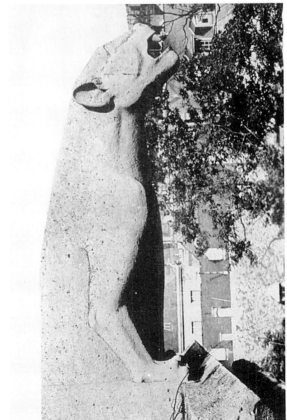

Reims Cathedral (Marne)

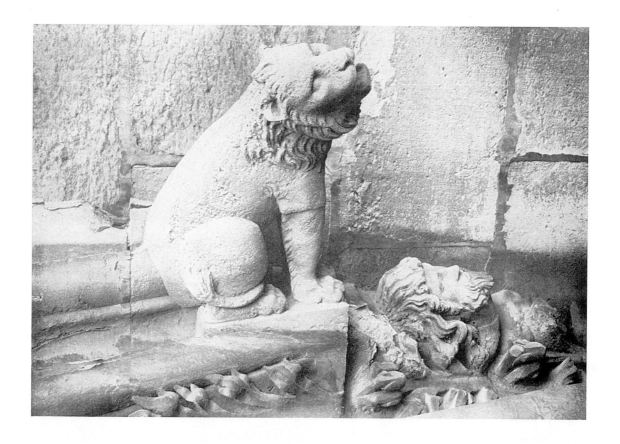

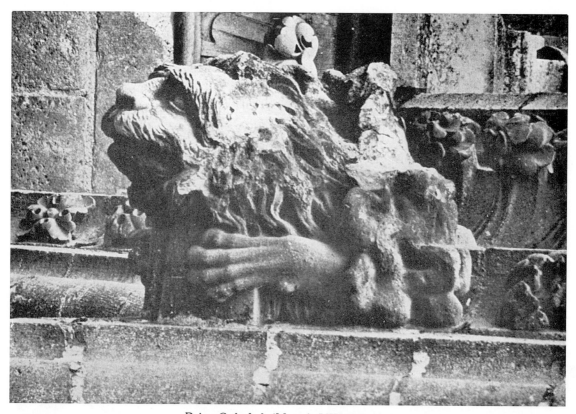

Reims Cathedral (Marne) XIIIth Century

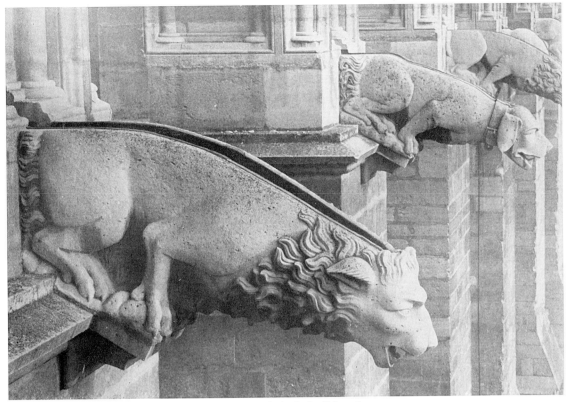

Reims—Cathedral (Marne)

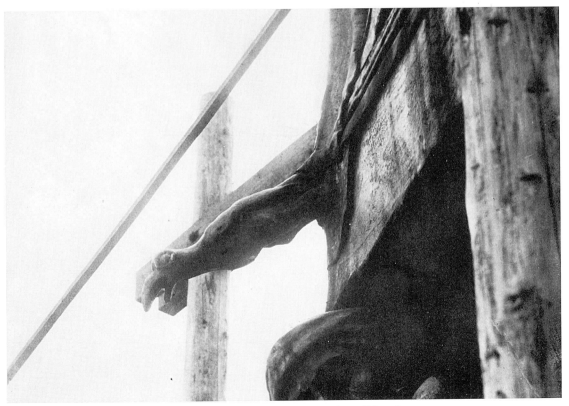

Lead Gargoyle—Reims Cathedral (Marne)

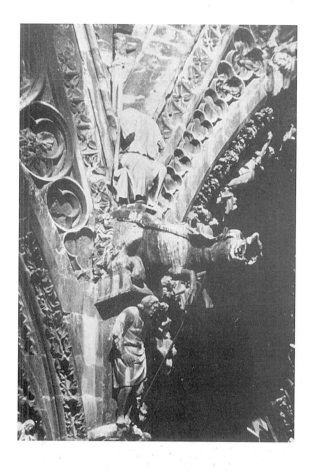
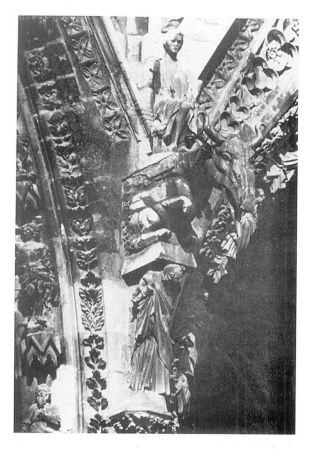
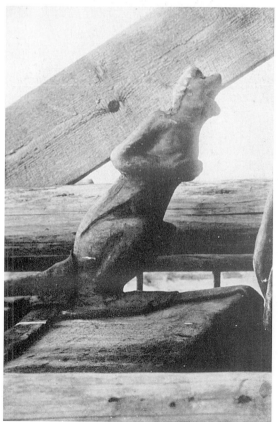
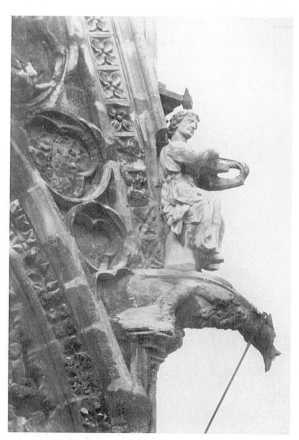

Lead Gargoyles Reims Cathedral—(Marne) After the Fire of 1481

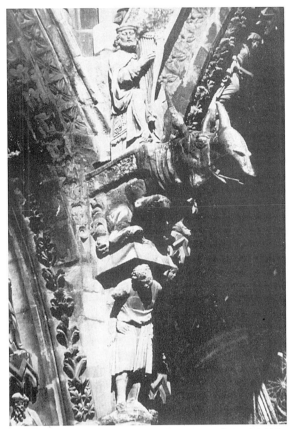

Lead Gargoyle Reims (Marne) After the Fire of 1481

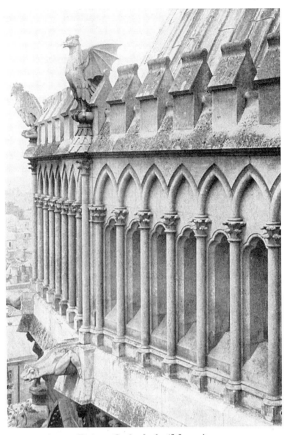

Reims Cathedral (Marne)

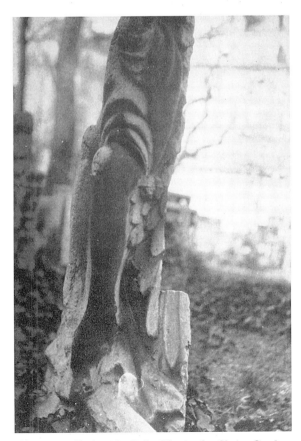

Gargoyle—Fool with Bells Musée de Cluny Garden
Paris (Seine)

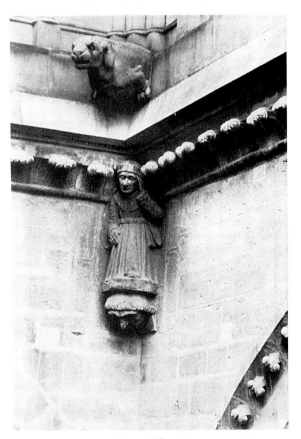

Reims (Marne)

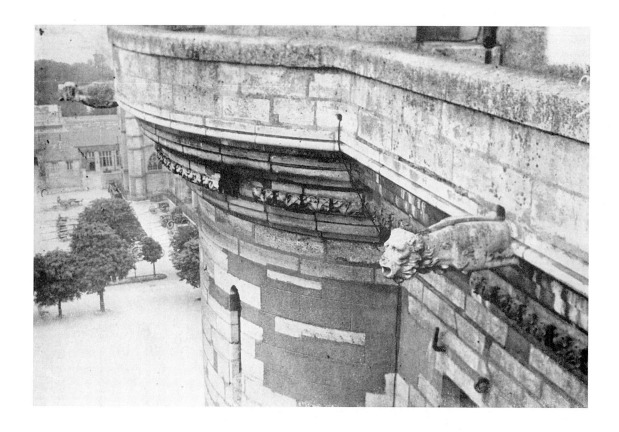

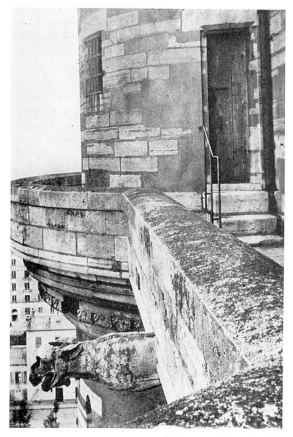
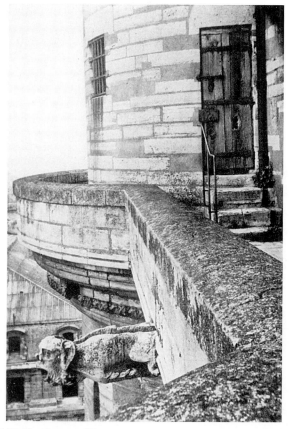

Vincennes (Seine) Château XIVth Century Donjon

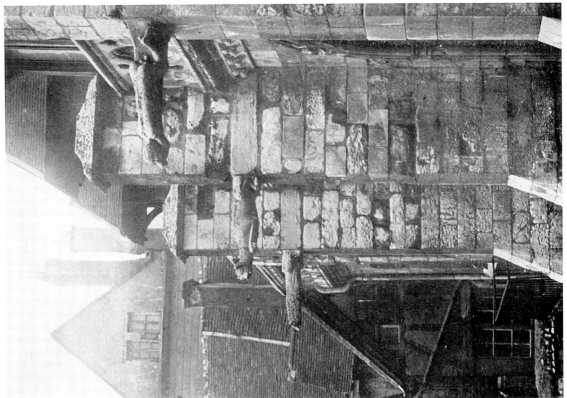

Rouen Cathedral XIIIth Century The Cloister

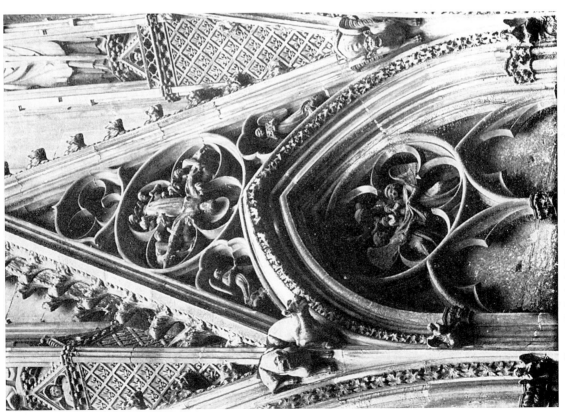

Rouen Cathedral (Seine Inférieur) Portal of the Book Stalls

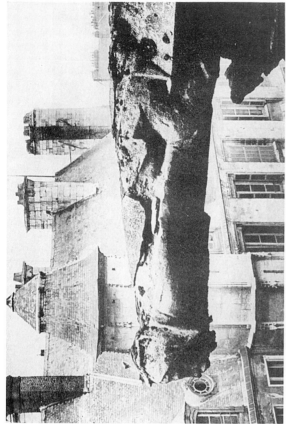

Rouen—XIVth Century Cathedral (Seine Inférieur)

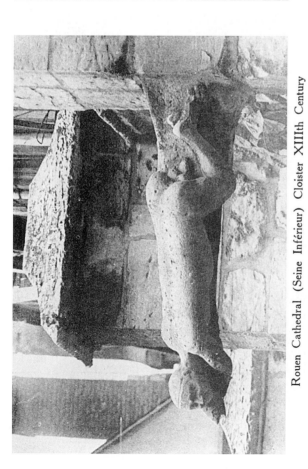

Rouen Cathedral (Seine Inférieur) Cloister XIIIth Century

Rouen—St. Ouen (North) (Seine Inférieur) XIVth Century

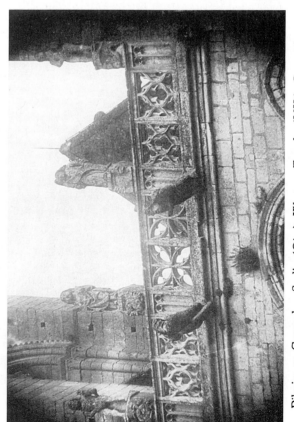

Pilgrim as Gargoyle—Senlis (Oise) Western Facade (XIIth Century)

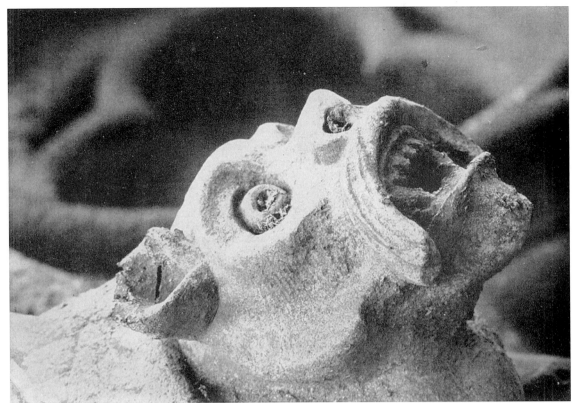

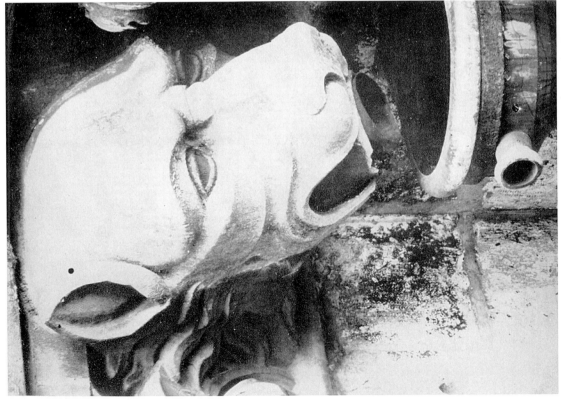

Amiens (Somme) Cathedral

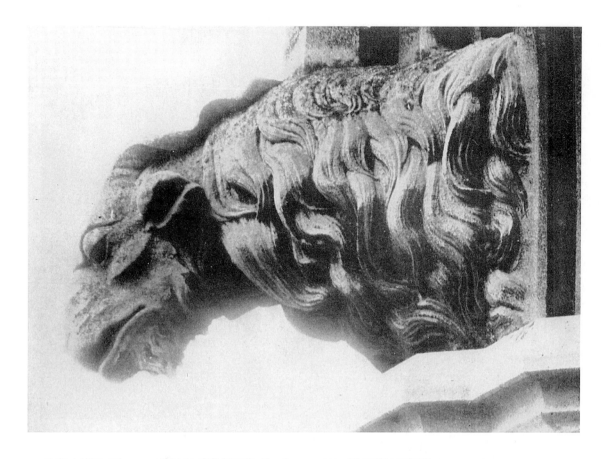

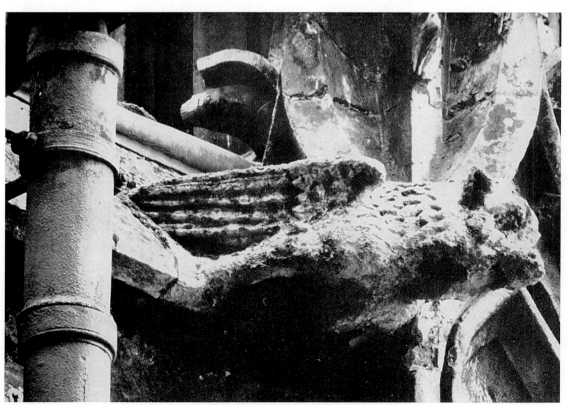

Amiens Cathedral Gargoyles (Somme)

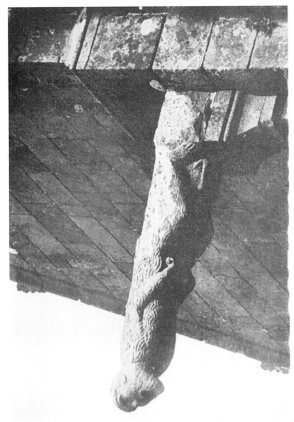

Notre Dame Josselin (Morbihan) South Portal—XVth Century

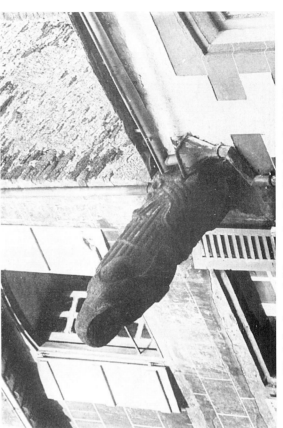

Monk In Jaws of Monster Josselin (Morbihan) Old House

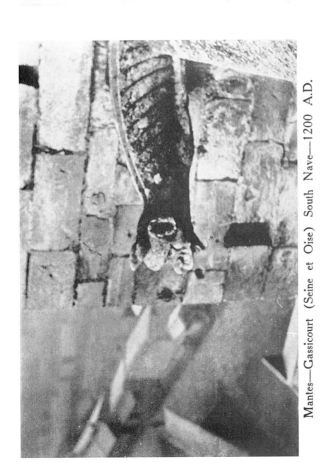

Mantes—Gassicourt (Seine et Oise) South Nave—1200 A.D.

Paris—Saint Severin, (Seine) XVth Century

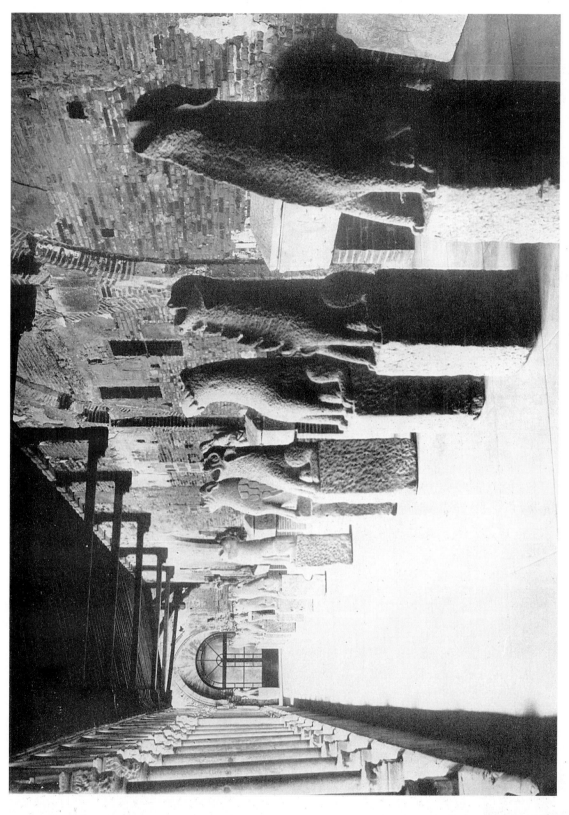

Museum of Toulouse (Haute Garonne)

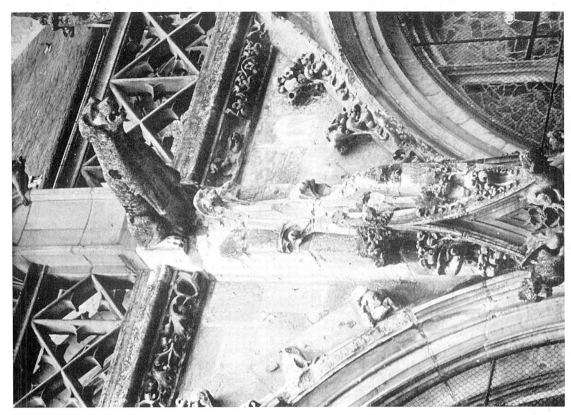

Le Grand Andely (Eure) South Facade XIIIth Century

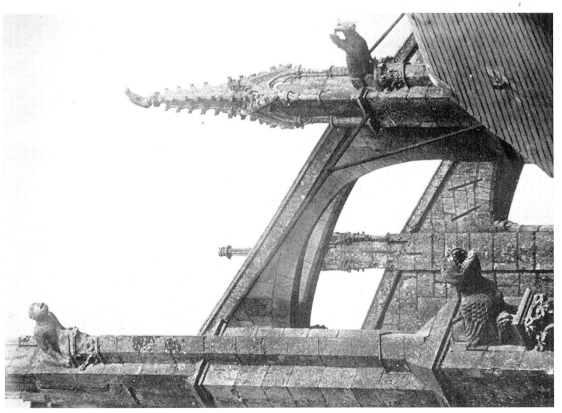

Le Mans Cathedral (Sarthe) Large Jawed Type Gargoyle South Side of Apse XIIIth Century

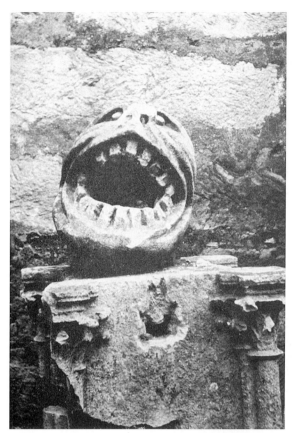 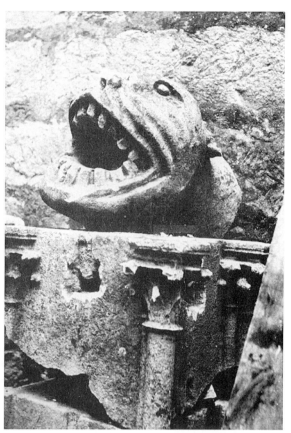

Le Mans (Sarthe) Cathedral, XIIIth Century, Detail
of the heavy jaw type of gargoyle

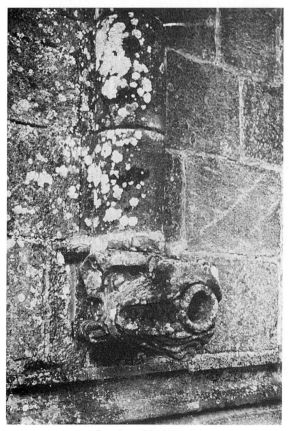 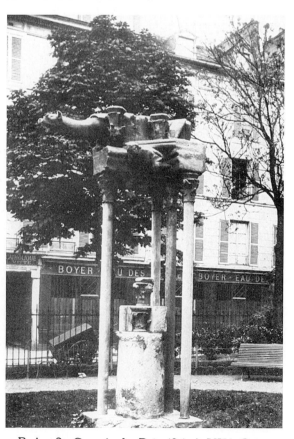

Josselin (Morbihan) Paris—St. Germain des Prés (Seine) XIIth Century

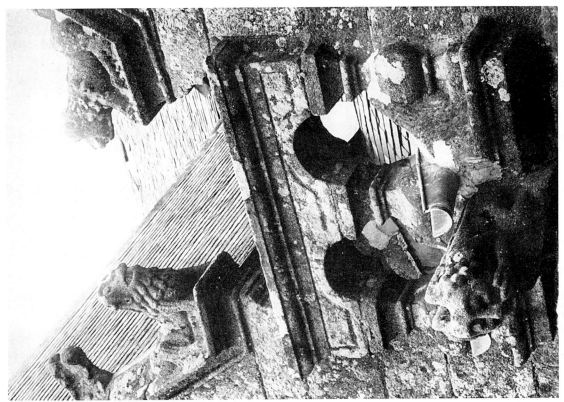

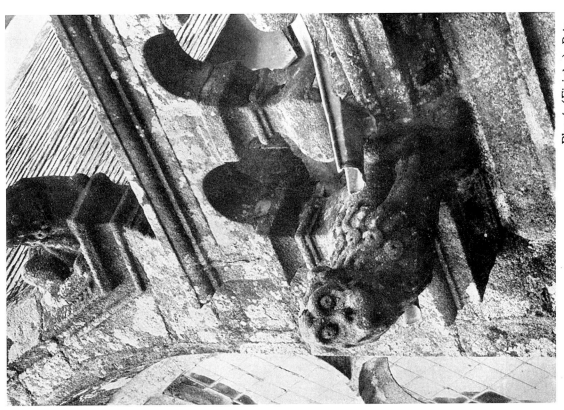

Ploaré (Finistère) Brittany Church South Side XVIth Century

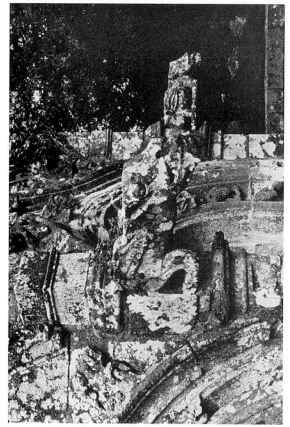

Pluméliau (Morbihan) Fountain—XVIIth Century

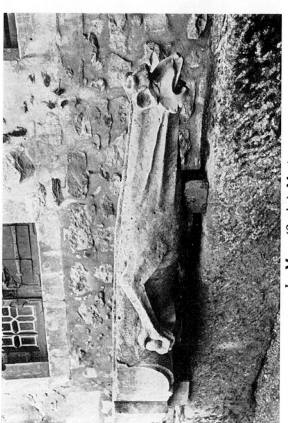

Plougonven (Finistère) (Brittany) XVIth Century

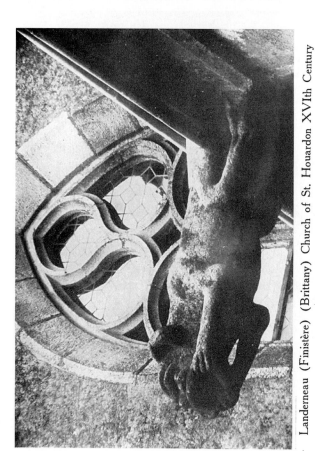

Landerneau (Finistère) (Brittany) Church of St. Houardon XVIth Century

Le Mans (Sarthe) Musée

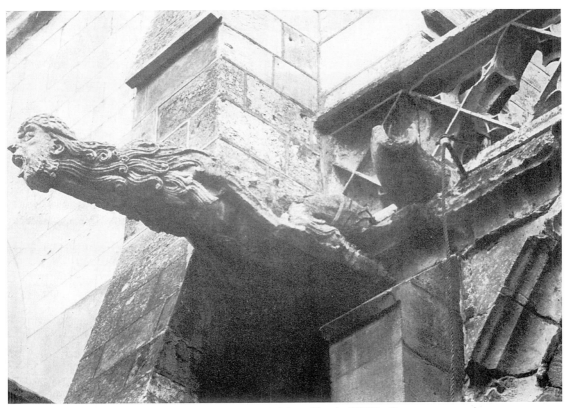

Louviers (North Side)—(Eure) XIIIth Century

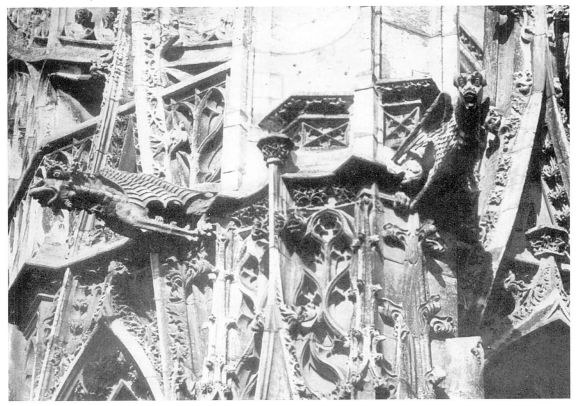

Louviers (Eure) South Side XVIth Century

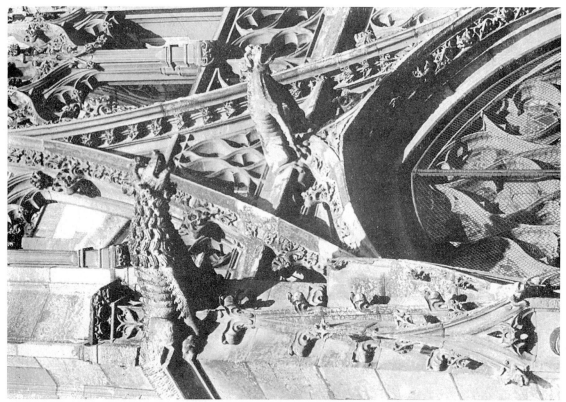

Louviers (Eure) South Side XVIth Century

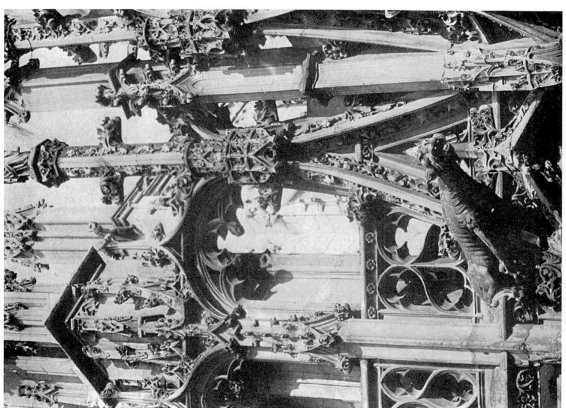

Louviers—(Eure) West Side XVIth Century

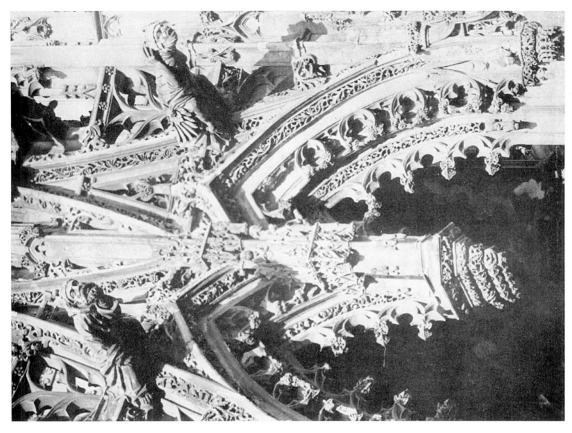

Louviers (Eure) South Porch XVIth Century

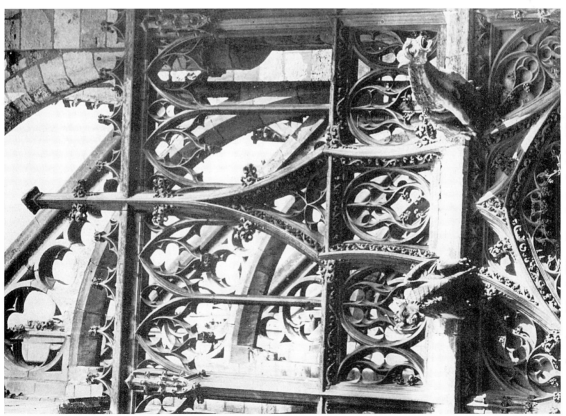

Louviers (Eure) West Portal, South Side XVIth Century

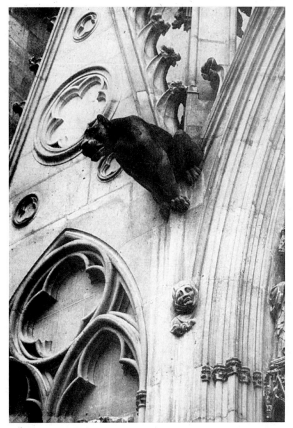

Meaux (Seine et Marne) South Facade—XIIth Century

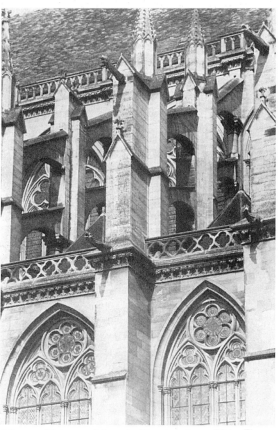

Meaux (Seine et Marne) Showing Long-Thin Types
South Side—XIIIth

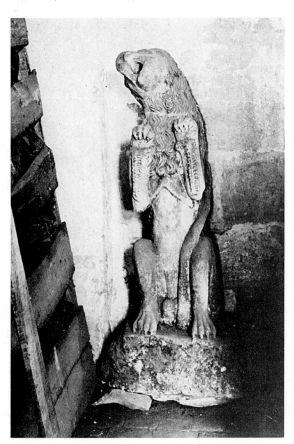

Laon (Aisne) Bishop's Chapel

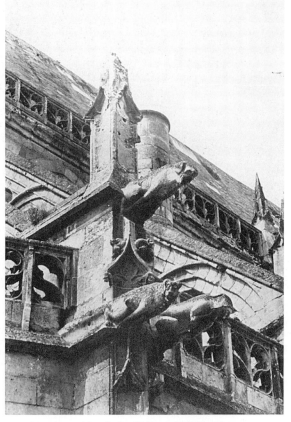

Beauvais (Oise) St. Etienne XIIIth Century

Saint Urbain de Troyes, Gargoyle—Draped figure
holding vase XIIIth Century

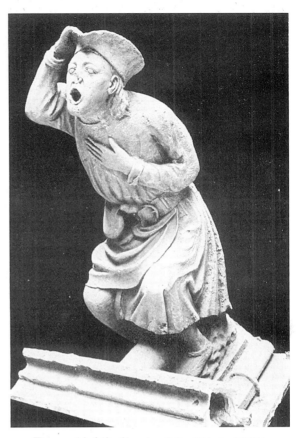

Troyes (Aube) Church of St. Urbain XIIIth
Century Gargoyle

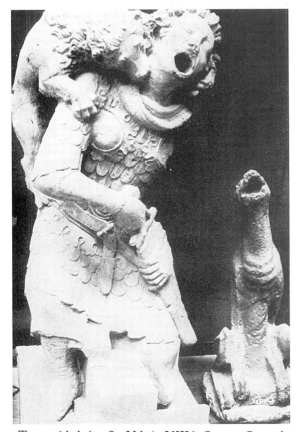

Troyes (Aube)—St. Urbain XIIIth Century Gargoyle

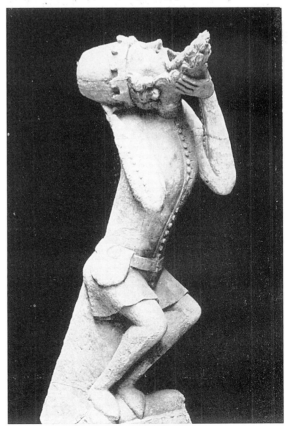

Troyes (Aube) St. Urbain—XIIIth Century Gargoyle

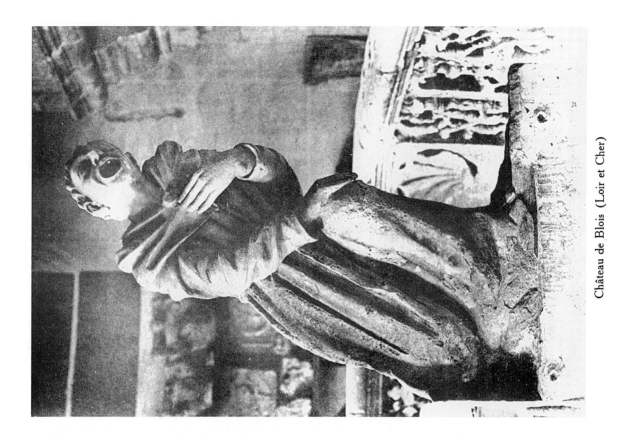

Château de Blois (Loir et Cher)

Gargoyles—St. Urbain, Troyes, (Aube), XIIIth Century

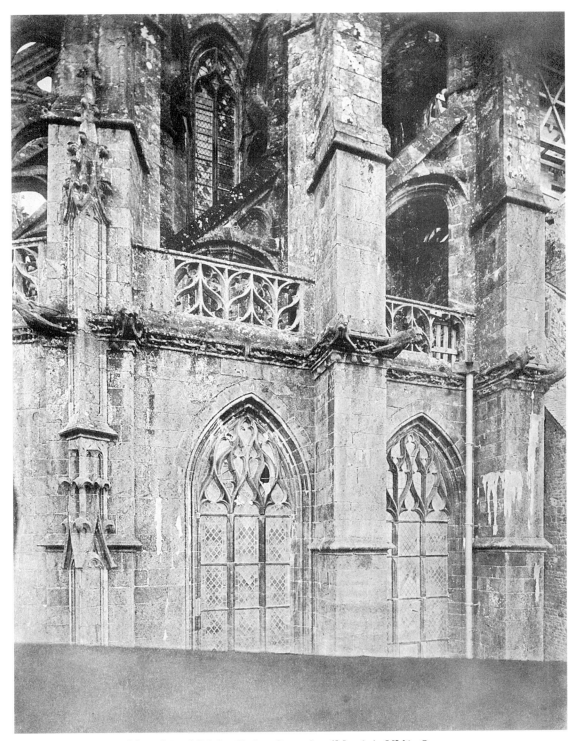

Mont Saint Michel—Choir—Gargoyles (Manche) XVth Century

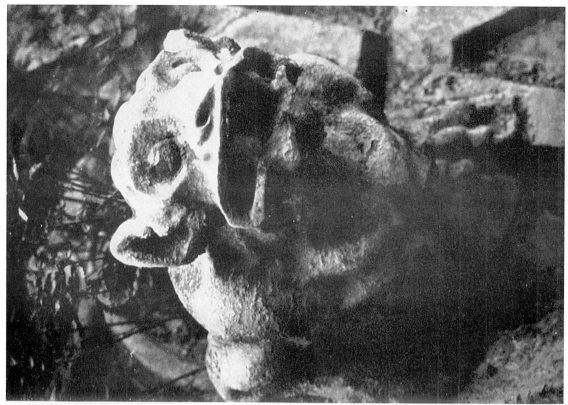

Amiens Cathedral (Somme)

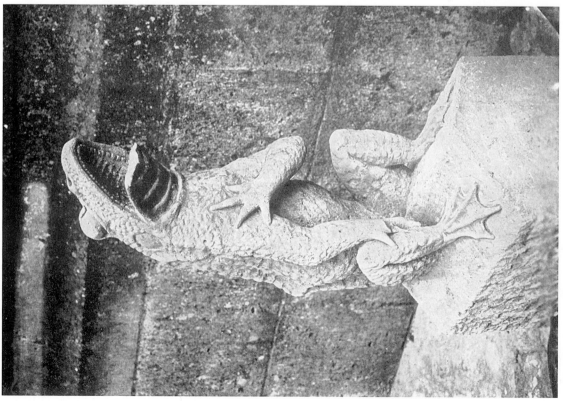

Château of Blois, (Loir et Cher), Gargoyle, the Amorous Frog

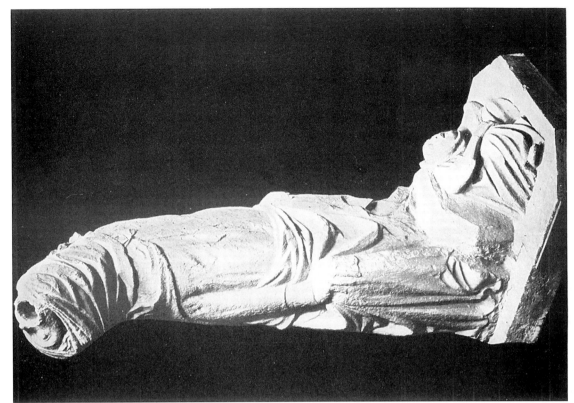

Laon Notre Dame (Aisne) XIIIth Century

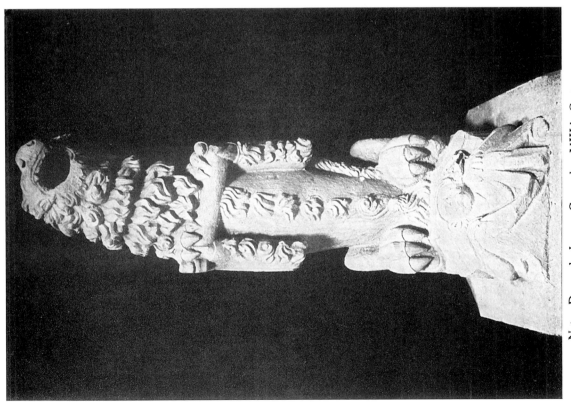

Notre Dame de Laon—Gargoyle—XIIIth Century

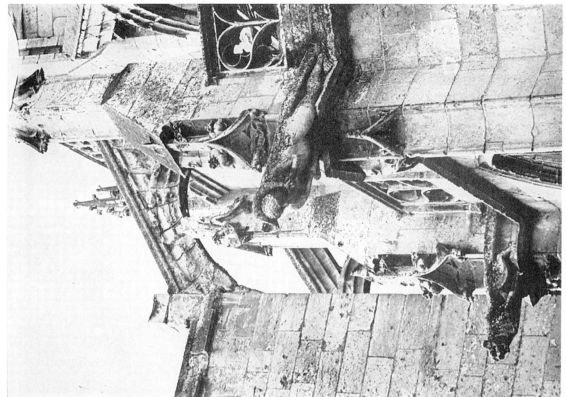

Beauvais (St. Etienne) (Oise) XIIIth Century

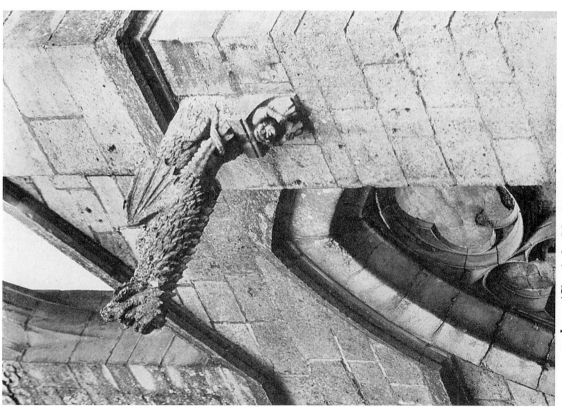

Laon (Church St. Martin) (Aisne) XIIth Century

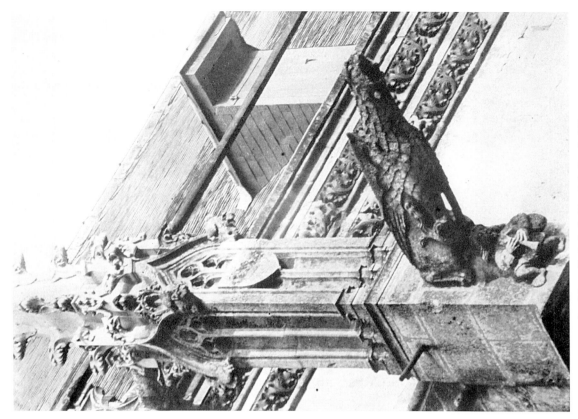

Le Mans Cathedral (Sarthe) South Side

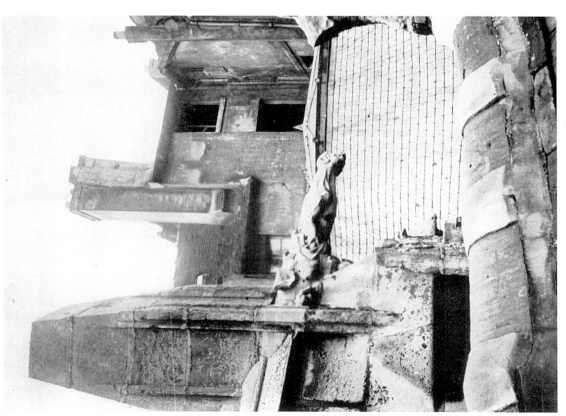

Dog Swallowing Animal—St. Severin—Paris

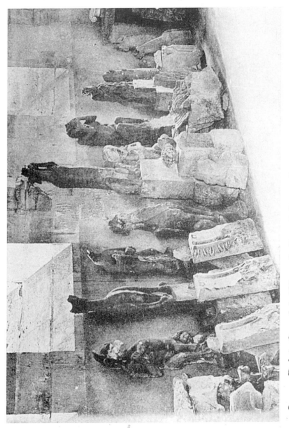

Sens—Palais Synodal (Yonne) Set of Gargoyles in Basement XVIth Century

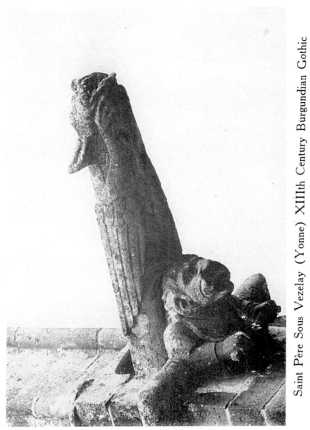

Saint Père Sous Vezelay (Yonne) XIIIth Century Burgundian Gothic

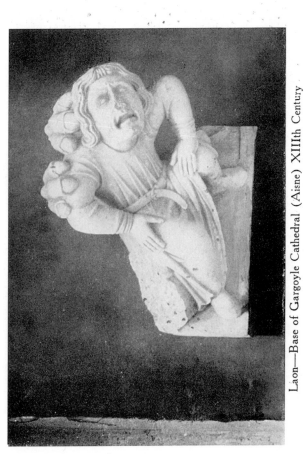

Laon—Base of Gargoyle Cathedral (Aisne) XIIIth Century

Mantes—Gassicourt (Seine et Oise) Compound Type—South Side 1200 A.D.

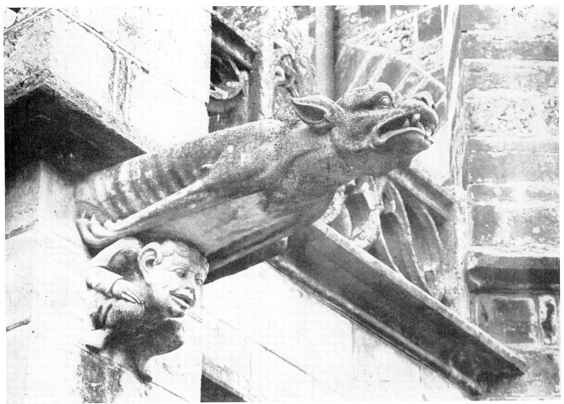

Saint Père sous Vézelay (Yonne) XIIIth Century Burgundian Gothic

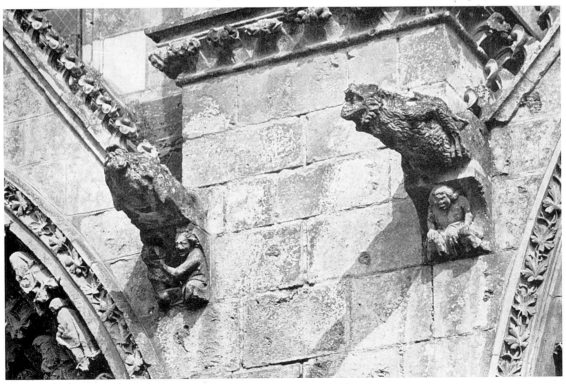

Poitiers (Vienne) Cathedral, Facade

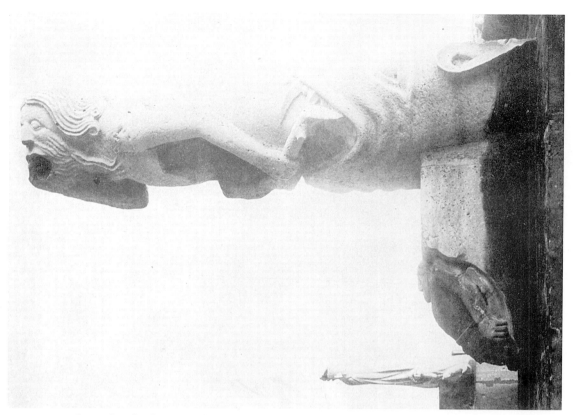

Gargoyle—St. Germain L'Auxerrois, Paris, Man being vomited from a dragon's mouth

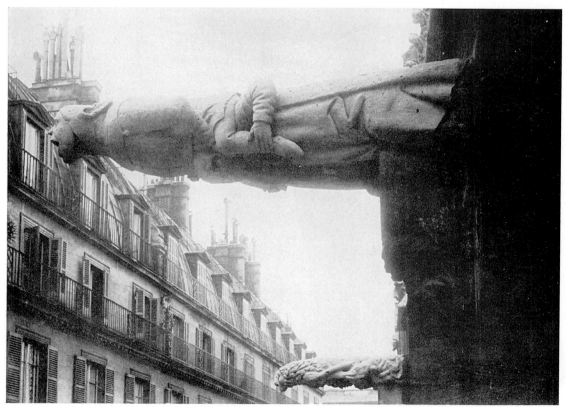

Gargoyle—St. Germain L'Auxerrois, Paris, Fool standing on old man's shoulders

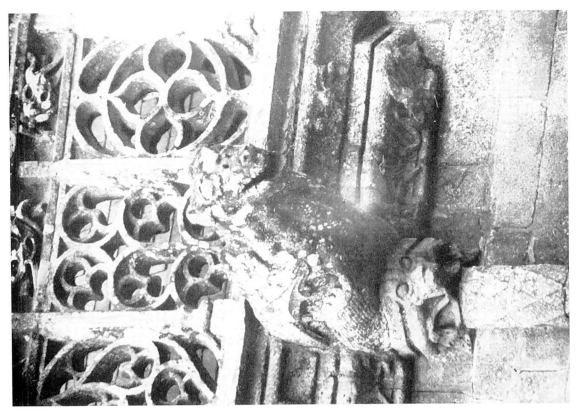

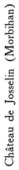

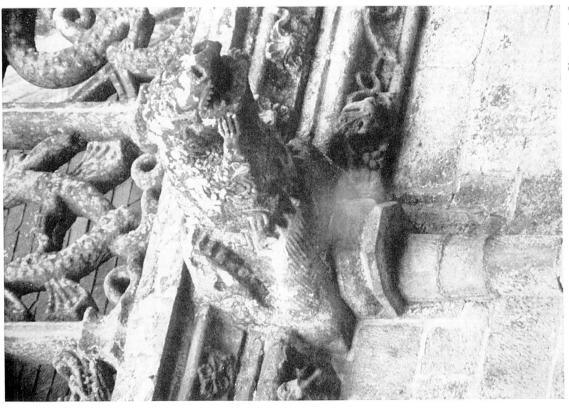

Château de Josselin (Morbihan)

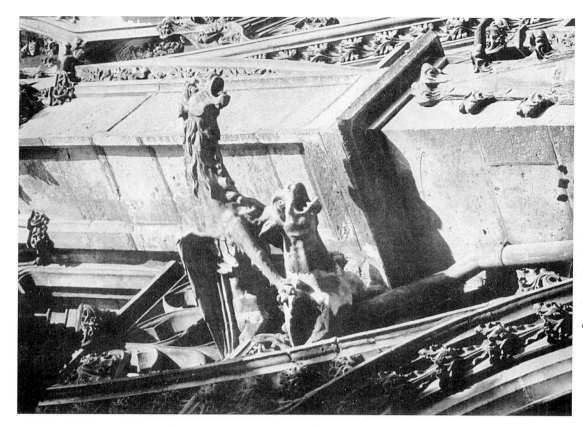

Louviers (Eure) South Side XVIth Century

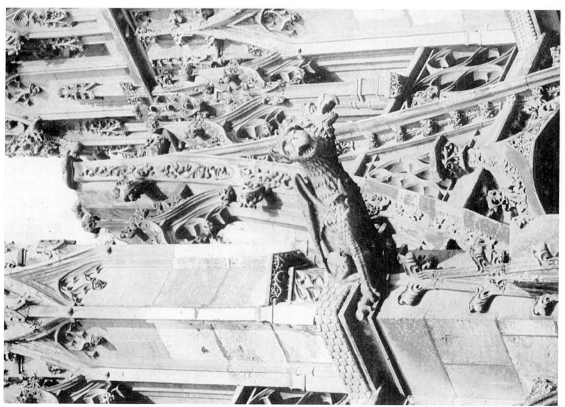

Louviers (Eure) South Side XVIth Century Double Headed Gargoyle

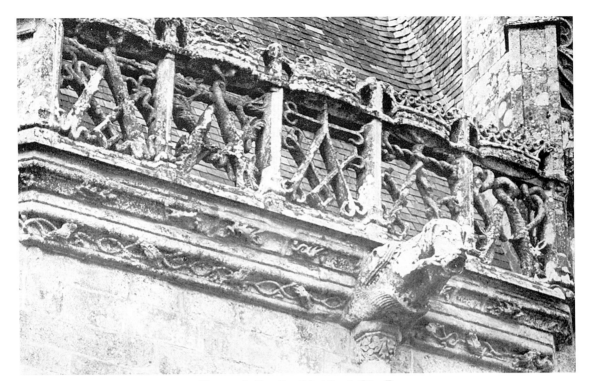

Château de Josselin (Morbihan) Côte Parc

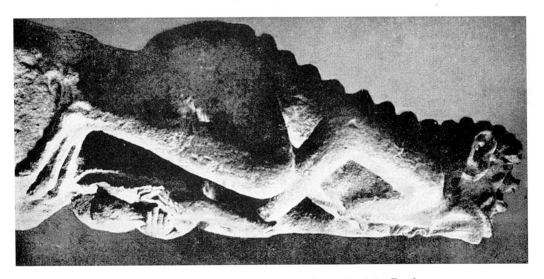

Colmar Museum XVIth Century Gargoyle of the Devil
Church of Rouffach (Haute Rhin)

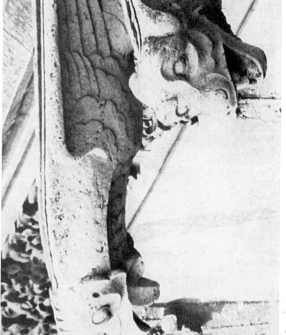

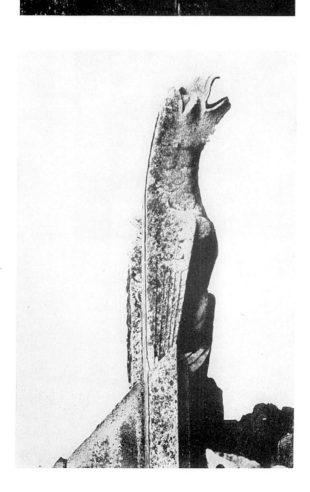

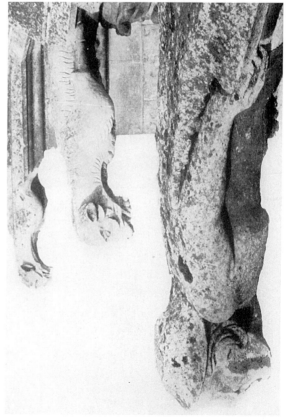

Amiens Cathedral (Somme)

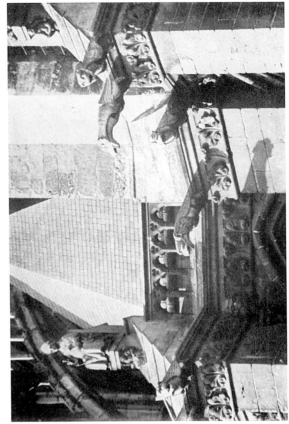

Amiens (Somme) Restored

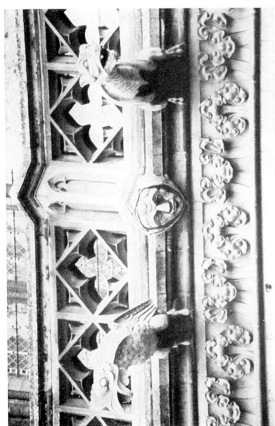

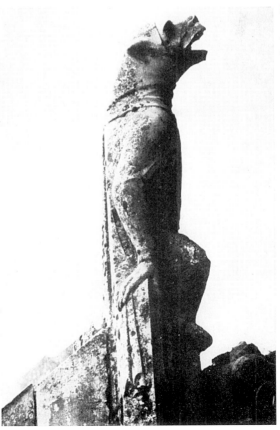

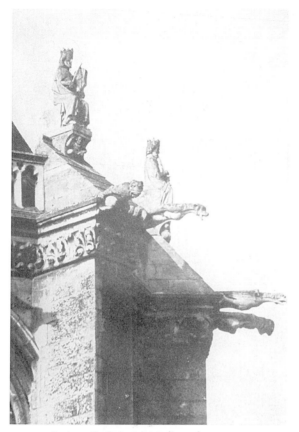

Amiens Cathedral (Somme) (Restored)

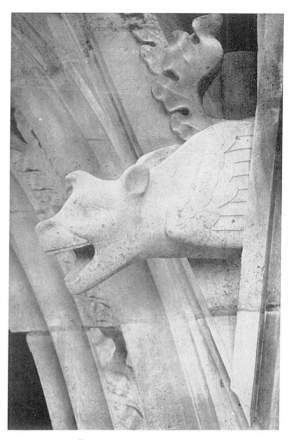

Reims (Marne) Cathedral

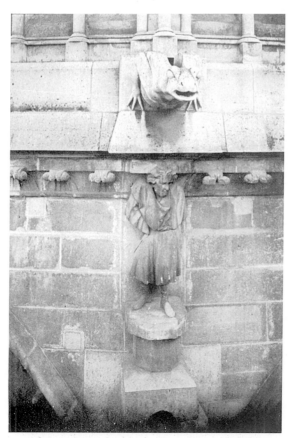

Modern Work Frog Gargoyle—Reims (Marne)

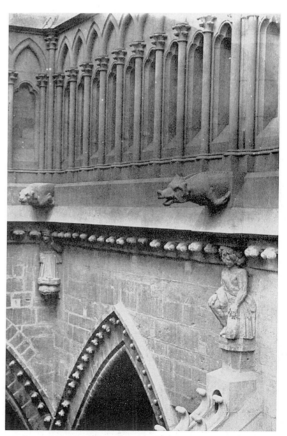

Reims (Apse) Modern Pig Gargoyle

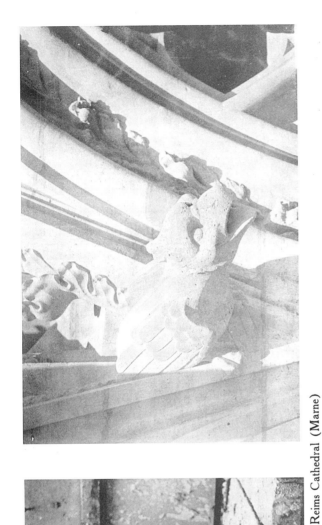

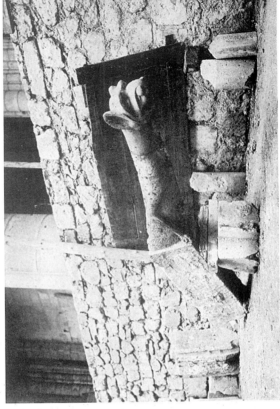

Reims Cathedral (Marne)

Soissons (Aisne) Restoration North Side 1926

Soissons (Aisne) Restoration South Nave

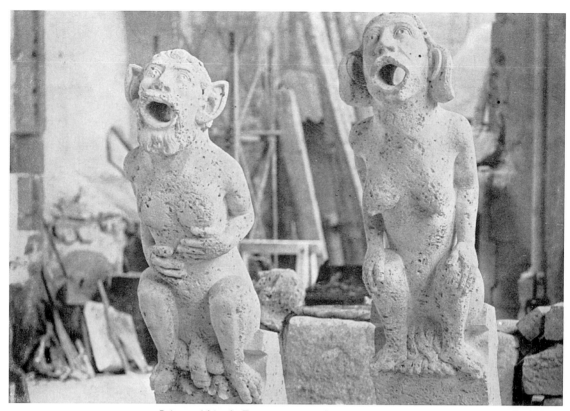

Soisson (Aisne) Restoration 1926 North Transept

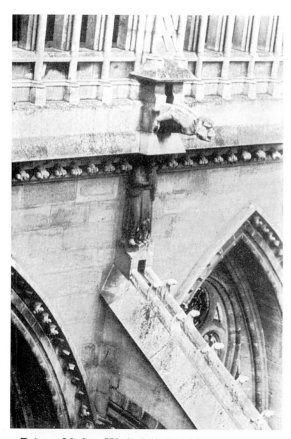

Reims—Modern Work Cathedral Monkey Gargoyle

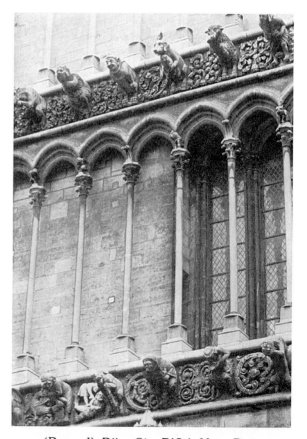

(Restored) Dijon Côte D'Or) Notre Dame

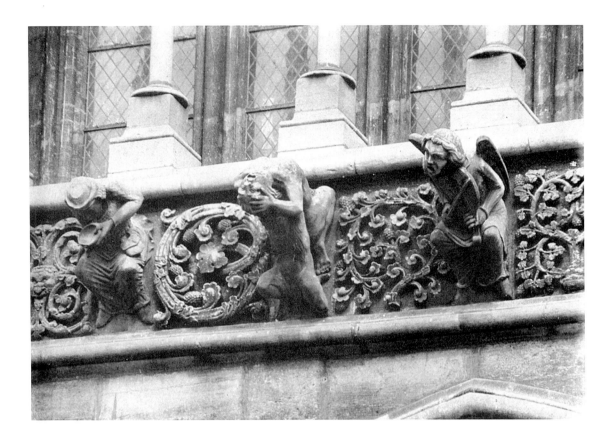

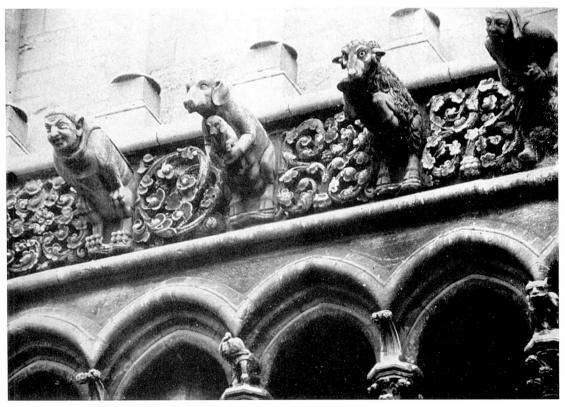

Dijon (Côte D'Or) Modern Notre Dame

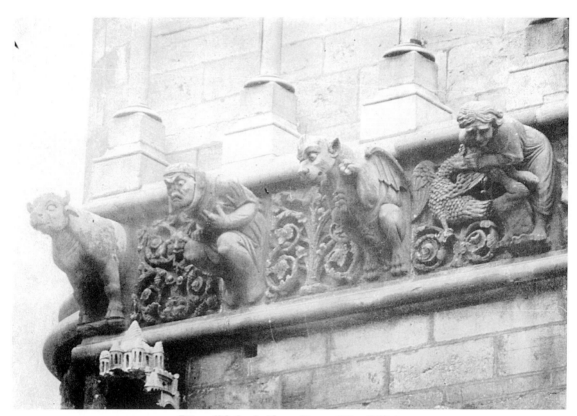

Dijon (Modern) Notre Dame (Côte D'Or)

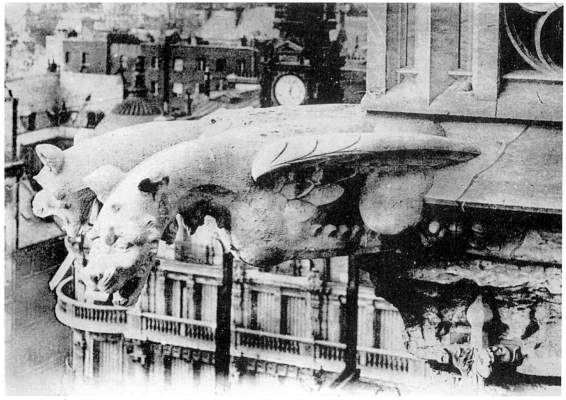

Rouen—(Facade) Seine Inférieur

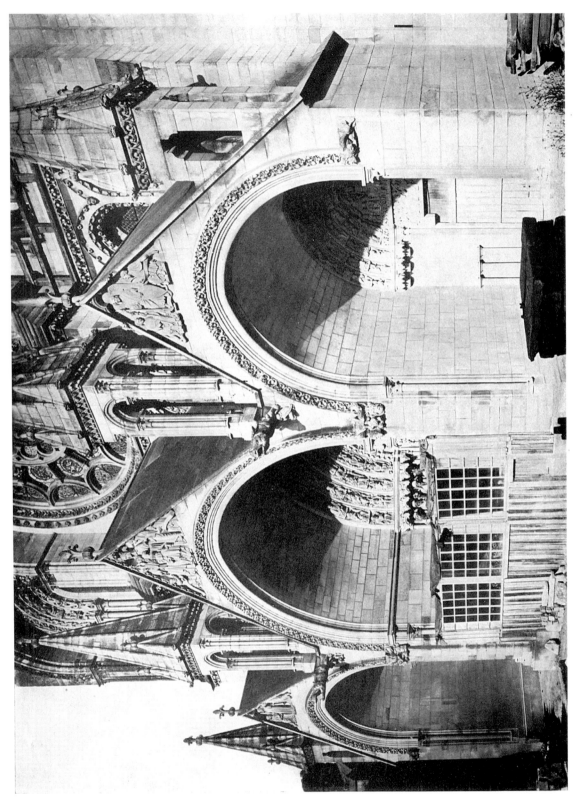

Notre Dame de Laon—(Aisne) Gargoyles on facade, and grotesque heads on towers and brackets (Restored)

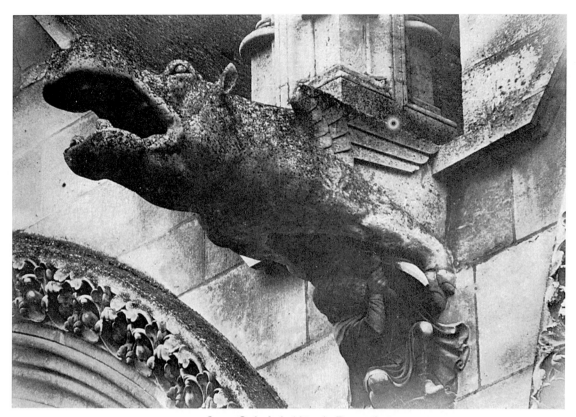

Laon Cathedral (Aisne) Restored

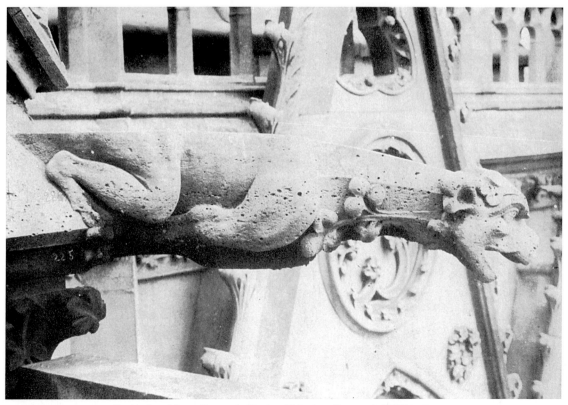

Gargoyle—Notre Dame de Paris, (Seine). Restored, XIXth Century

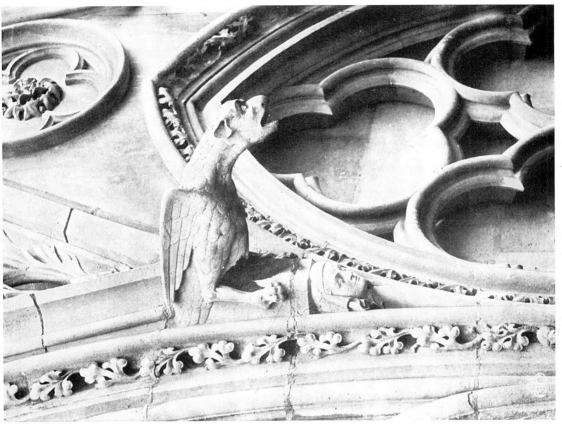

Notre Dame de Paris—Gargoyle (Restored)

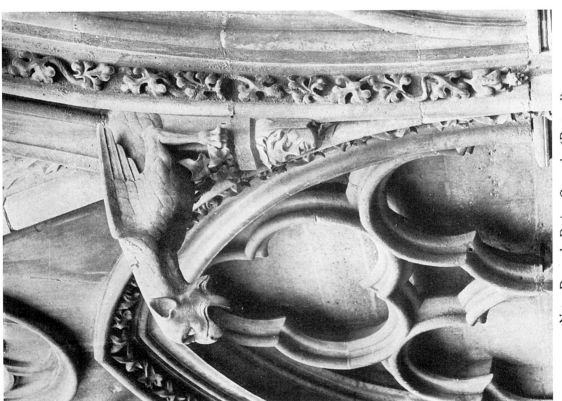

Notre Dame de Paris—Gargoyle (Restored)

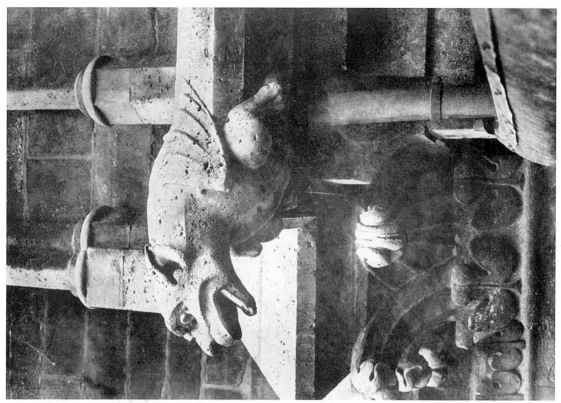

Gargoyle Notre Dame de Paris (Restored)

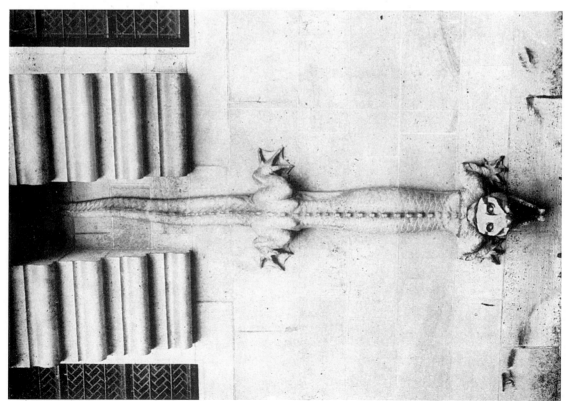

Gargoyle Pierrefonds, (Oise) (Restored)

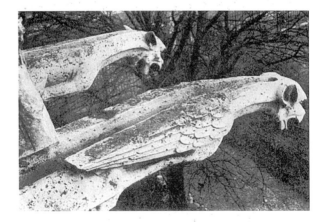

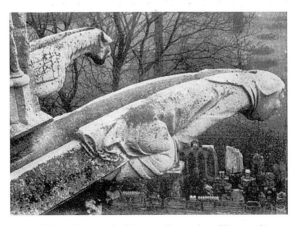

Notre Dame de Paris—Gargoyles (Restored)

Notre Dame de Paris Gargoyles—Apse Wall North Side

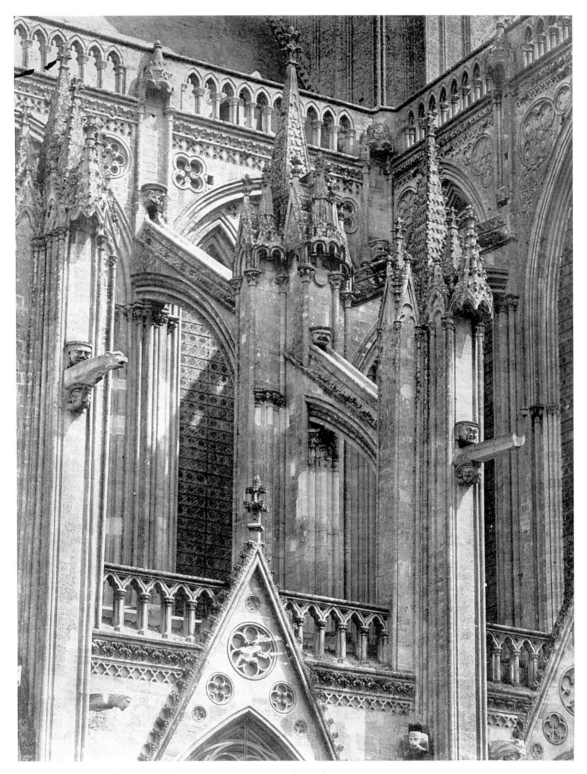

Bayeux (Calvados) Showing Use of Heads on Flying Buttresses of the
Cathedral (Restored)

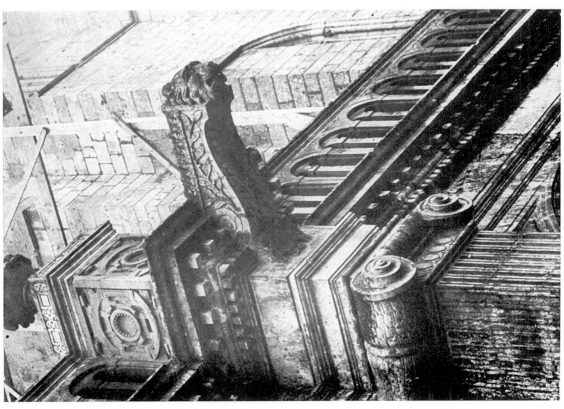

Le Grand Andely (Eure) North Side

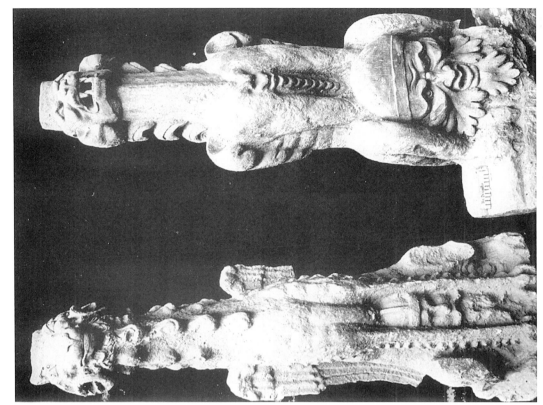

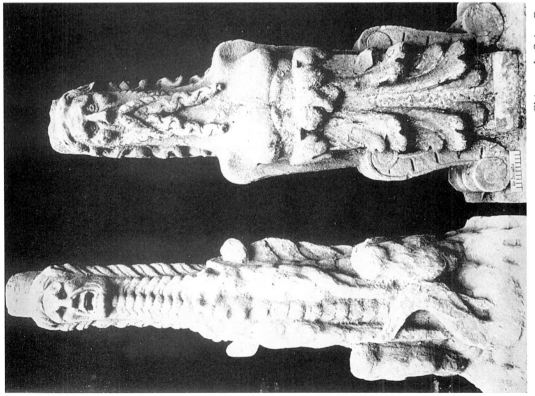

Château de Saint Germain-en-Laye (Seine et Oise)

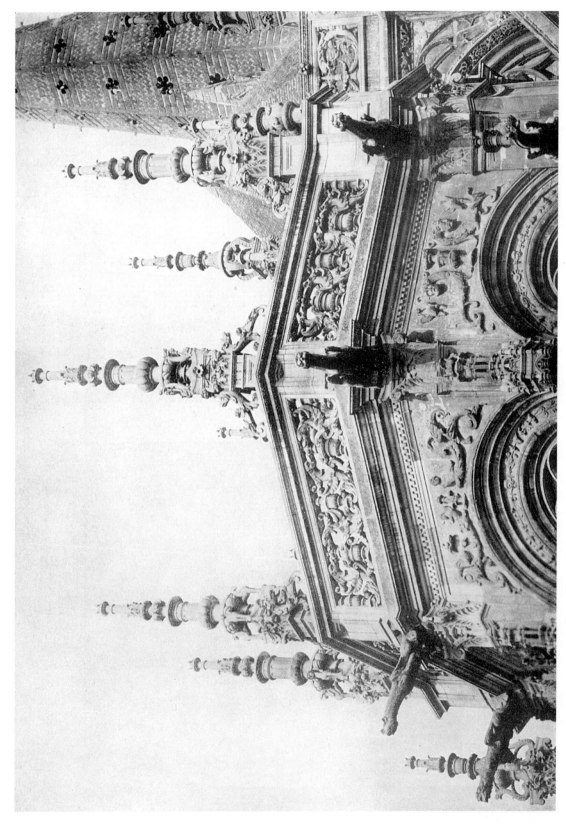

Caen (Calvados) St. Pierre (Apse) Gargoyles With Flamboyant Candelabra Style

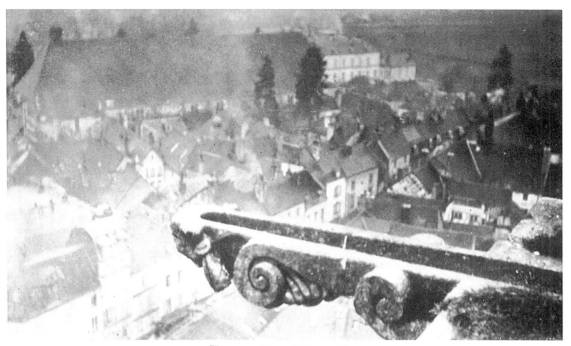

Tonnere (Yonne) Notre Dame

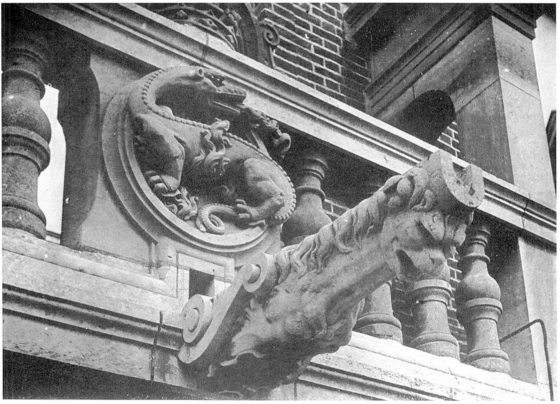

Renaissance Type Château of St. Germain-En-Laye (Seine et Oise) and Salamander
of Francis the First, (above)

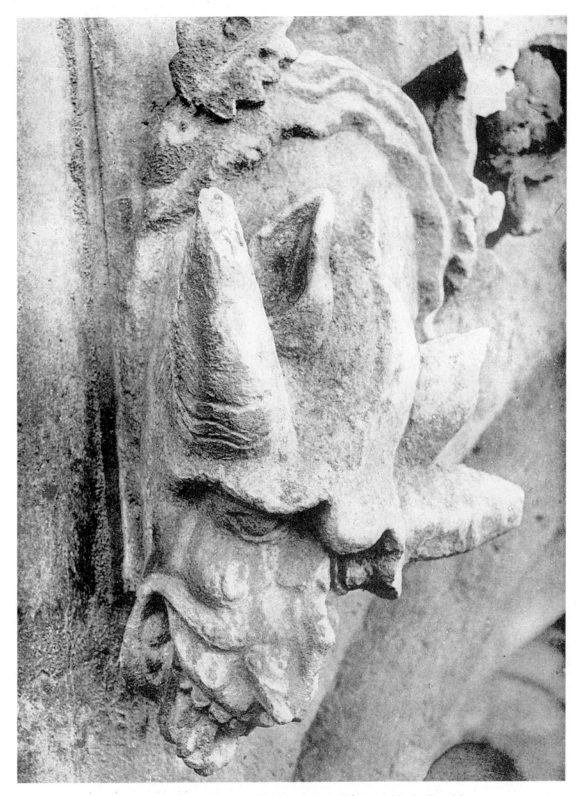

Cathédrale de Chartres (Eure et Loire) Detail of North Portal

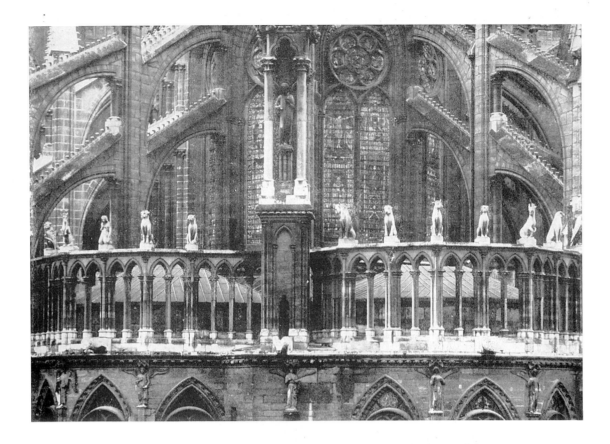

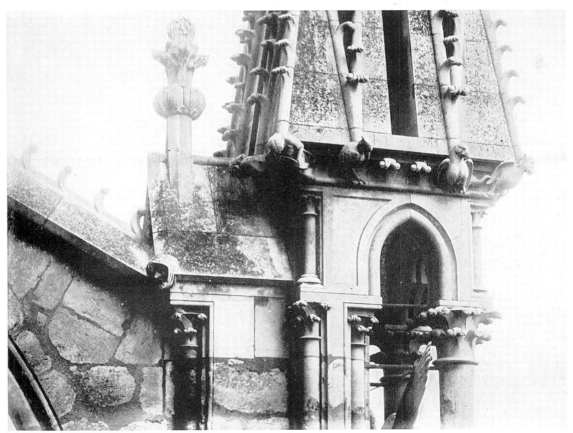

Reims Cathedral (Marne)

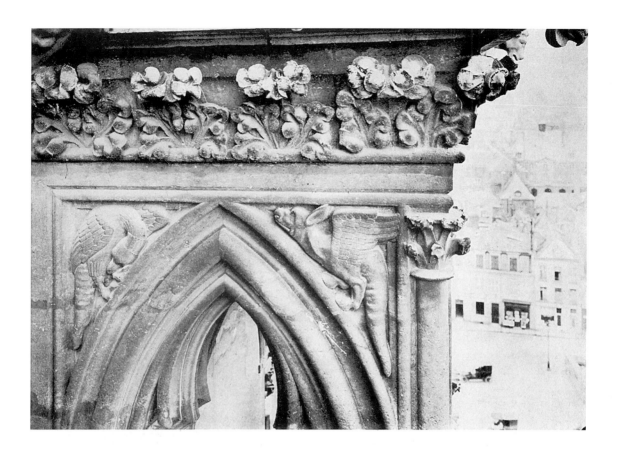

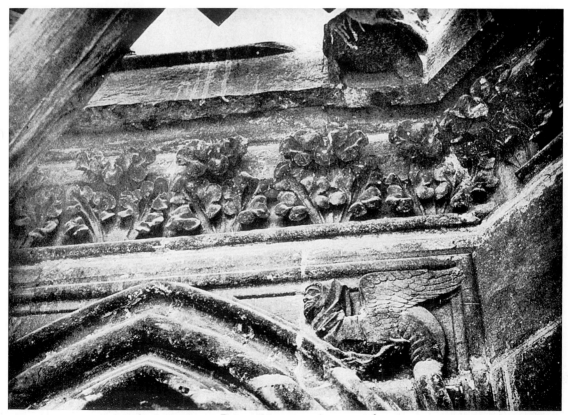

Reims (Marne) Cathedral

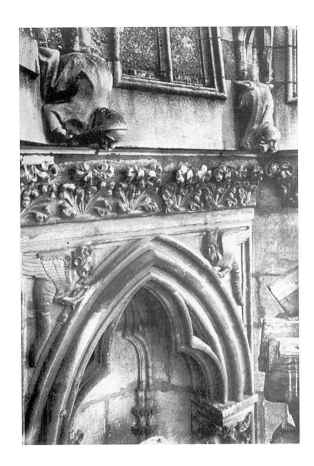

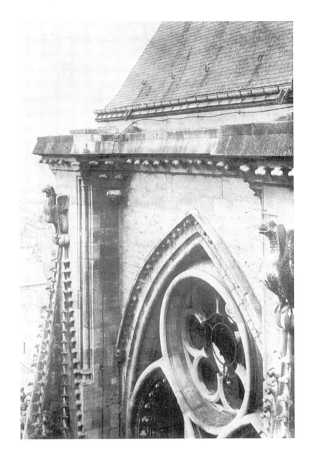

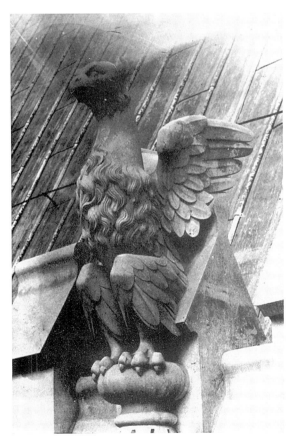

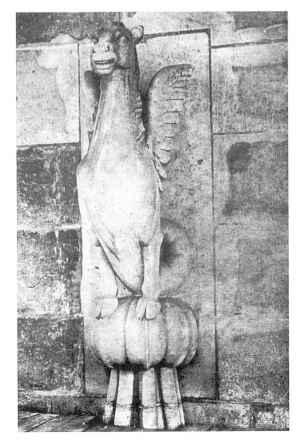

Reims (Marne) Cathedral

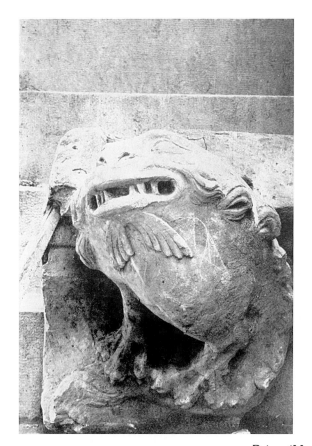

Reims (Marne) Cathedral

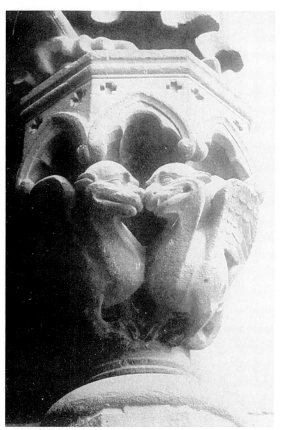
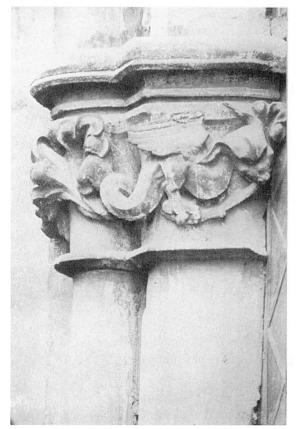

Amiens Cathedral (Somme) XIIIth Century

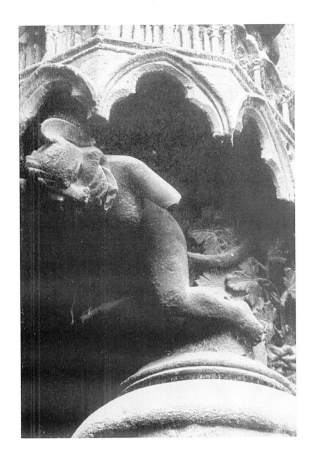
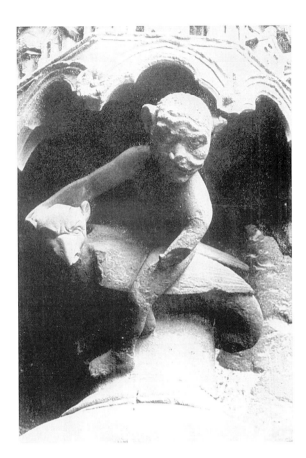
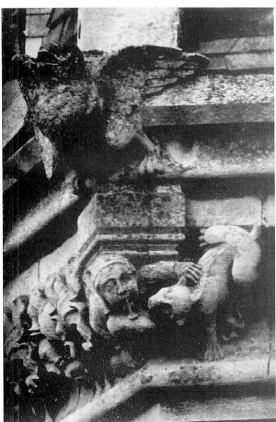
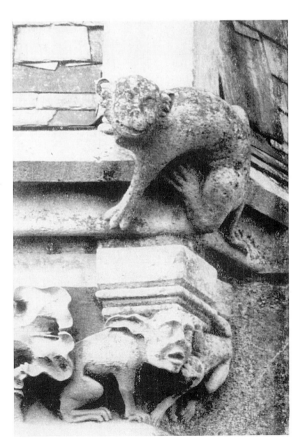

Amiens Cathedral (Somme) XIIIth Century

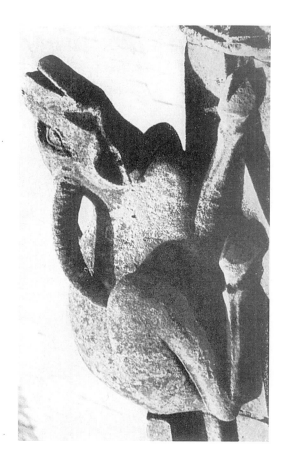
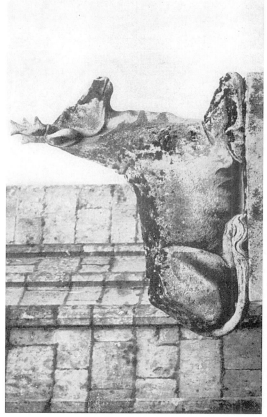
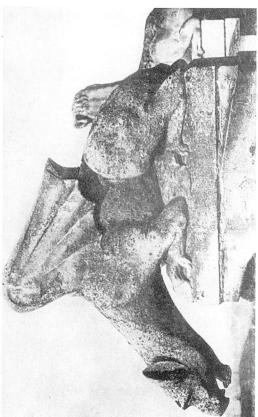
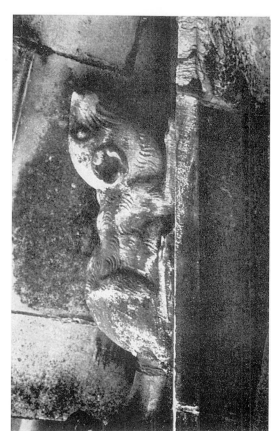

Amiens Cathedral (Somme) XIIIth Century

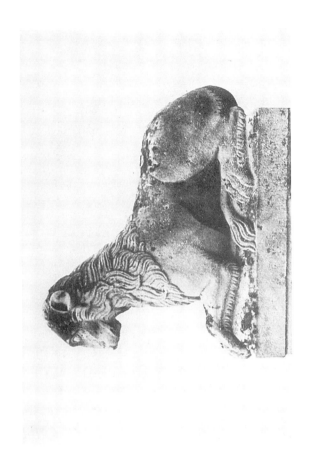

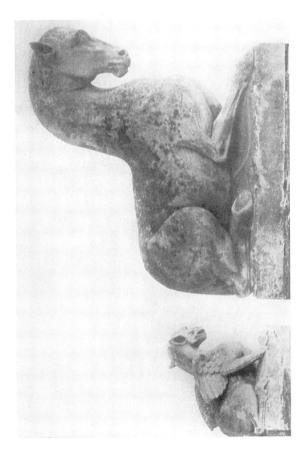

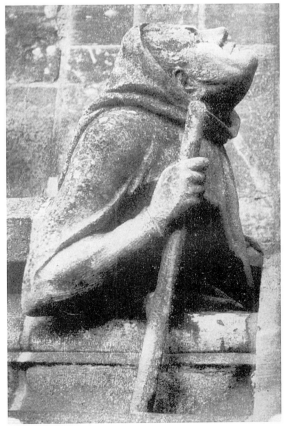

Amiens Cathedral (Somme)

Bayeux Cathedral (Calvados),
Pinnacles on the Central Tower

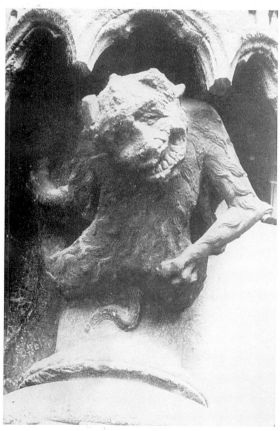 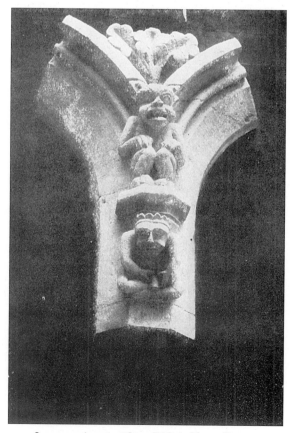

Amiens Cathedral (Somme) XIIIth Century

Semur-en-Auxois (Côte D'Or) Notre Dame—
XIIIth Century

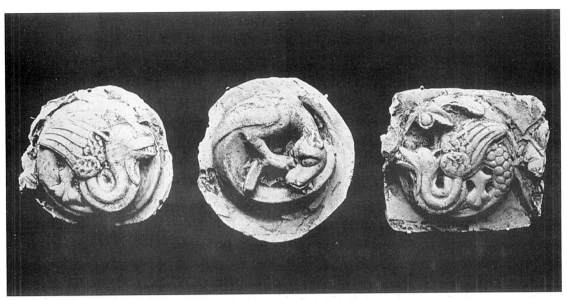

Bosses—Mont. St. Michel Cloister (Manche)

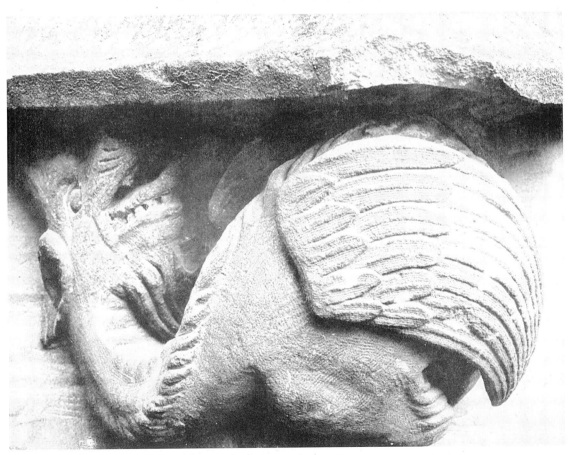

Beauvais—Palais de Justice (Oise)

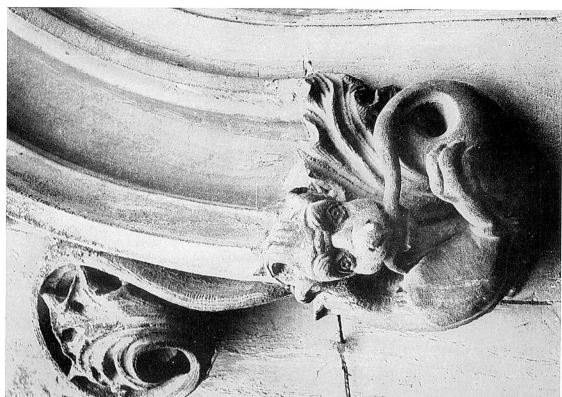

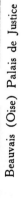

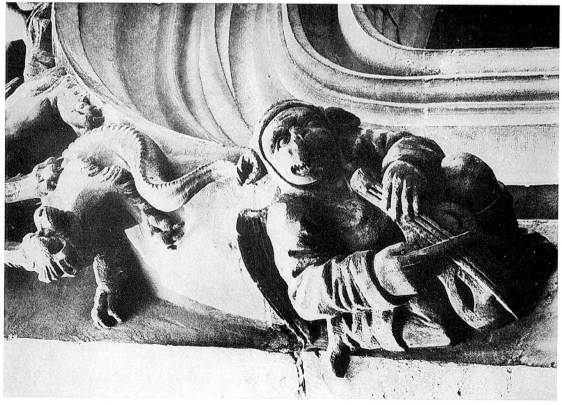

Beauvais (Oise) Palais de Justice

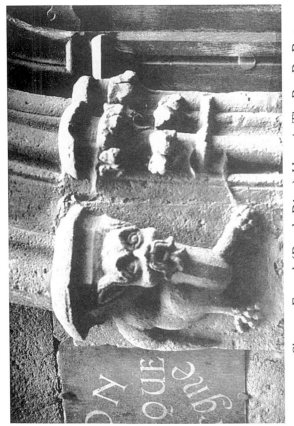

Clermont Ferrand (Puy de Dôme) House in The Rue Du Port

Rouen—Seine (Inférieur) Cathedral Tour de Buerre
Stairway (North) XVth Century

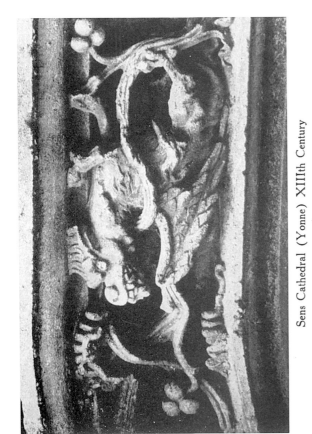

Sens Cathedral (Yonne) XIIIth Century

Le Puy—En—Velay (Haute Loire) Cathedral

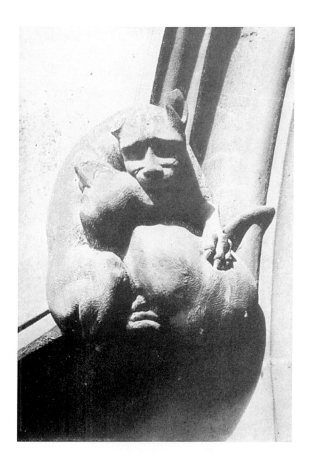
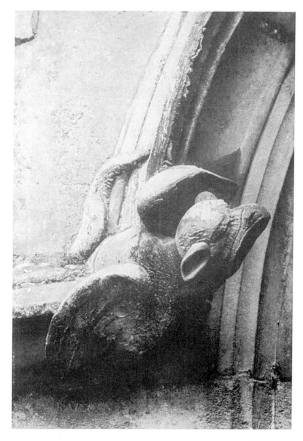
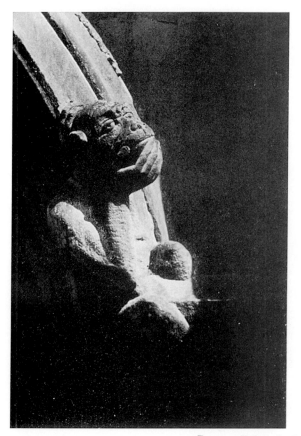
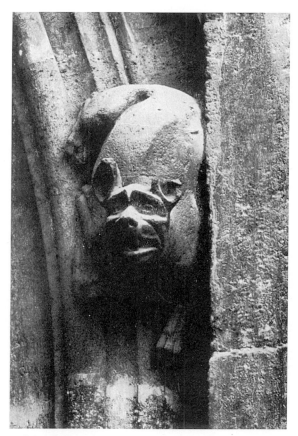

Rouen—Palais de Justice (Seine Inférieur)

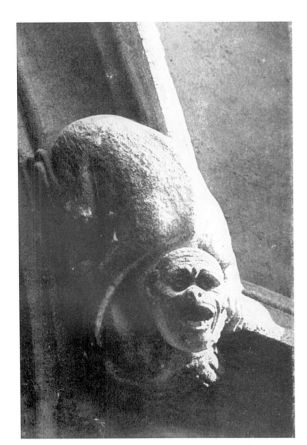 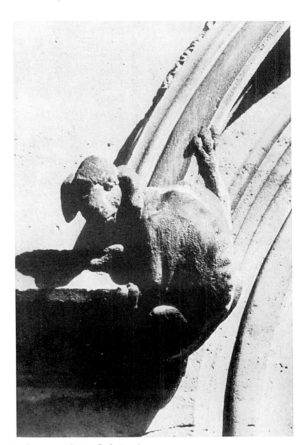

Rouen—Palais de Justice (Seine Inférieur)

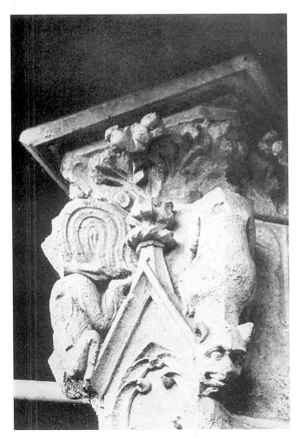 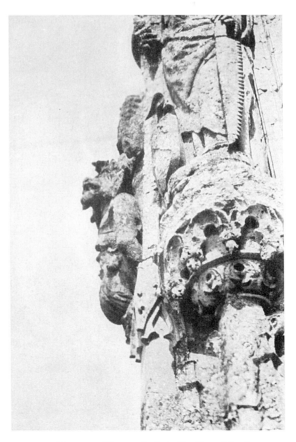

Soisson (Aisne) Cloister of St. Jean des Vignes Chartres (Eure et Loire) Devil on North
 Tower XVIth Century

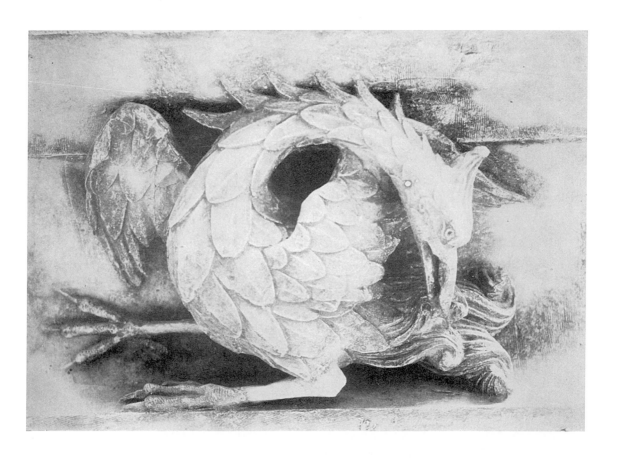

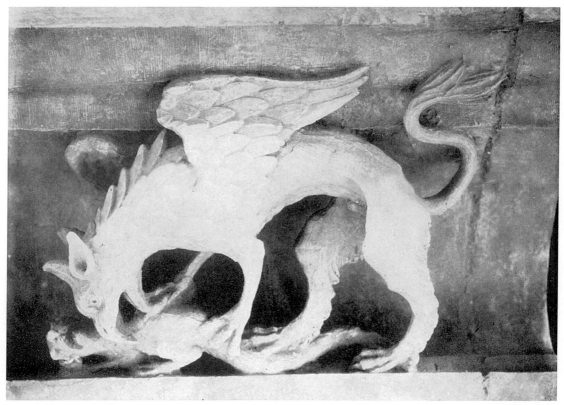

Chimeres—Troyes—(Aube), Cathedral (XVth Century) Chimerical bird

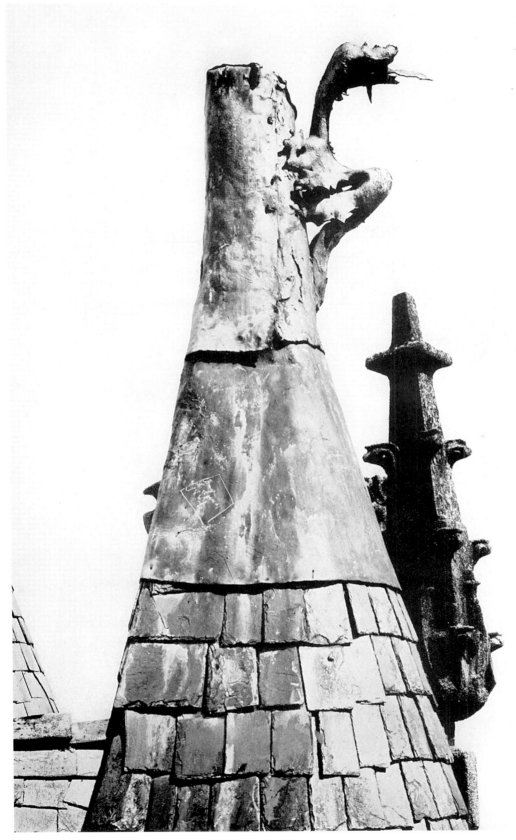

Poitiers (Vienne) Chimere in Lead Work of a Spire

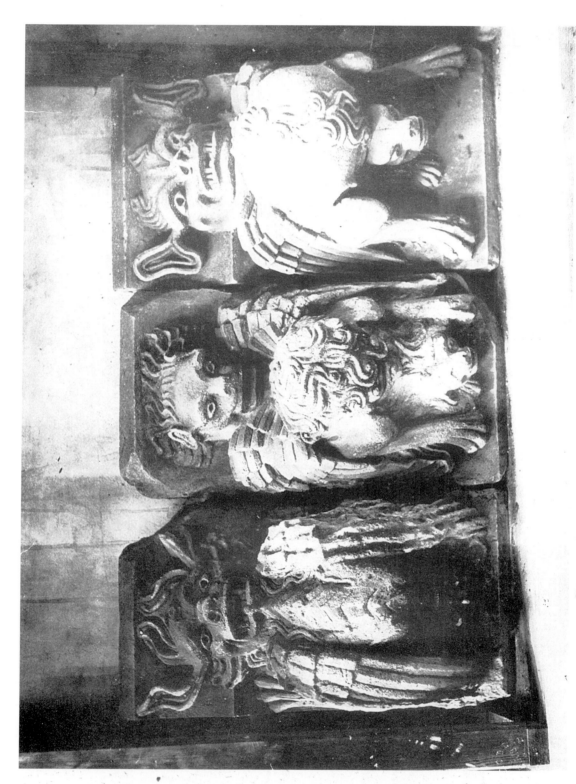

Chimeres—Caen, (Calvados). Musée du Vieux St. Etienne Chimerical corbels

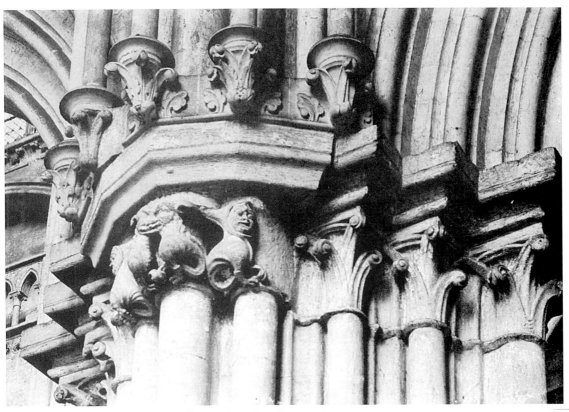

Rouen Cathedral Nave—(Seine Inférieur)

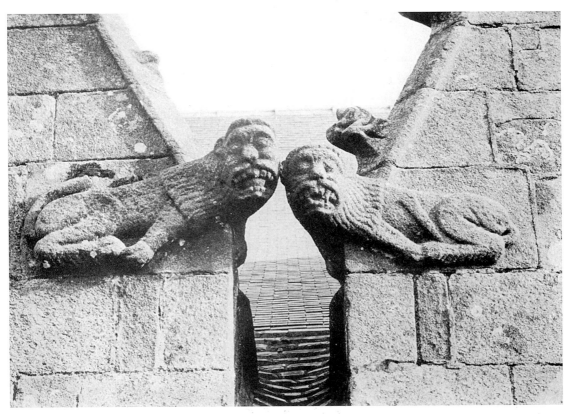

Ploügonven (Finistère) Brittany

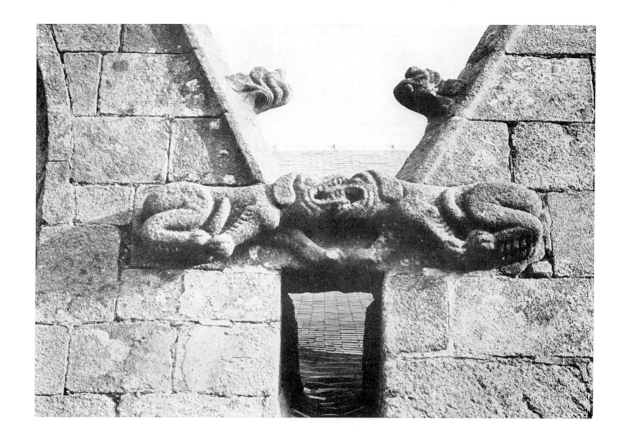

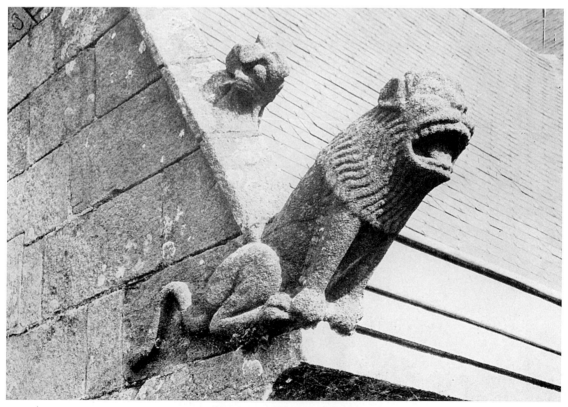

Plougonven (Finistère) Brittany

Bourges Cathedral (Cher)

Josselin (Morbihan) Château—Park Side

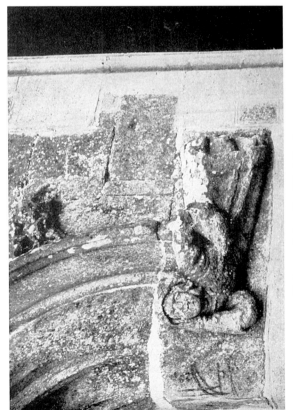

Château of Josselin (Morbihan)

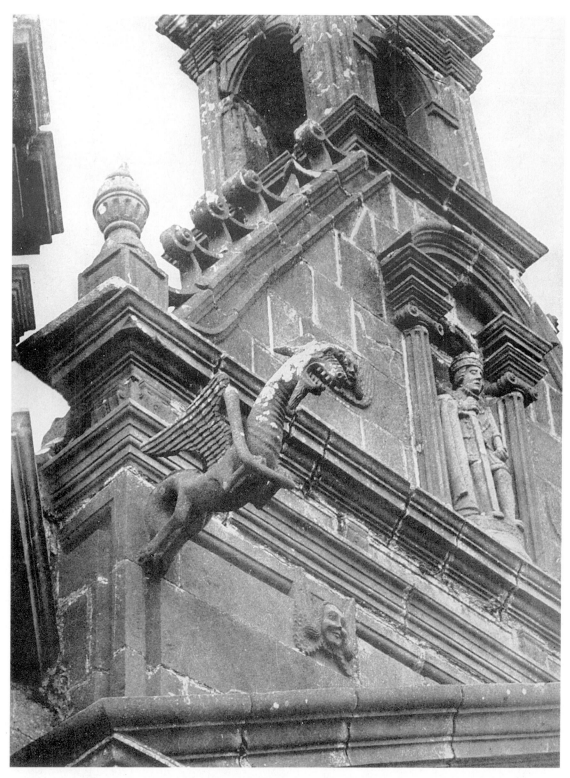

Guimiliau (Finistère) Brittany South Side of Church

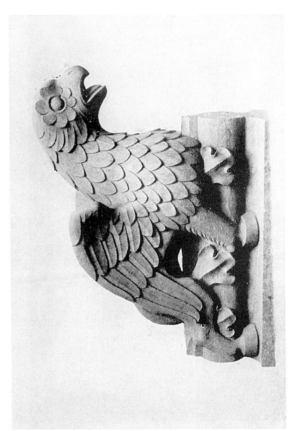

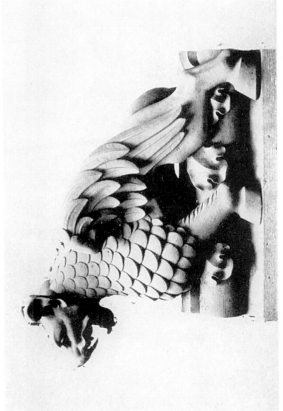

Reims (Marne) Cath. (Restoration) South Arm of Transcept

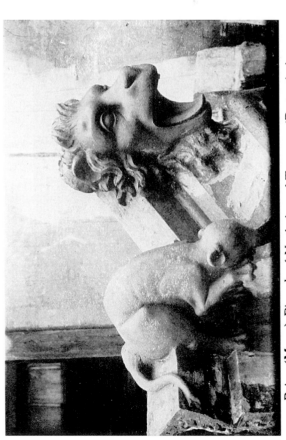

Reims (Marne) Cathedral (Restoration)

Reims (Marne) Pinnacle of North Arm of Transcept (Restoration)

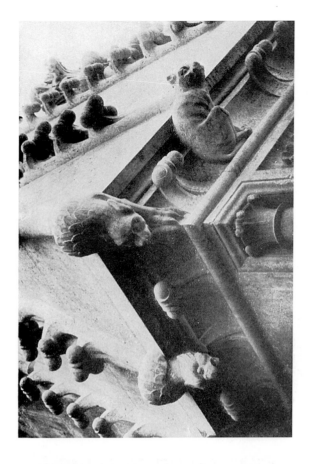

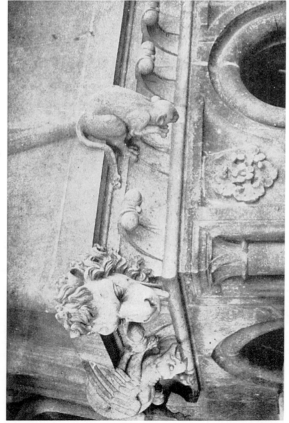

Reims Cathedral (Marne)

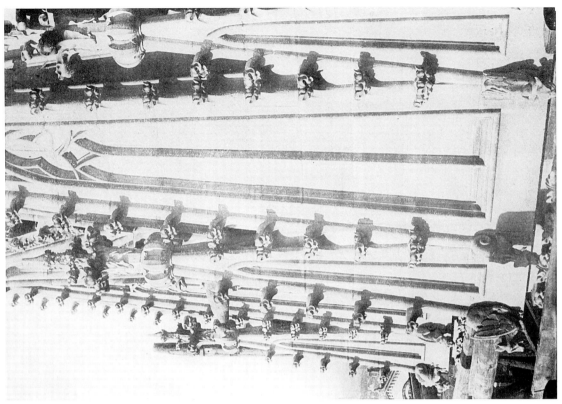

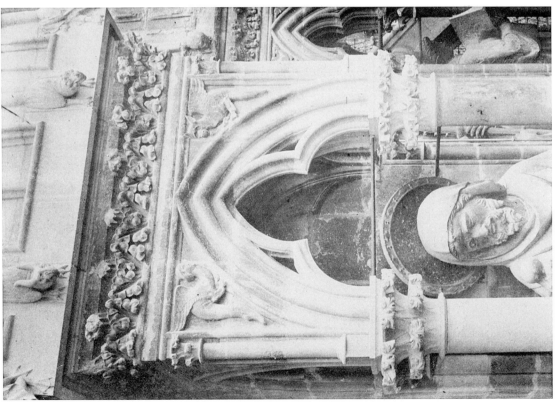

Reims (Marne) Cathedral

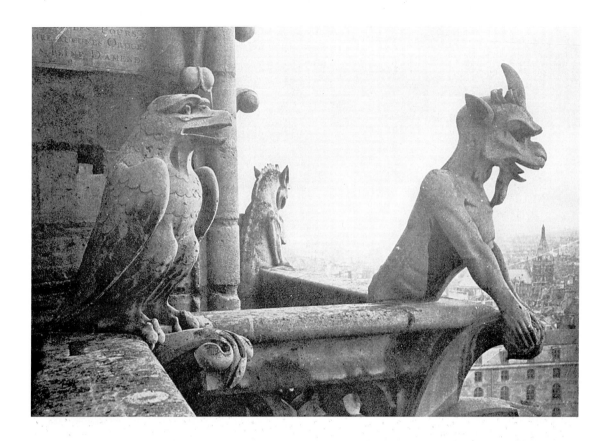

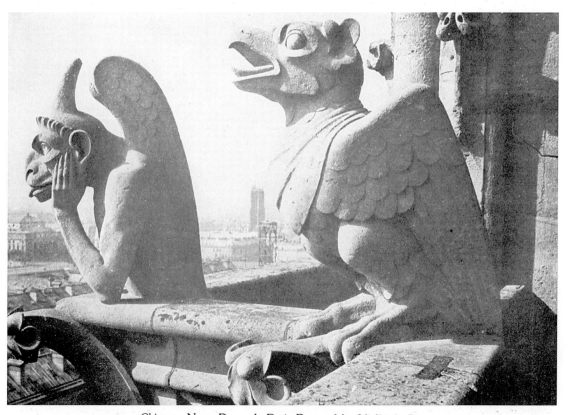

Chimeres Notre Dame de Paris Restored by Viollet le Duc

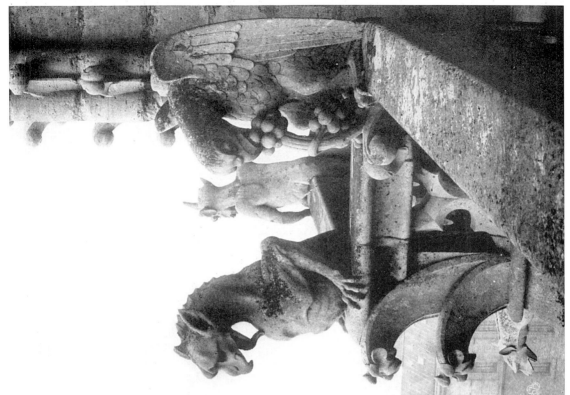

Chimeres—Notre Dame de Paris Restored by Viollet le Duc

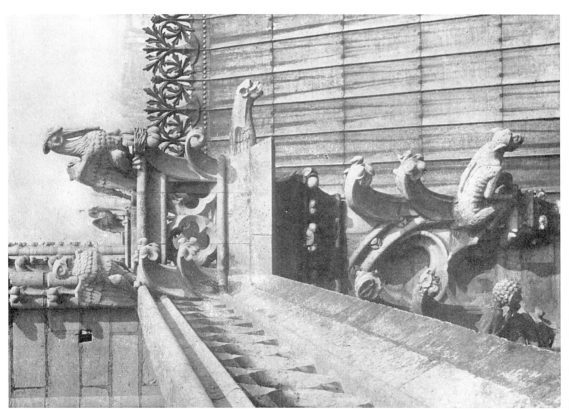

Notre Dame de Paris—Showing arrangement of Gargoyles and Chimeres on the gallery. (Restored)

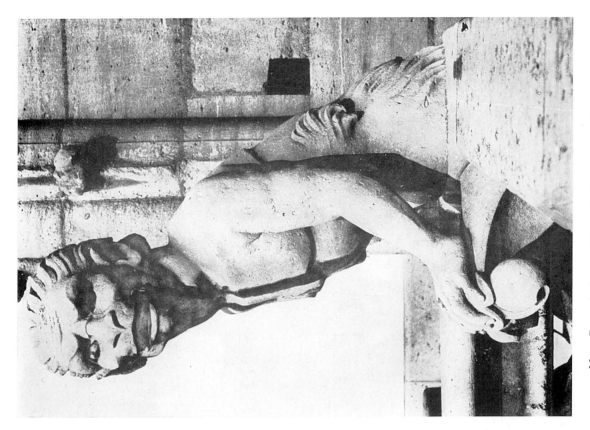

Notre Dame de Paris—Chimere in human form (Restored)

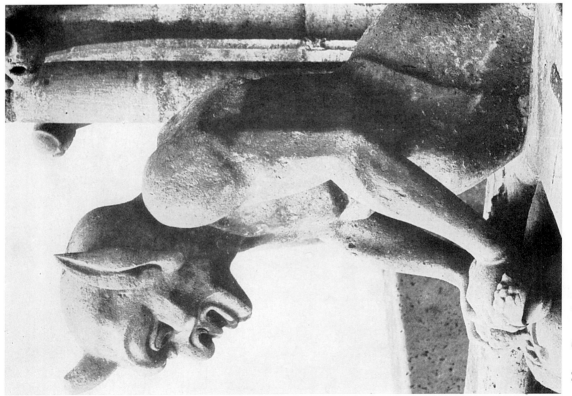

Notre Dame de Paris—Chimere, monster of human form clutches lizard
(Restored)

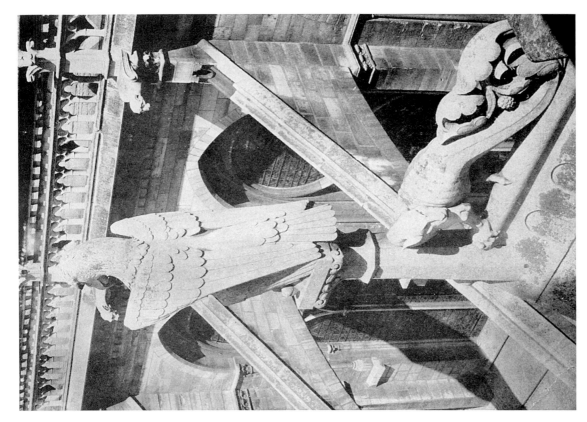

Notre Dame de Paris—Showing gargoyles emptying into channels in the flying buttresses, chimere on the pinnacle, and an animal with a tail ending in foliage. (Restored)

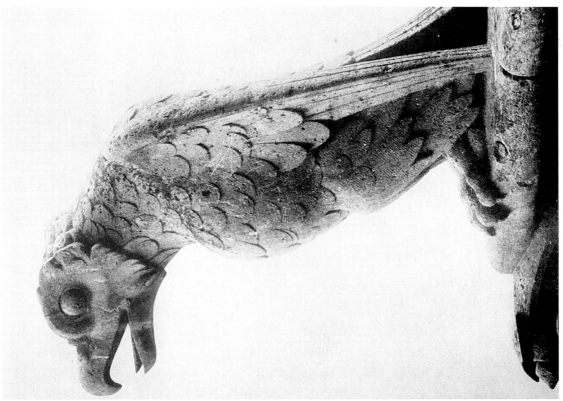

Notre Dame de Paris—Chimerical Bird (restored)

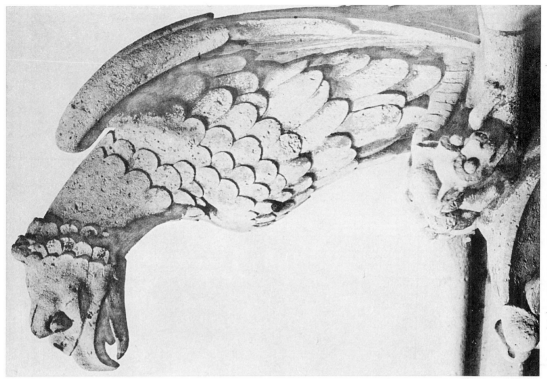

Notre Dame de Paris Chimerical bird clutching monster

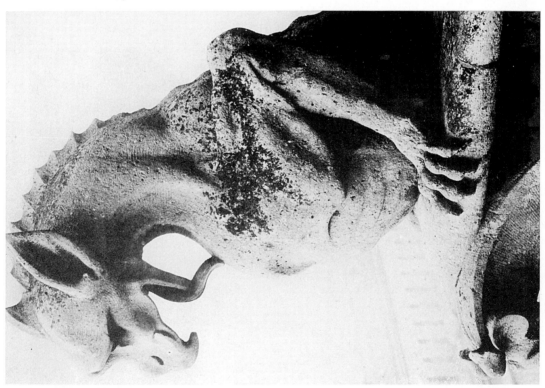

Notre Dame de Paris Chimere (Restored)

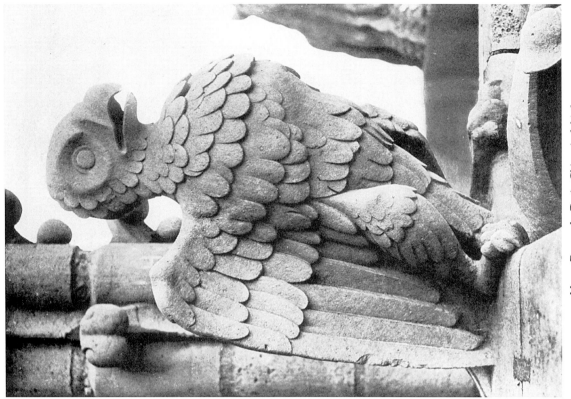

Notre Dame de Paris Chimerical bird

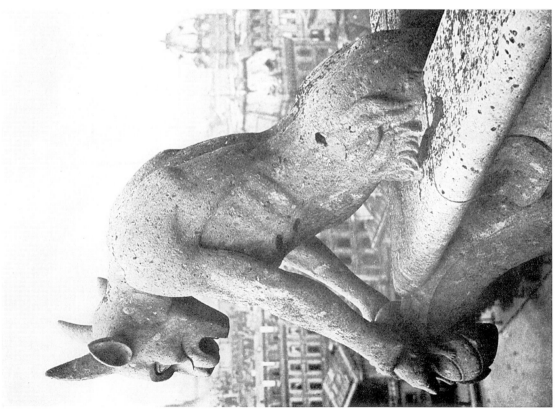

Notre Dame de Paris Monster clutching animal (Restored)

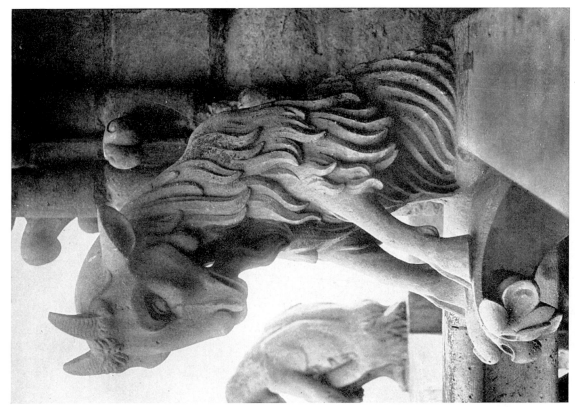

Notre Dame de Paris—Chimerical Ram (restored)

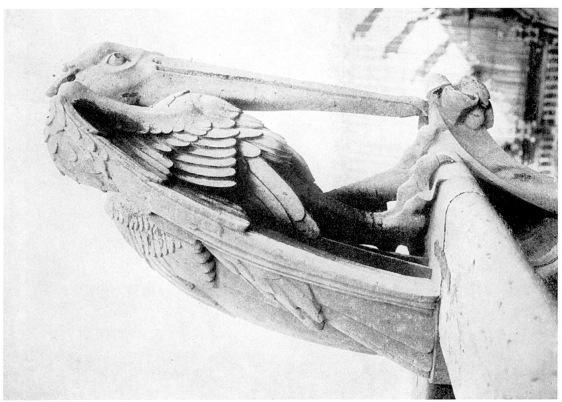

Notre Dame de Paris—Long billed bird (Restored)

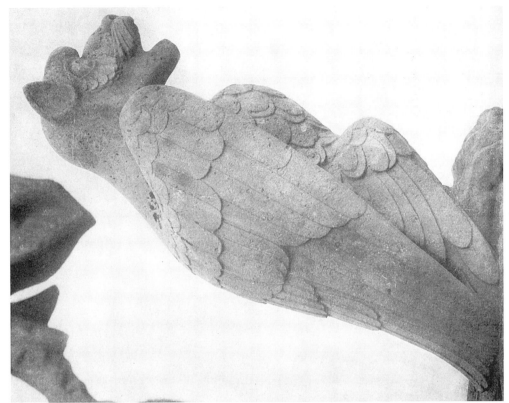

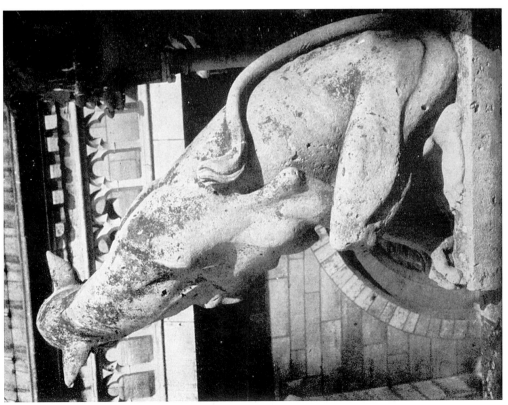

Chimeres Notre Dame de Paris Restored by Viollet le Duc

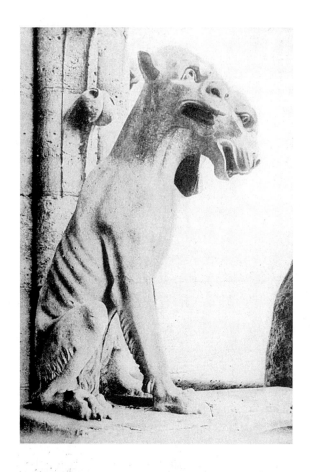
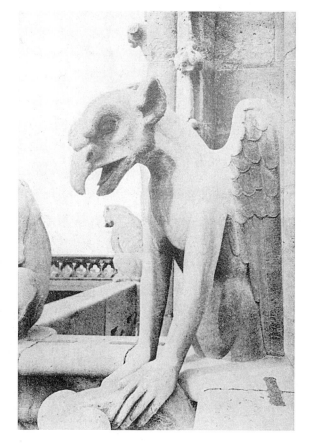
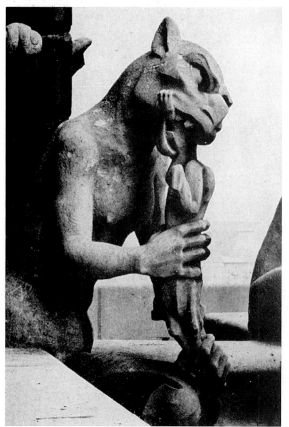
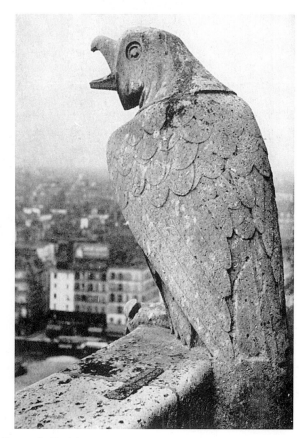

Chimeres (Notre Dame de Paris)

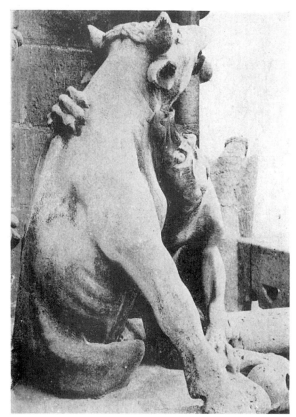
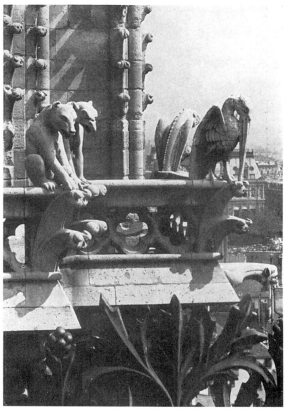

Notre Dame de Paris Chimeres

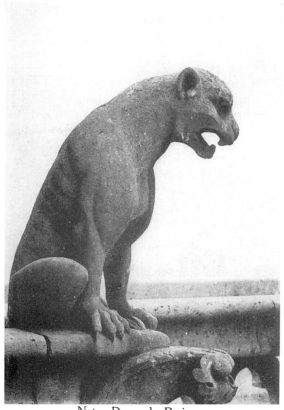
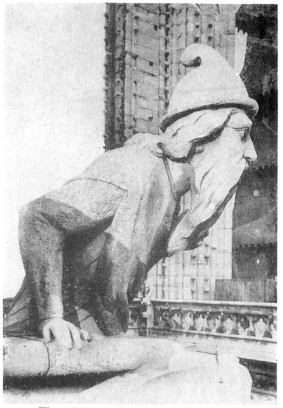

Notre Dame de Paris The Alchemist Notre Dame de Paris

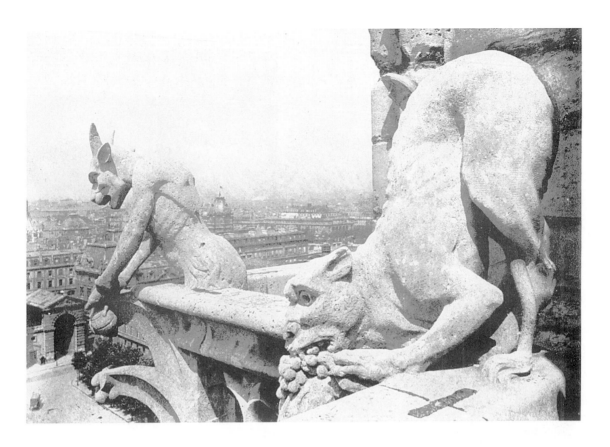

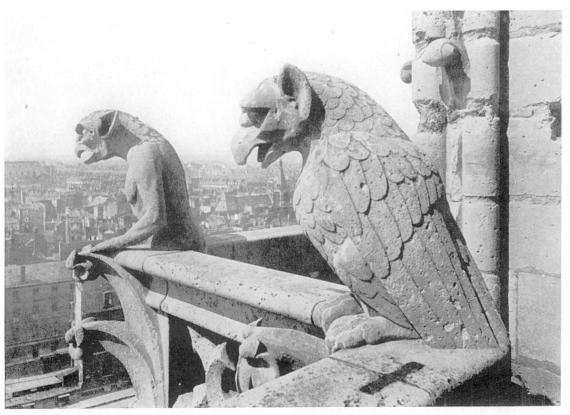

Notre Dame de Paris Chimeres (Restored)

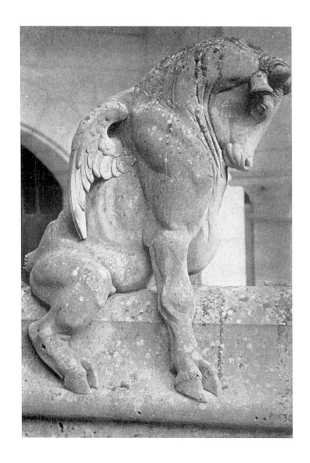
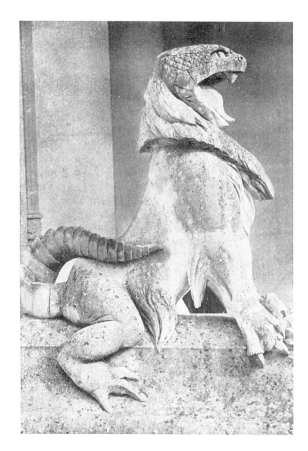
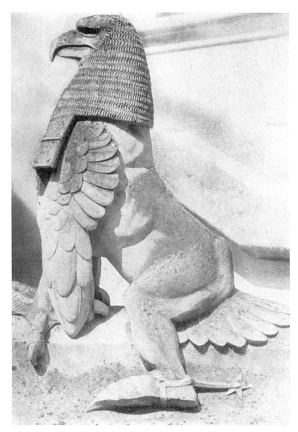
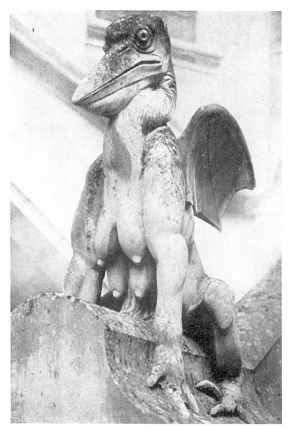

Château de Pierrefonds (Oise)

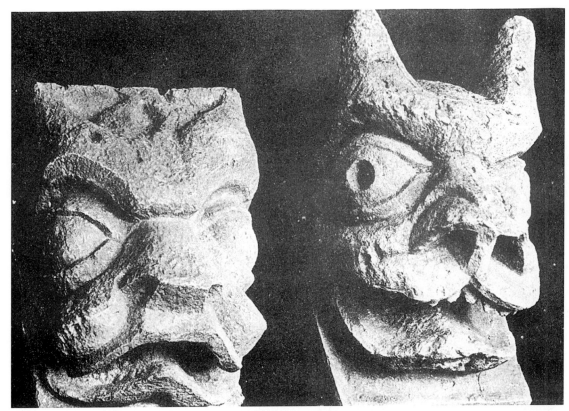

Chartres (Eure et Loire) South Tower XIIth Century

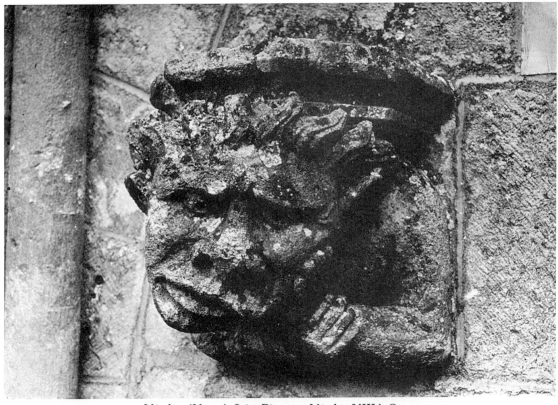

Vézelay (Yonne) Saint Père sous Vézelay XIIIth Century

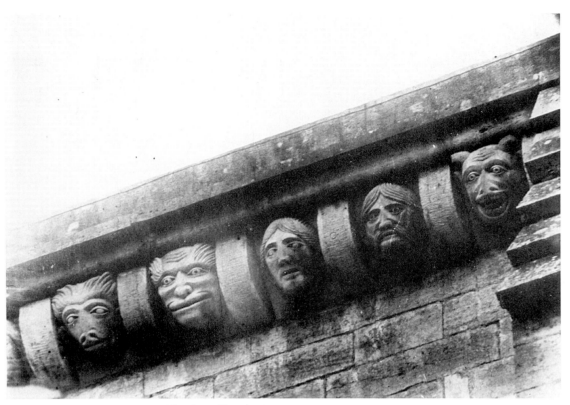

Vézelay (Yonne) South Facade—La Madeleine

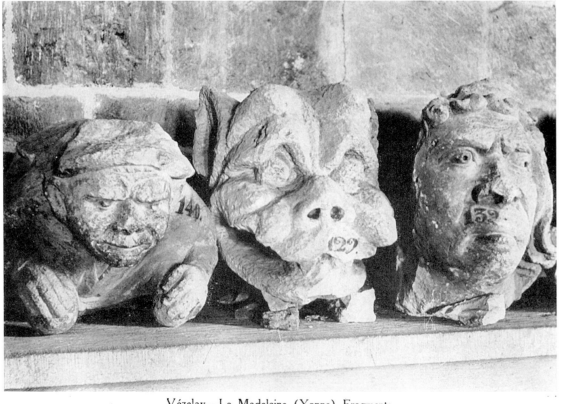

Vézelay—La Madeleine (Yonne) Fragments

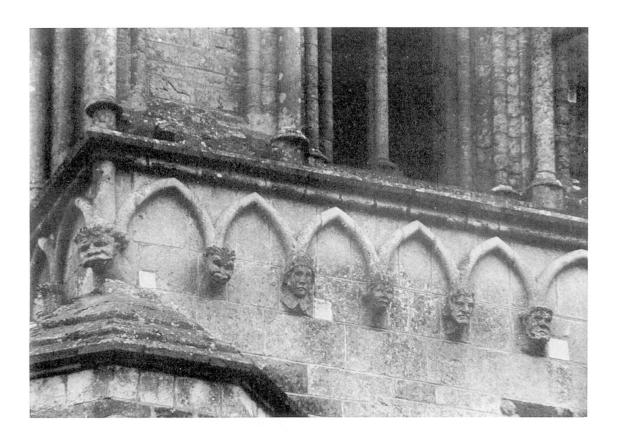

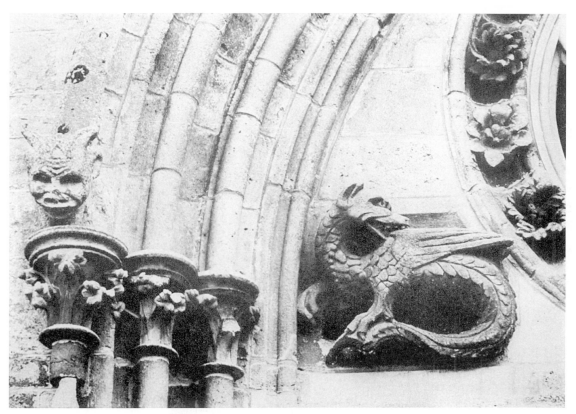

Saint Père sous Vézelay XIIIth Century Vézelay (Yonne)

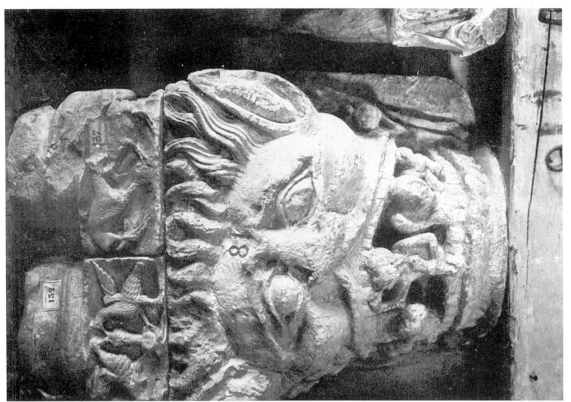

Nevers (Nièvre) Museum

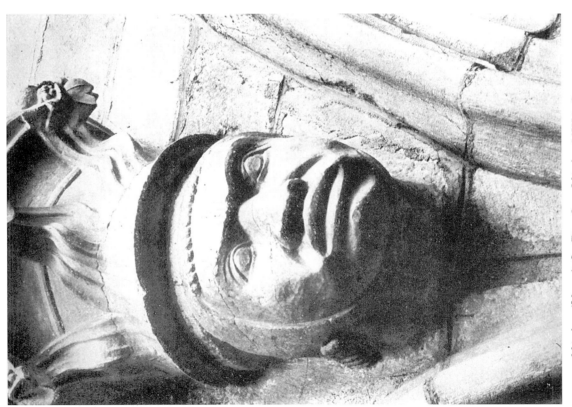

Vézelay (Yonne) St. Père Sous Vézelay XIIIth Century

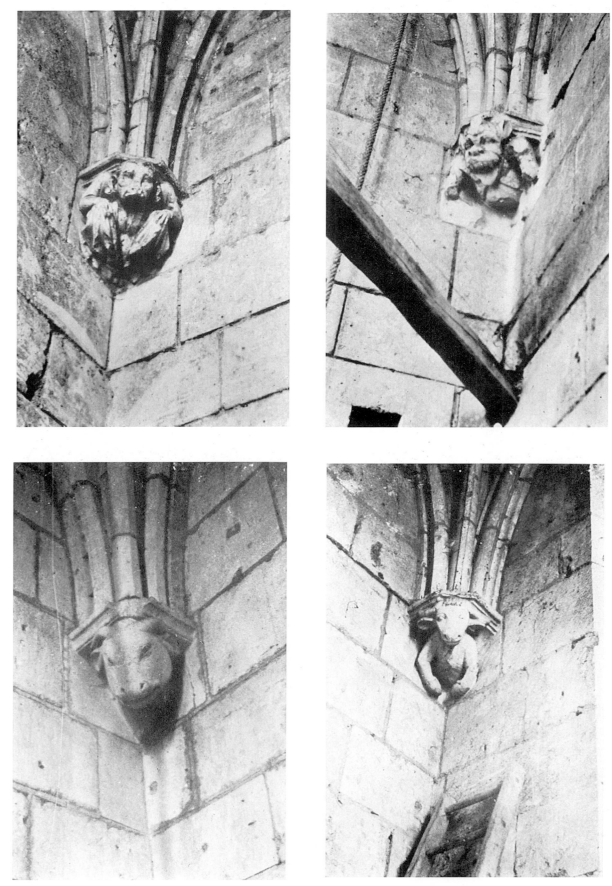

Poitiers (Vienne) Cathedral North Bell Tower

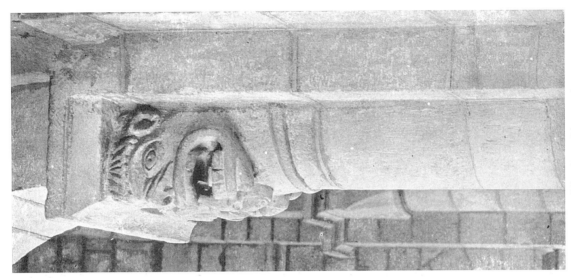

Montjaux (Aveyron)

Chartres Cathedral, Tower above North Portal
(Eure et Loire)

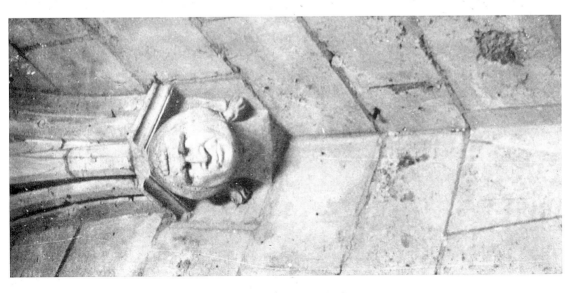

Poitiers (Vienne) Cath. North Bell Tower

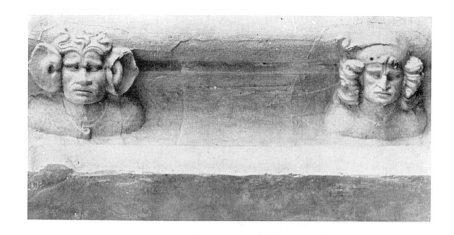

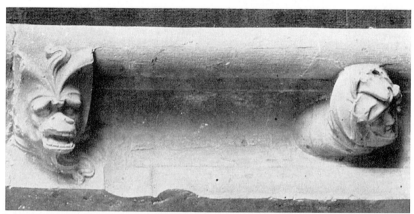

Auxerre Cathedral (Yonne) Mouldings Decorated with Heads XIIIth Century

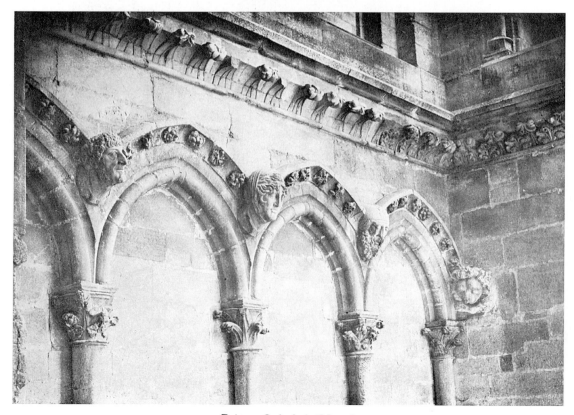

Reims—Cathedral (Marne)

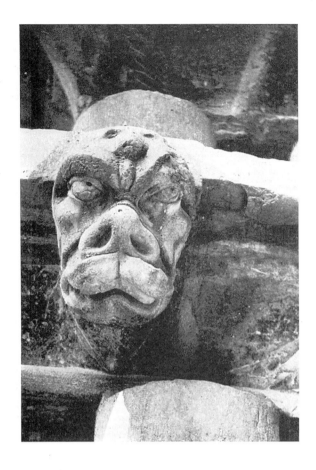
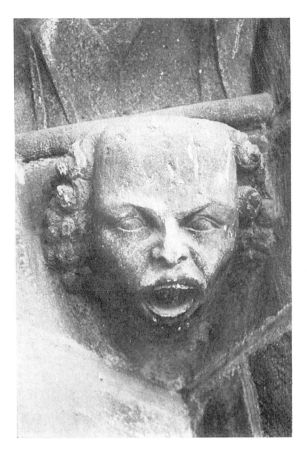
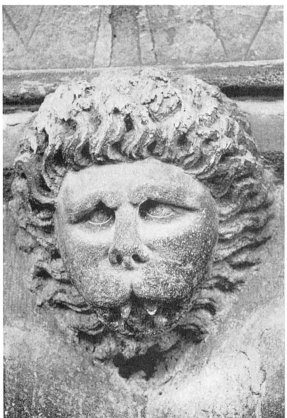
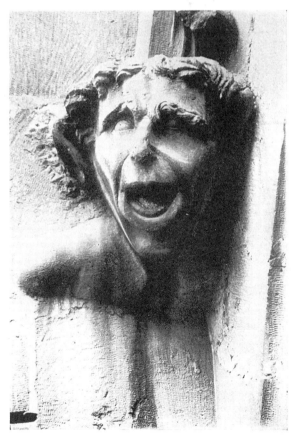

Reims (Marne) Cathedral

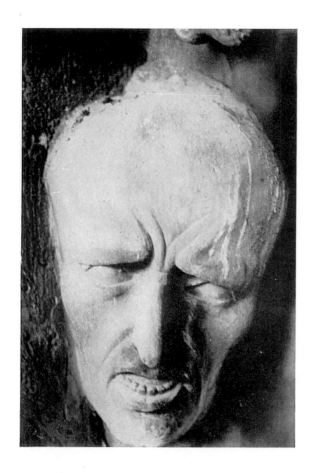
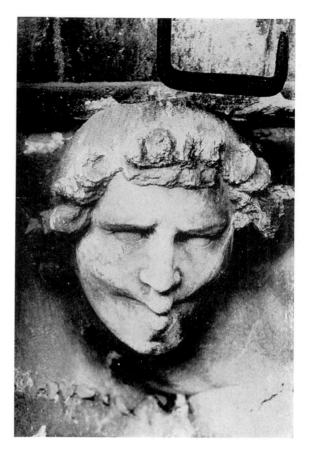
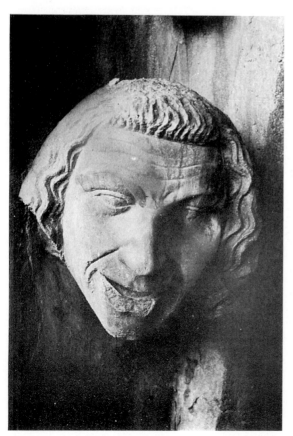
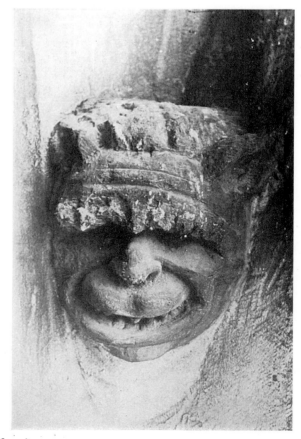

Reims (Marne)

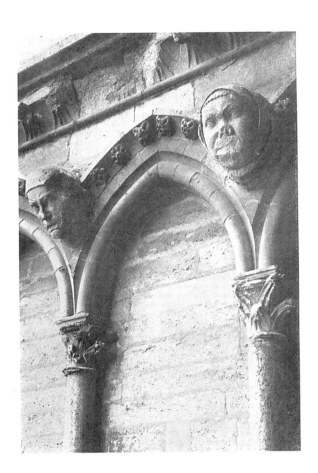
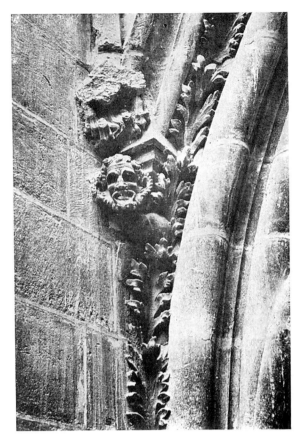
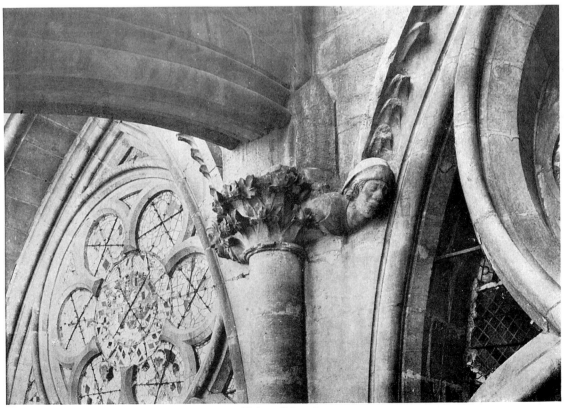

Reims (Marne)

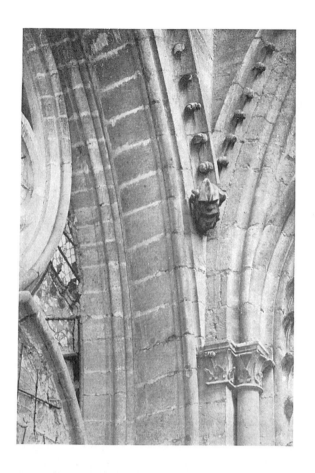

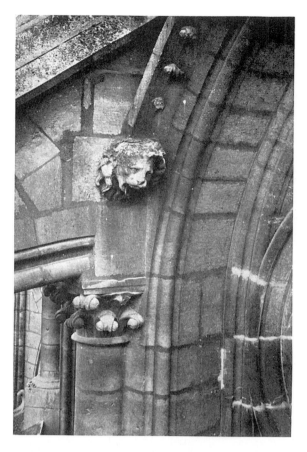

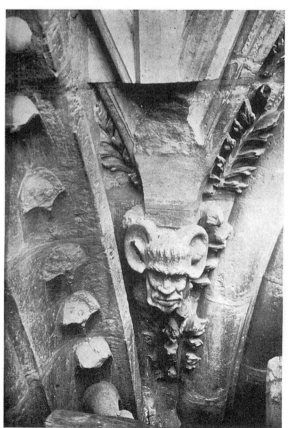

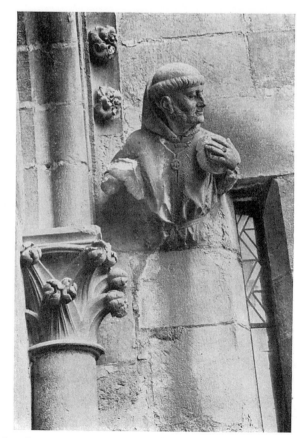

Reims (Marne)

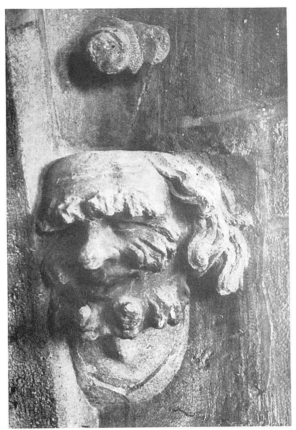
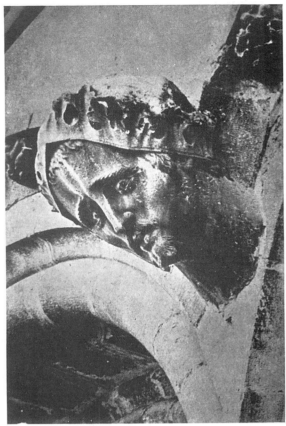

Reims (Marne)

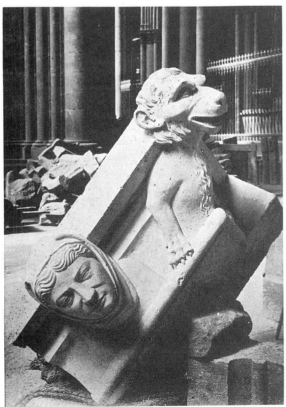
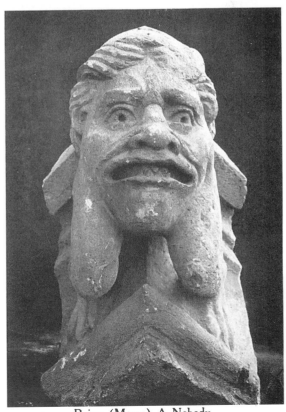

Reims (Marne) Restored After The War Reims (Marne) A Nobody

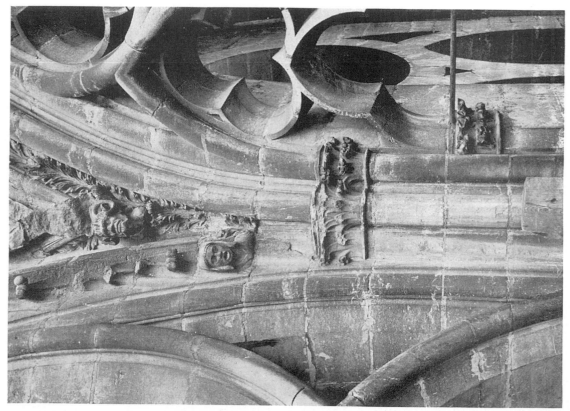

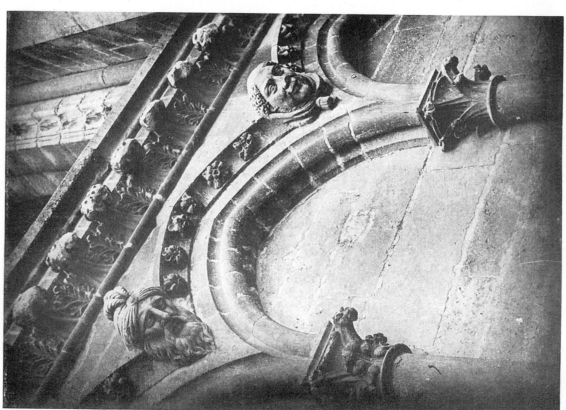

Reims (Marne)

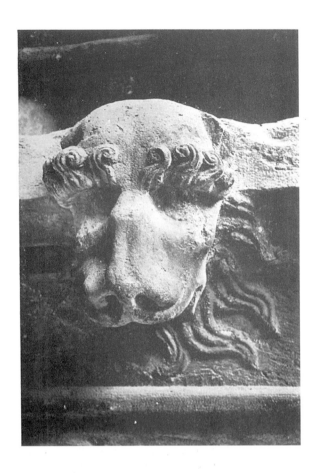
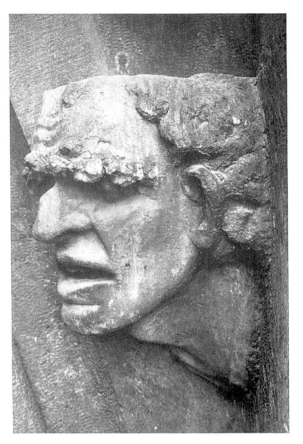
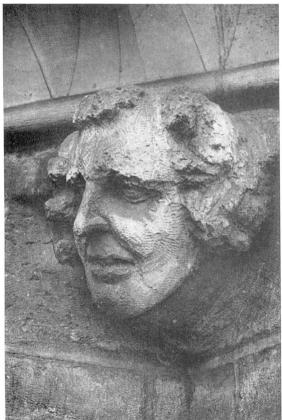
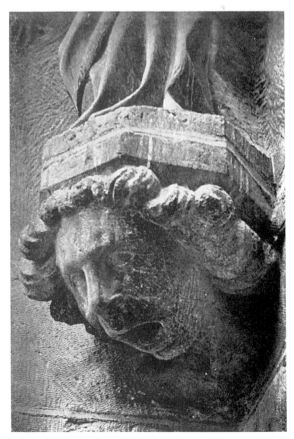

Reims (Marne)

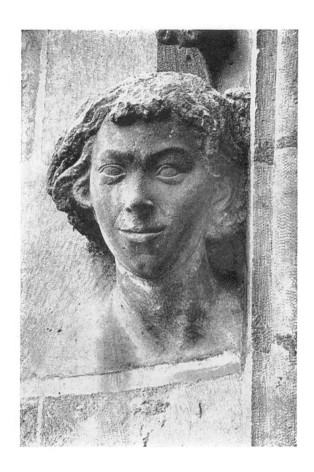
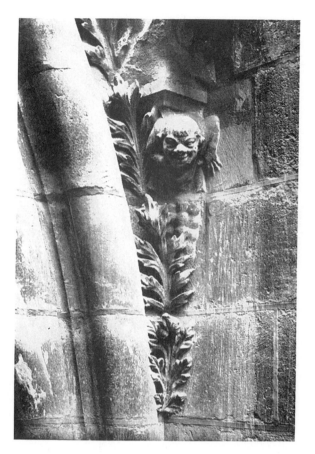
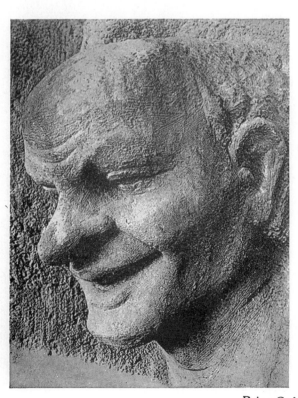
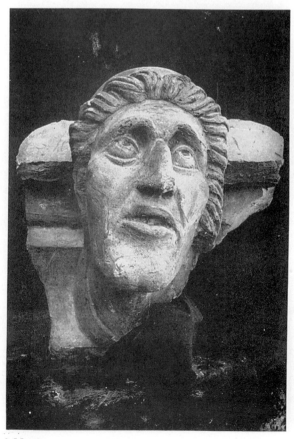

Reims Cathedral Head

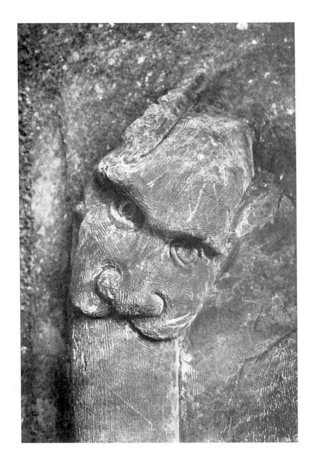
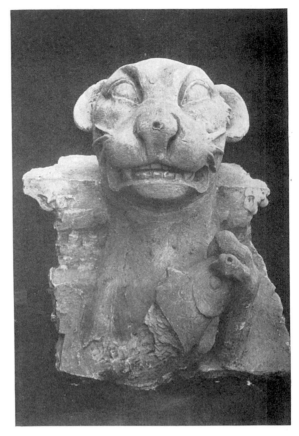
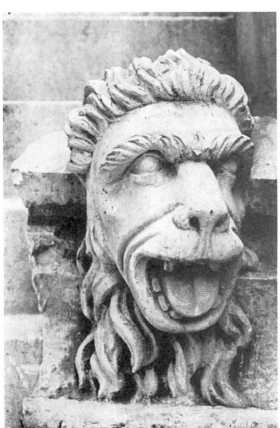
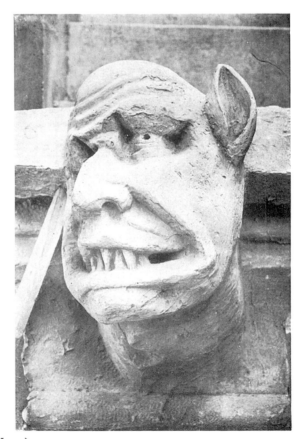

Reims (Marne)

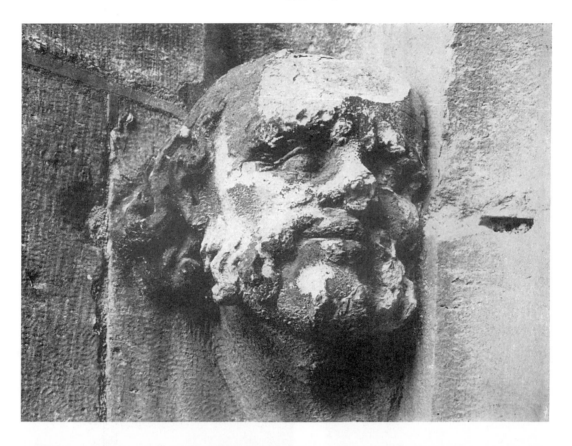

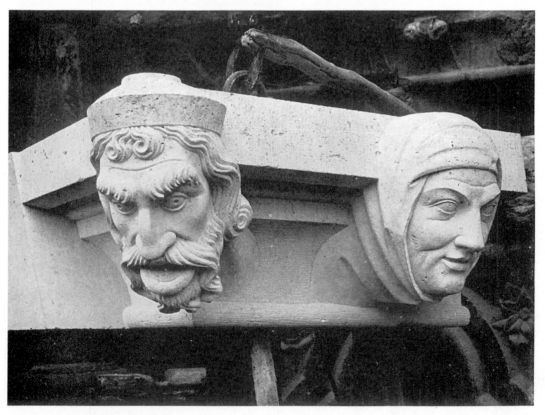

Reims (Marne)

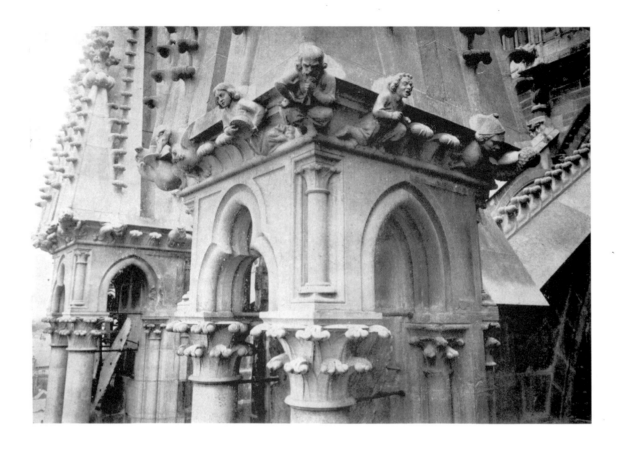

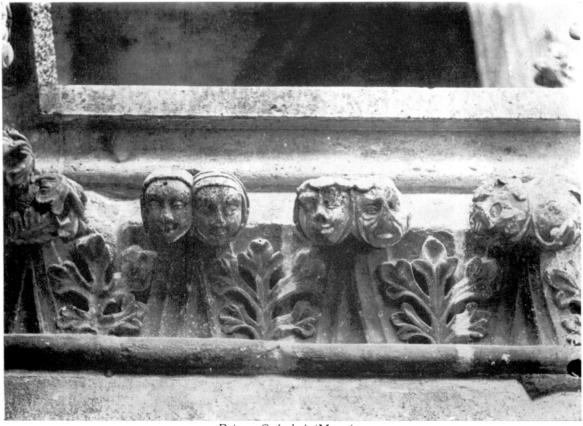

Reims—Cathedral (Marne)

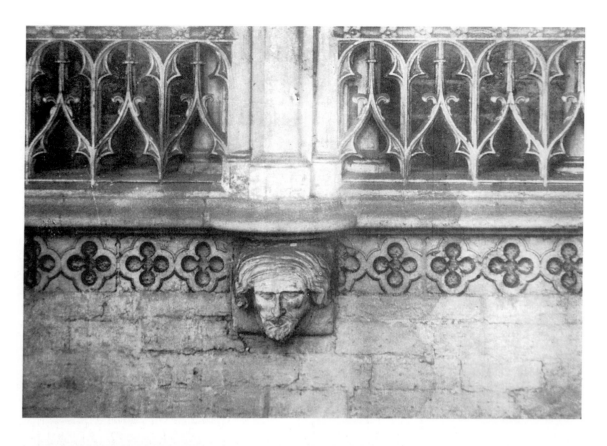

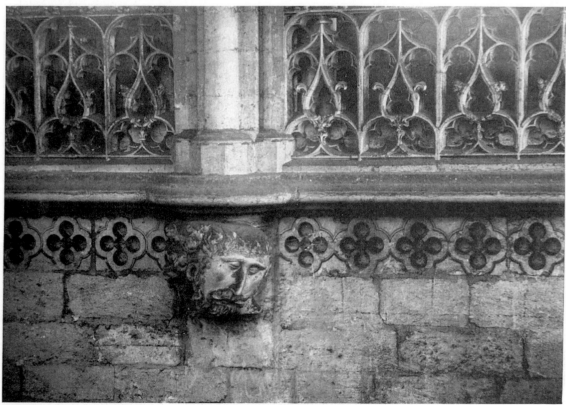

Amiens Cathedral (Somme) Transept

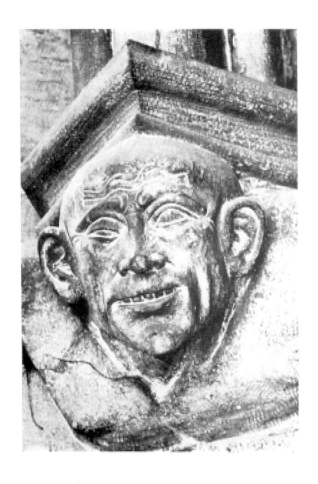
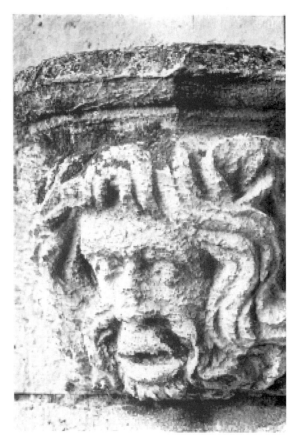
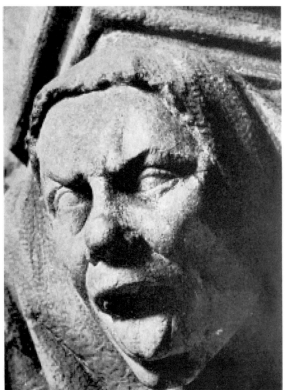
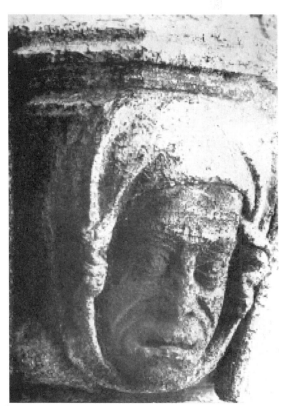

Amiens Cathedral (Somme)

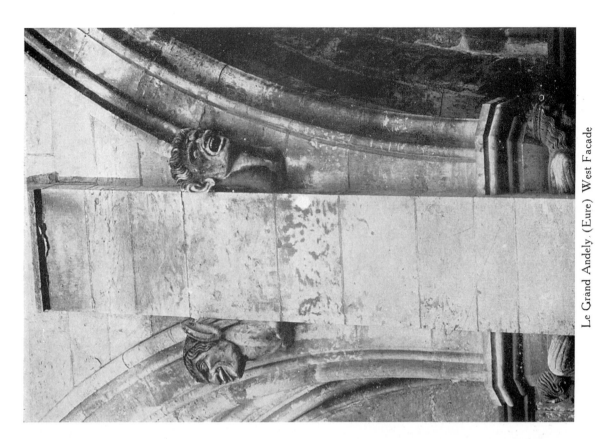

Le Grand Andely. (Eure) West Facade

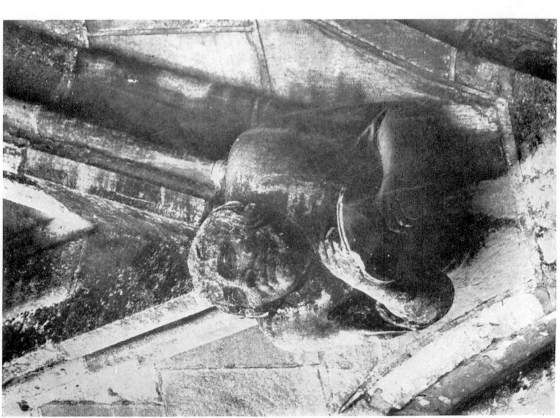

Amiens Cathedral (Somme)

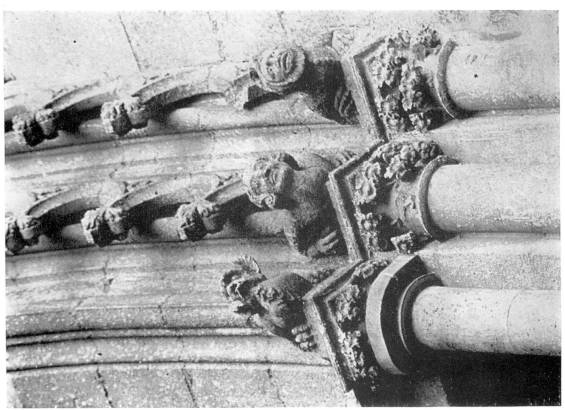

Soisson (Aisne) St. Jean des Vignes

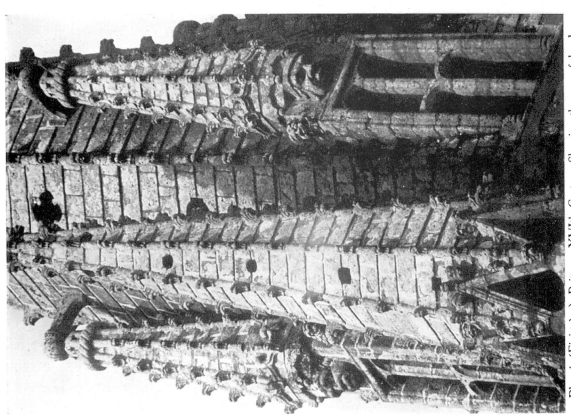

Ploaré (Finistère) Brittany XVIth Century Showing the use of heads

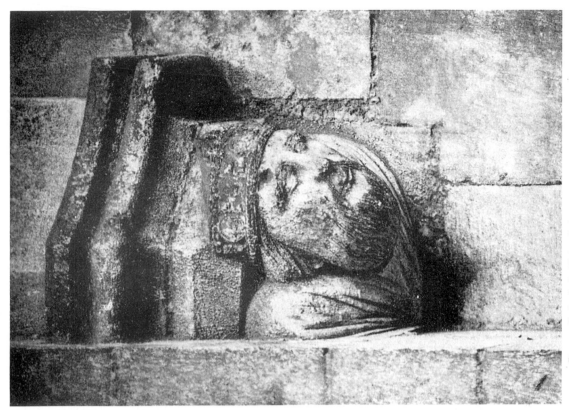

Rouen Cathedral (Seine Inférieur) Bracket Head of Bishop

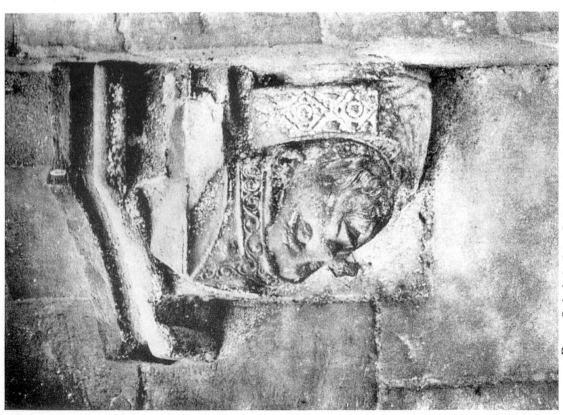

Rouen Cathedral (Seine Inférieur) Bracket Head of King

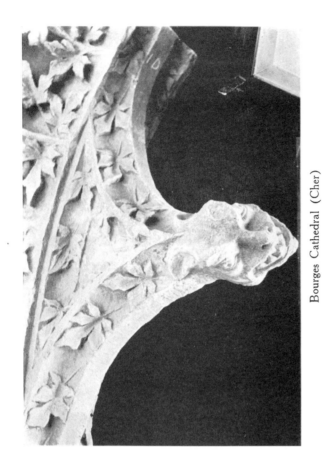

Bourges Cathedral (Cher)

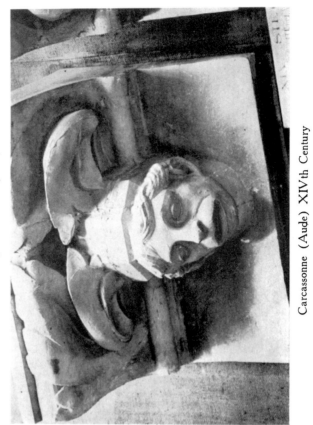

Carcassonne (Aude) XIVth Century

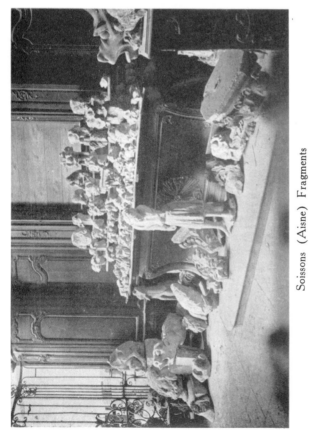

Soissons (Aisne) Fragments

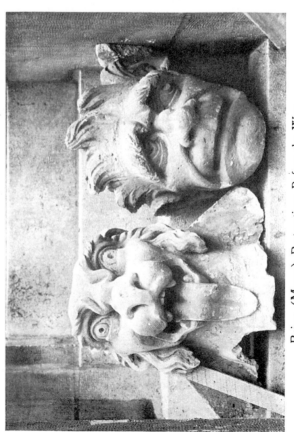

Reims (Marne) Restorations Before the War

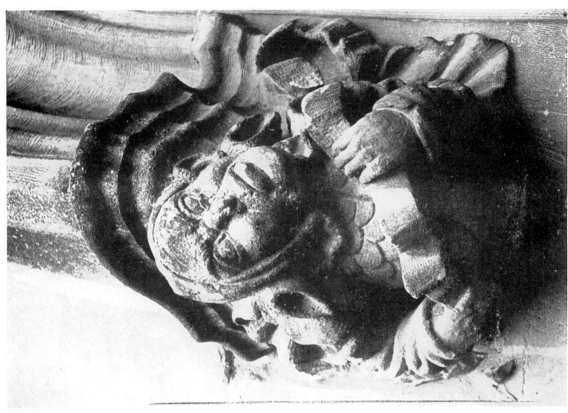

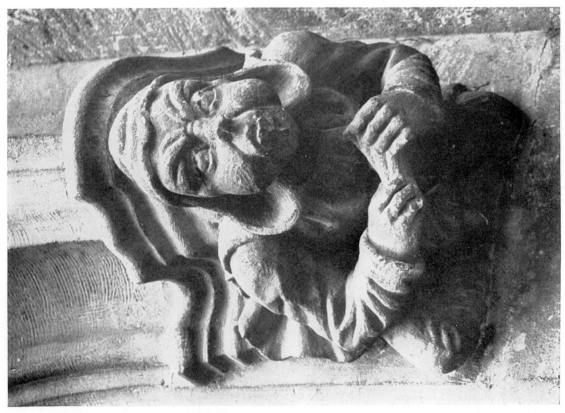

Beauvais (Oise) Palais de Justice East Facade

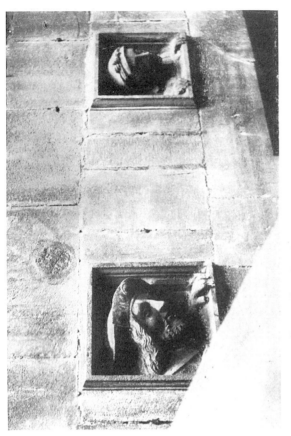

Riom (Puy De Dôme) Hotel Dumontal Court

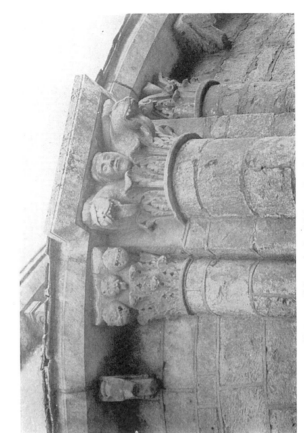

Poitiers (Vienne) St. Helaire Le Grand

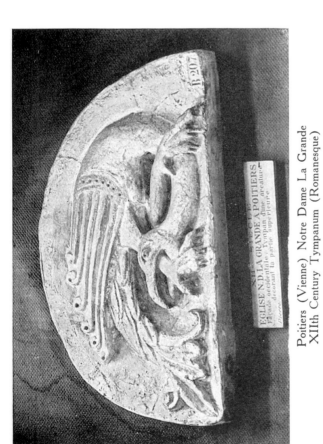

EGLISE N.D. LA GRANDE A POITIERS

Poitiers (Vienne) Notre Dame La Grande
XIIth Century Tympanum (Romanesque)

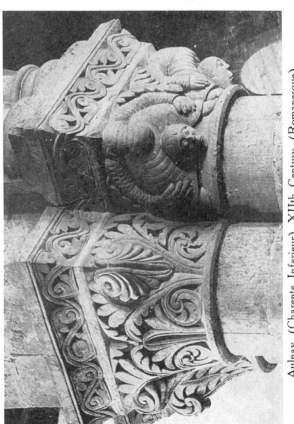

Aulnay (Charente Inferieur) XIIth Century (Romanesque)

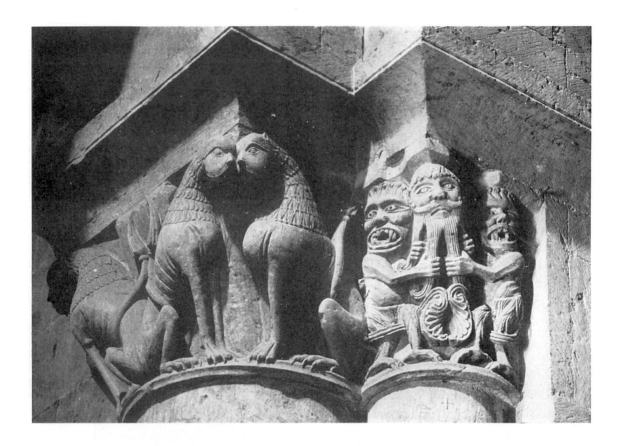

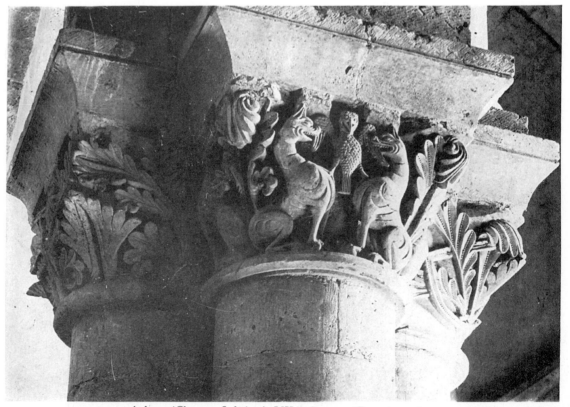

Aulnay (Charente Inférieur) XIIth Century (Romanesque)

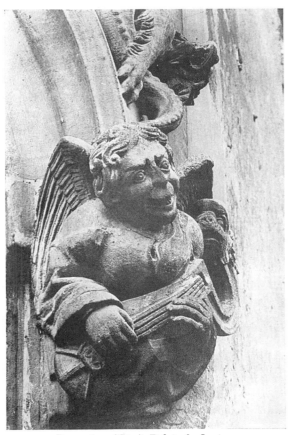

Beauvais—(Oise) Palais de Justice

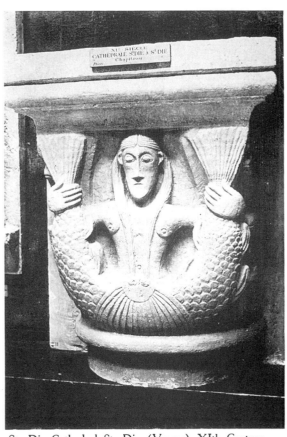

St. Die Cathedral St. Die (Vosges) XIth Century—
Romanesque Siren Motif

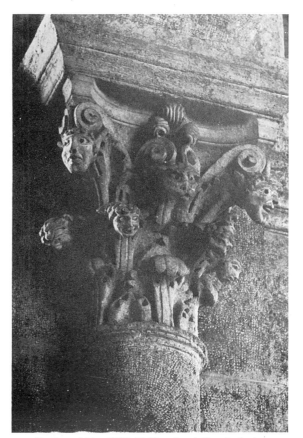

Saulieu (Côte D'Or) Church of St. Andoche

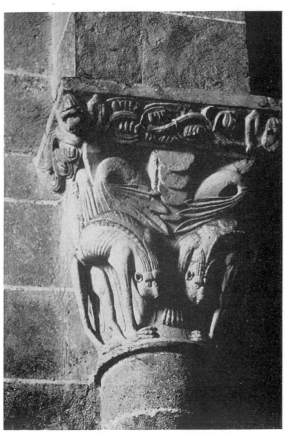

St. Gaudens (Hte. Garonne) End XIIth Century

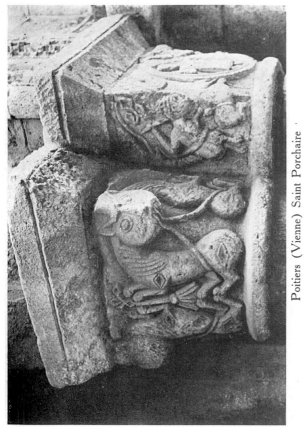

Poitiers (Vienne) Saint Porchaire

Chartres. Tympanum decoration above a window of a thirteenth century house.
(Eure et Loire)

Toulouse (Hte. Garonne) Church of St. Sernin Romanesque Capitals of the Tribune

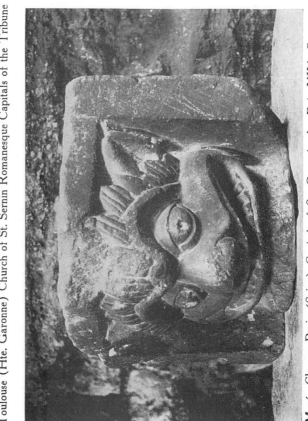

Musée Cluny—Paris (Seine) Capital of St. Germain des Prés XIIth Century

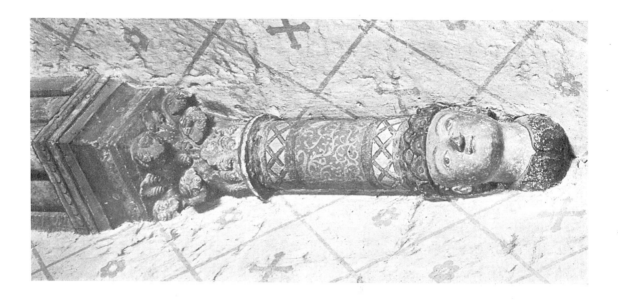

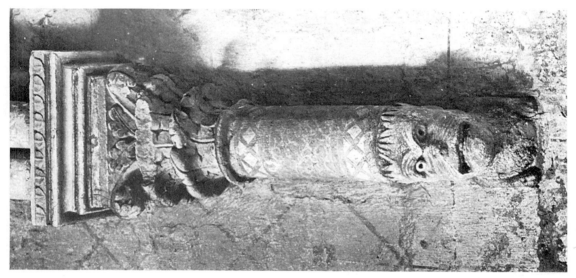

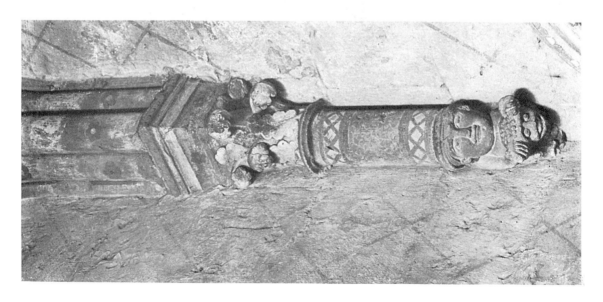

Poitiers (Vienne) Ste. Radegonde Sacristie

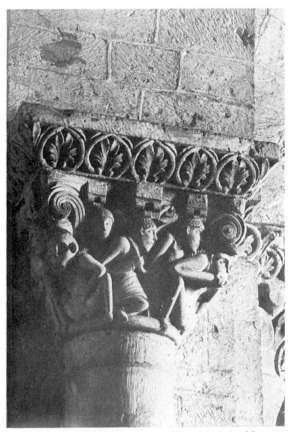

St. Gaudens (Hte Garonne) Capitals of the Nave
End of XIIth Century

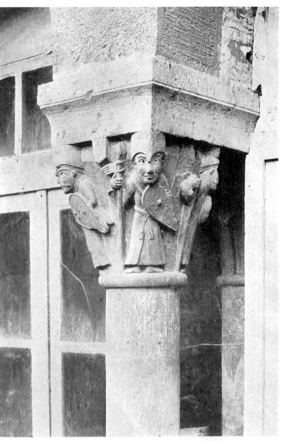

Conques (Aveyron) Capitals in Cloister XIth Centu

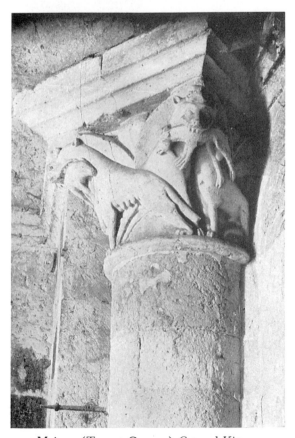

Moissac (Tarn et Garonne) Cat and Kittens

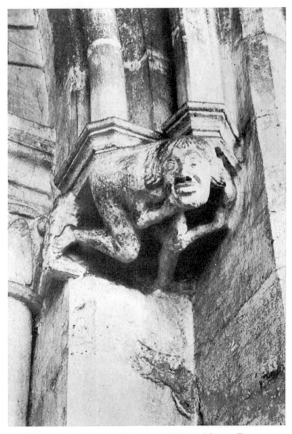

Mantes-Gassicourt (Seine et Oise) Notre Dame
Triforium Gallery Year 1200

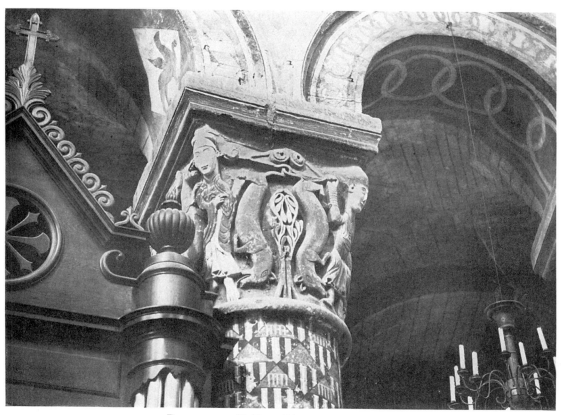

Romanesque—Poitiers (Vienne) Notre Dame

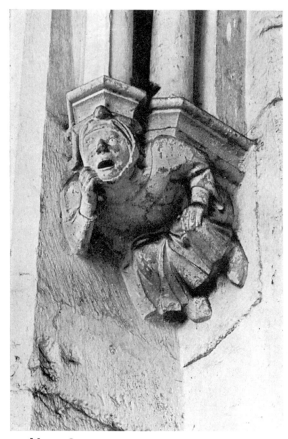

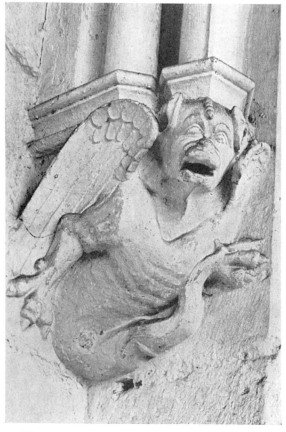

Mantes-Gassicourt (Seine et Oise) Notre Dame
Triforium Gallery Year 1200

Mantes-Gassicourt Notre Dame Triforium Gallery
(Seine et Oise) Year 1200

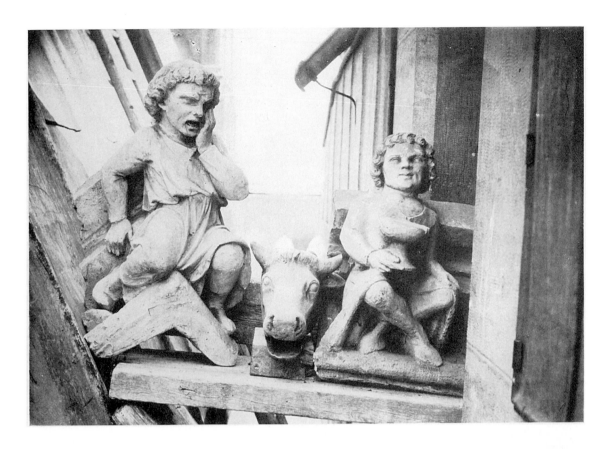

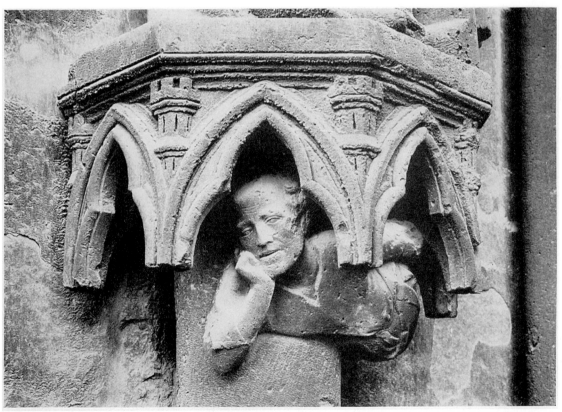

Reims Cathedral (Marne)

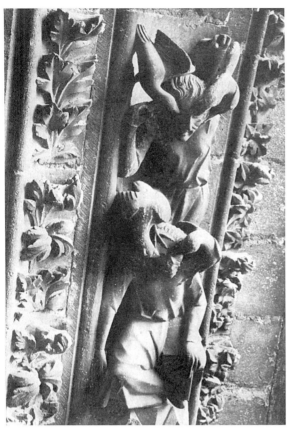

Birds Attacking Men Reims (Marne)

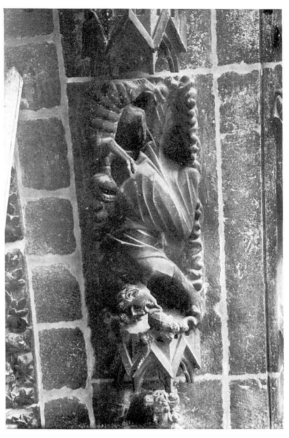

Reims (Marne) The Fall of A Sinner

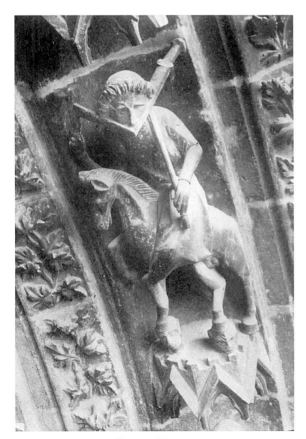

Reims (Marne)

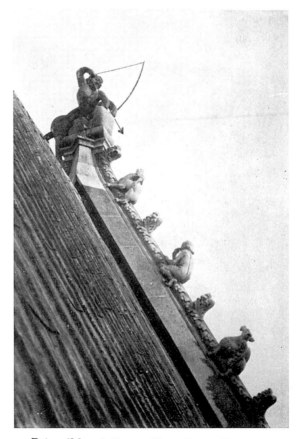

Reims (Marne) Centaur Shoots Down (Restored)

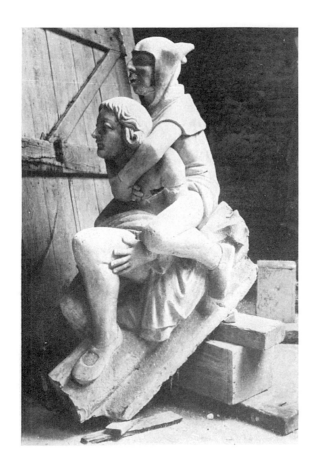
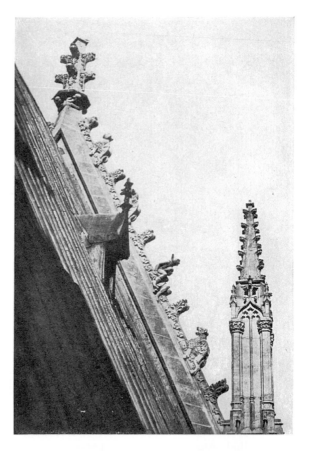
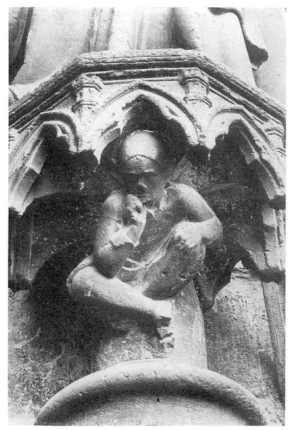
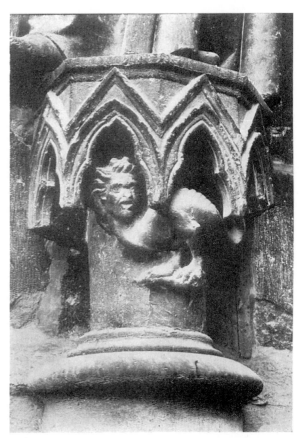

Reims (Marne)

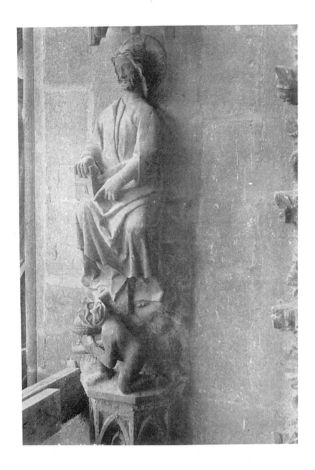

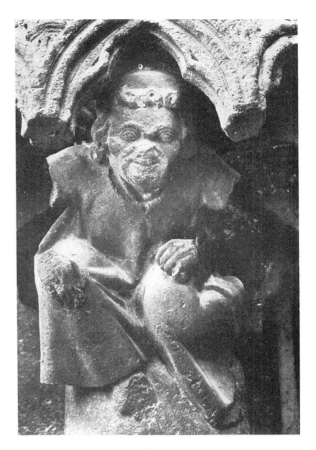

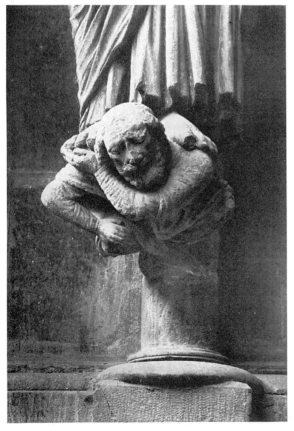

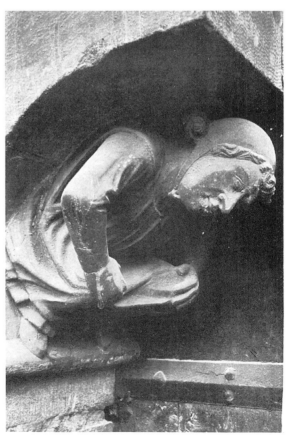

Reims (Marne)

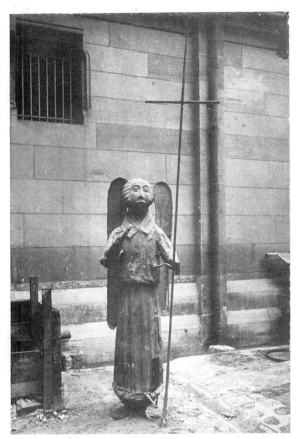

Reims (Marne) Leadwork Weathervane

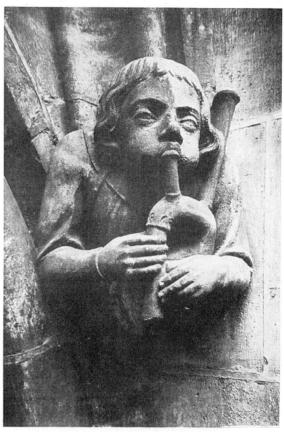

Amiens Cathedral (Somme) Bagpipe player

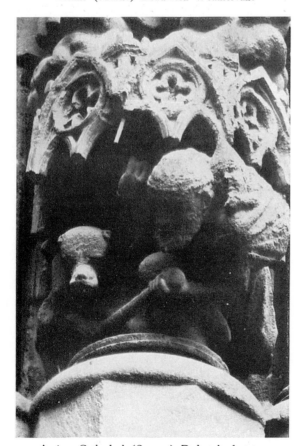

Amiens Cathedral (Somme) Pedestal of statue

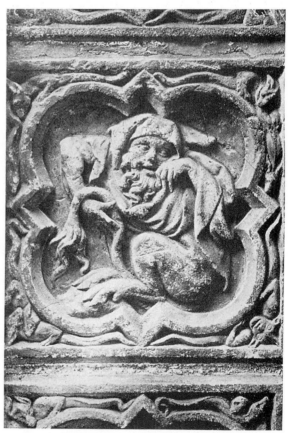

Rouen (Seine Inférieur) Portail des Librairies—
Quatrofoil Beginning of XIVth Century

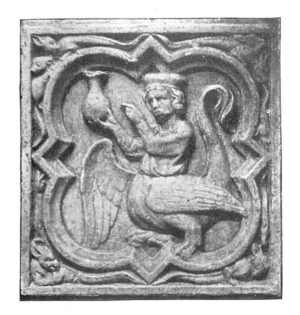
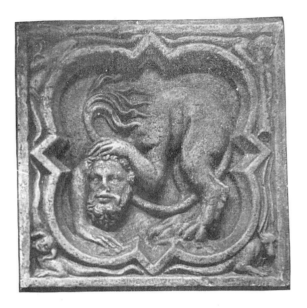
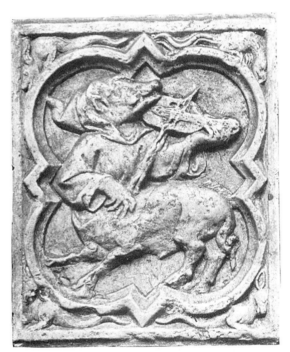
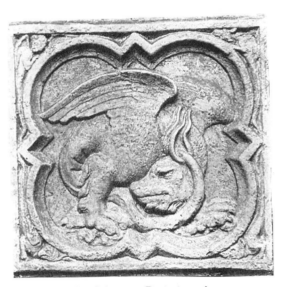

Rouen (Seine Inférieur) Cathedral Quatrofoils,—Portail des Librairies Beginning of
XIVth Century Imaginative Compositions

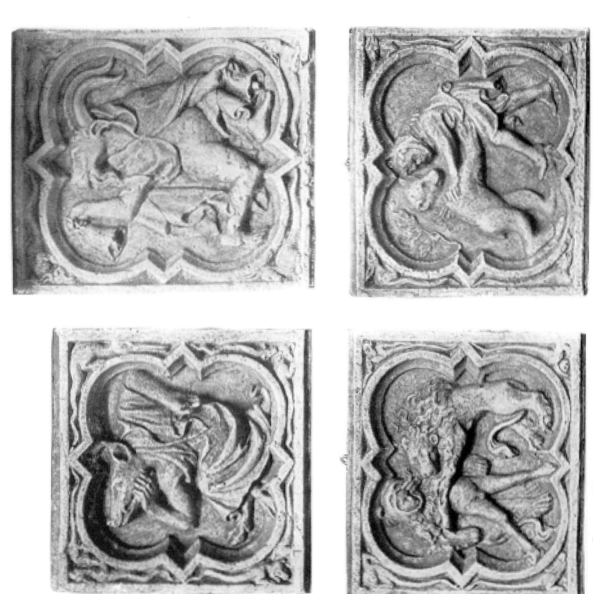

Rouen—(Seine Inférieur) Cath. Beginning XIVth Century Quatrofoils—Portail des
Librairies Imaginative Compositions

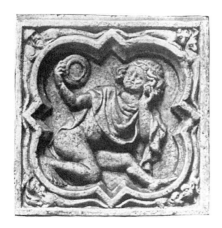

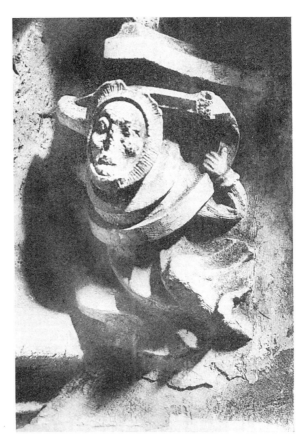

Rouen Cathedral (Seine Inférieur) Qua-
trofoils—Portail des Librairies Beginning
of XIVth Century Imaginative
Compositions

Stairway of Library Rouen Cath. (Seine Inférieur)

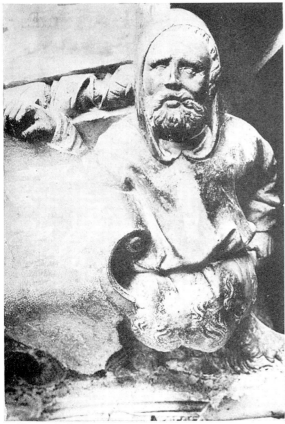

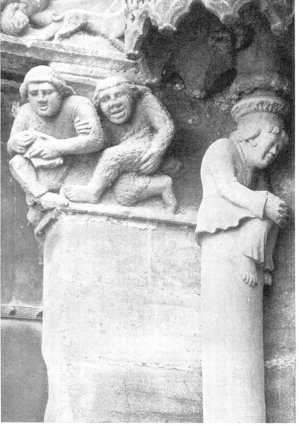

Rouen Cathedral (Seine Inférieur) Statue of Rouland
Leroux, Sculptor

Semur-En-Auxois (Côte D'Or) Notre Dame—North
Portal XIIIth Century

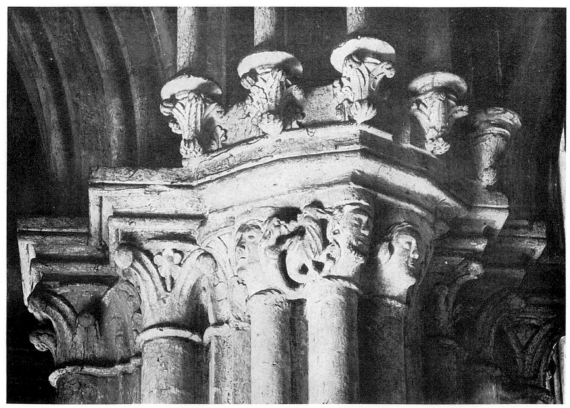

Rouen Cathedral (Seine Inférieur) Capital

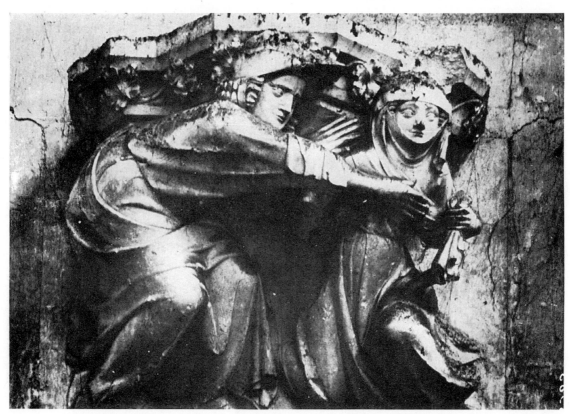

Auxerre (Yonne) St. Etienne—Transept "The Fight Over the Breeches"—
Household Quarrel

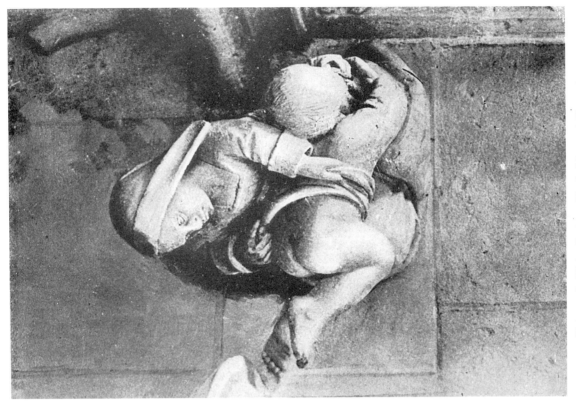

Château de Blois (Loir et Cher) Maternal Correction

Evreux (Eure) St. Taurin—XIVth Century

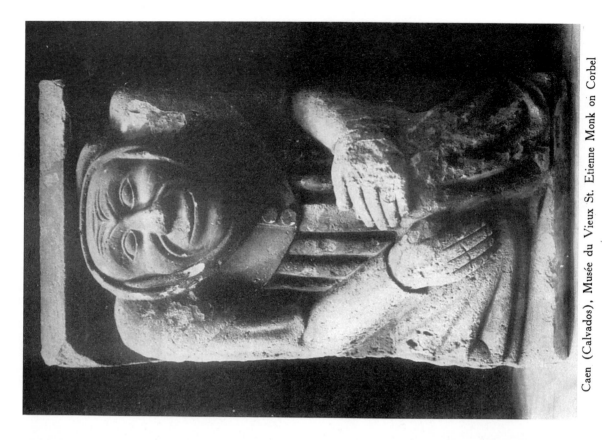

Caen (Calvados), Musée du Vieux St. Etienne Monk on Corbel

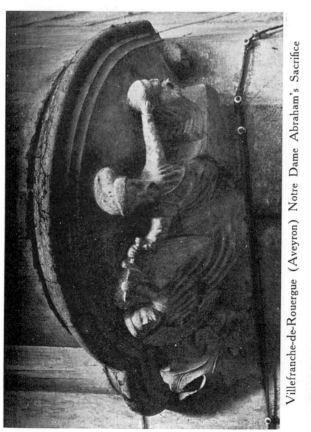

Villefranche-de-Rouergue (Aveyron) Notre Dame Abraham's Sacrifice

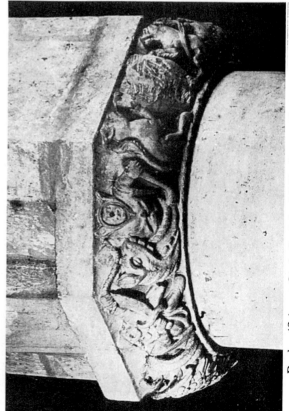

Presles (Seine et Oise) Capital—XVth Century Fools Fighting

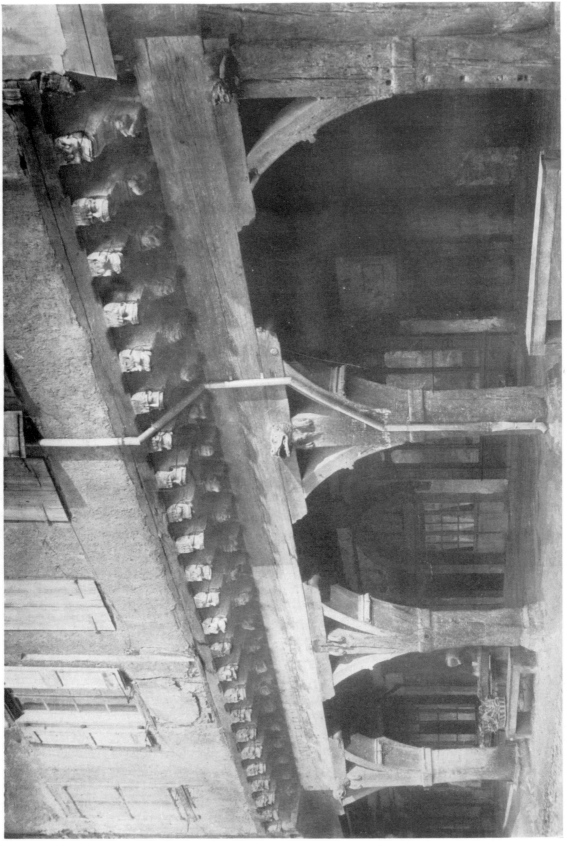

Woodwork—Mirepoix (Ariège) Galerie de la Place—Showing carved beam ends as found in stonework

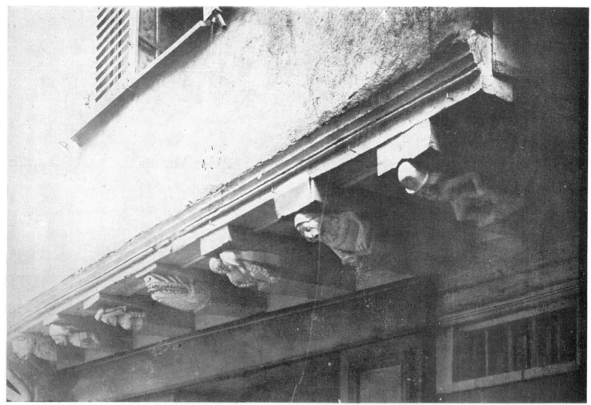

Thiers (Puy de Dôme) The Seven Deadly Sins XVth Century House

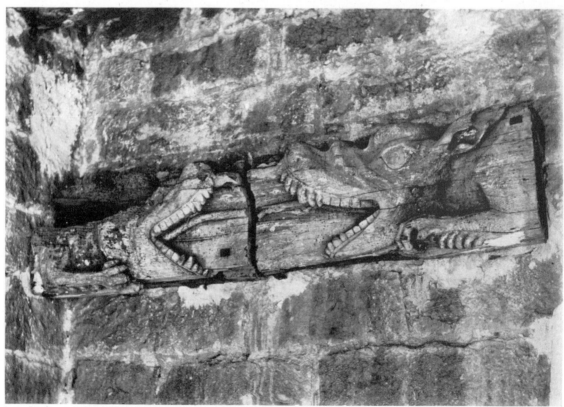

Le Mans (Sarthe) Beam Supports

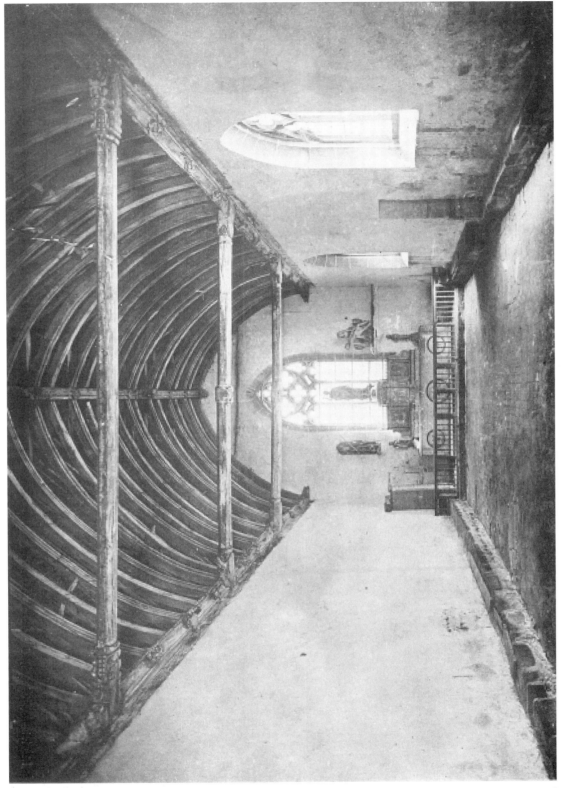

Plescop—Lézurgan (Morbihan) (Brittany) Shows Use of Dragon's Heads As Beam Ends—In Chapel XVIth Century

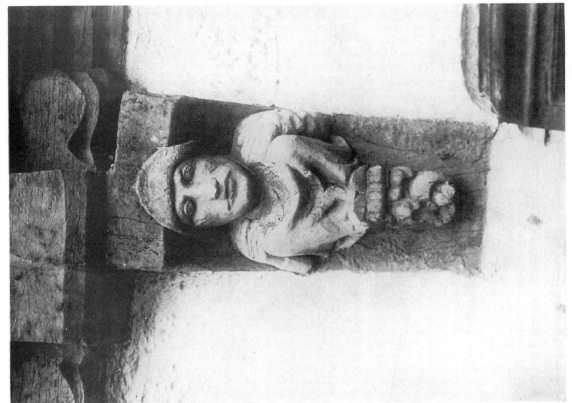

Malestroit (Morbihan) Maison-Gresbossen XVth Century

Morlaix—(Finistère) Man in Shirt XVth Century

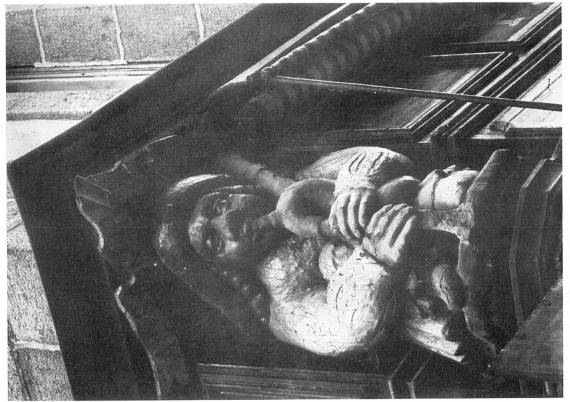

Morlaix (Finistère) Rue de Notre Dame Player of Bagpipe

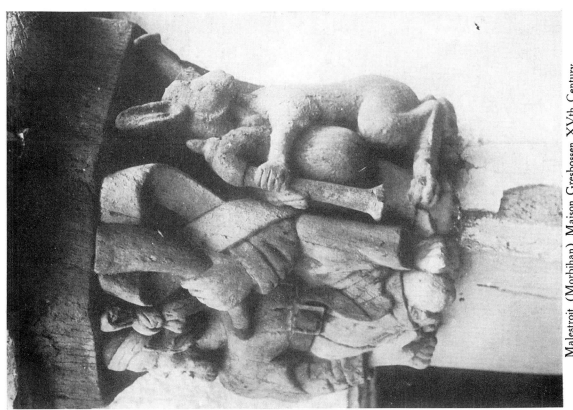

Malestroit (Morbihan) Maison Gresbossen XVth Century

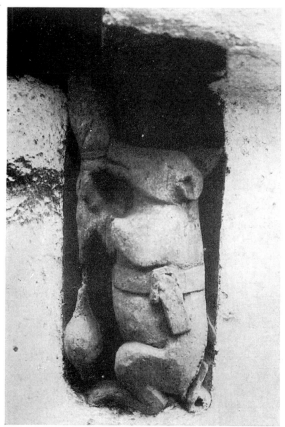

Malestroit (Morbihan) Spinning Sow XVth Century

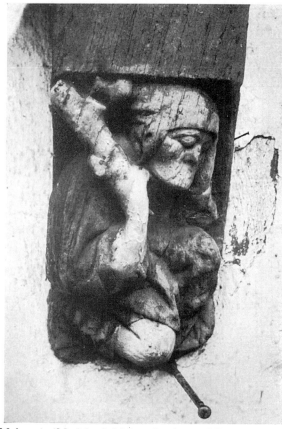

Malestroit (Morbihan) Maison Gresbosson XVth Century

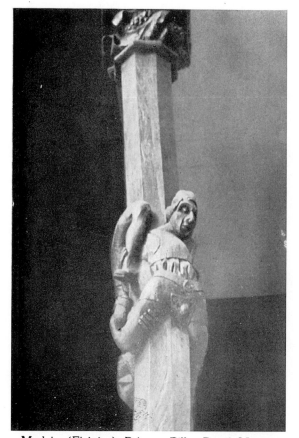

Morlaix (Finistère) Brittany Pillar Detail Museum

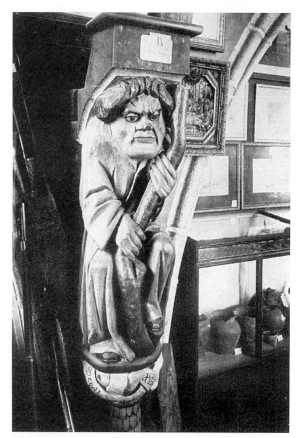

Morlaix (Finistère) Museum XVth Century

Le Faouët (Morbihan) Church St. Fiacre Proverb of Fox Coming Out of Man—Symbol of Drunkenness

Le Faouët (Morbihan) Church of St. Fiacre—Screen Flamboyant Gothic

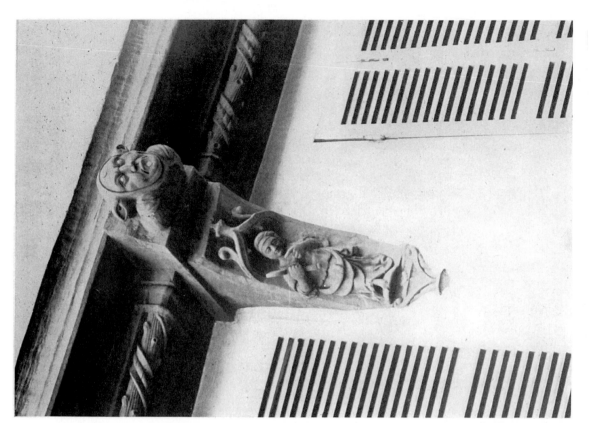

Beauvais (Oise) Fool's Head

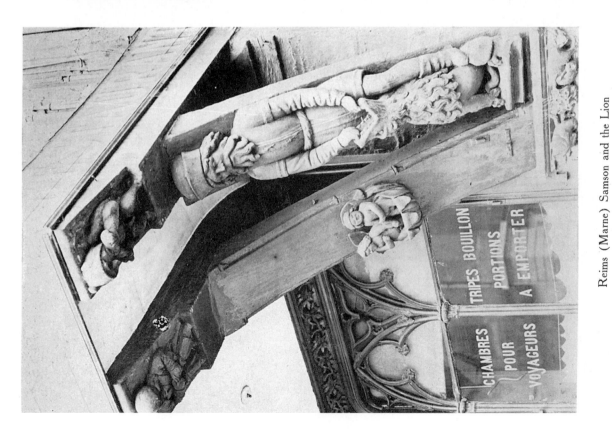

Reims (Marne) Samson and the Lion

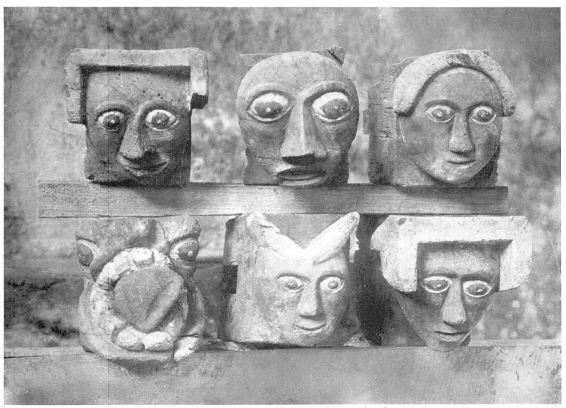

Le Faouët (Morbihan) Eglise St. Fiacre

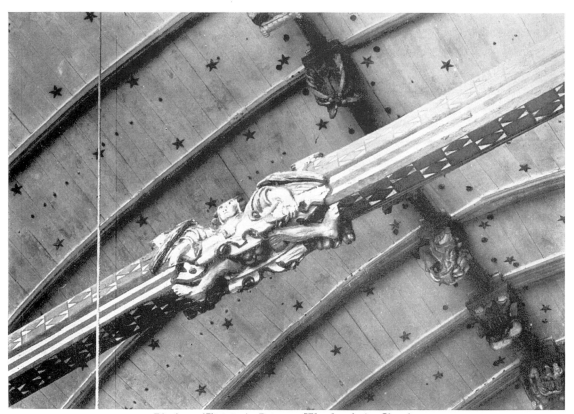

Pleyben (Finistère) Brittany Woodwork in Church

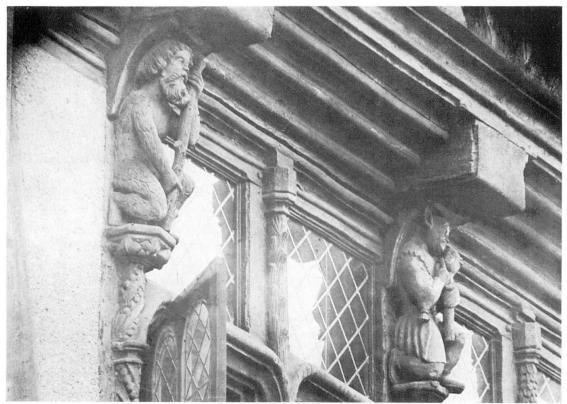

Morlaix (Finistère) House of Queen Anne

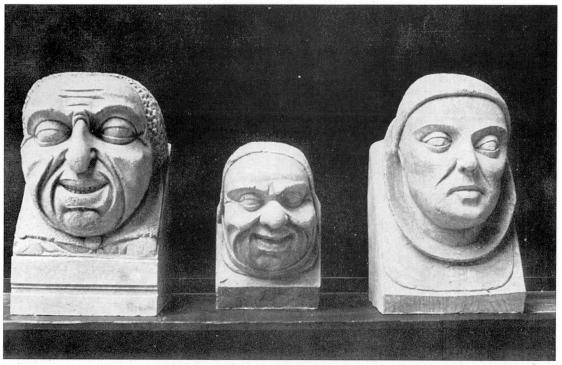

Amiens—Monk's Heads—In Museum of Picardy (Somme)

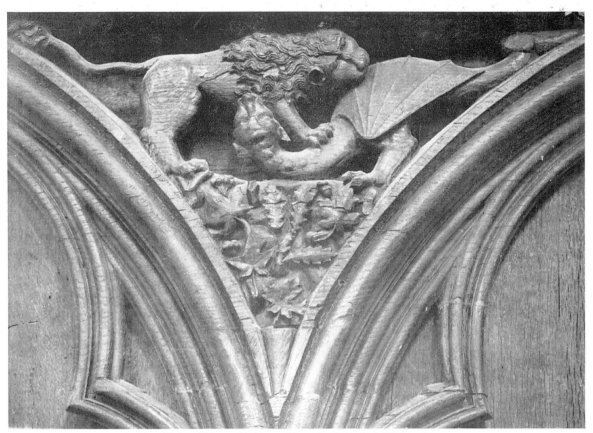

Lion Fights Chimere Poitiers (Vienne) Cathedral XIIIth Century

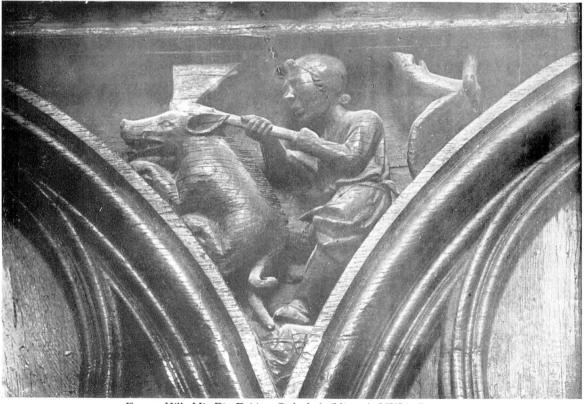

Farmer Kills His Pig Poitiers Cathedral (Vienne) XIIIth Century

Money Changer Amiens (Somme) XVIth Century

Amiens, (Somme) Cathedral, Housewife, XVIth Century stall

Vegetable Woman Amiens (Somme) XVIth Century

Apothecary Amiens (Somme) XVIth Century

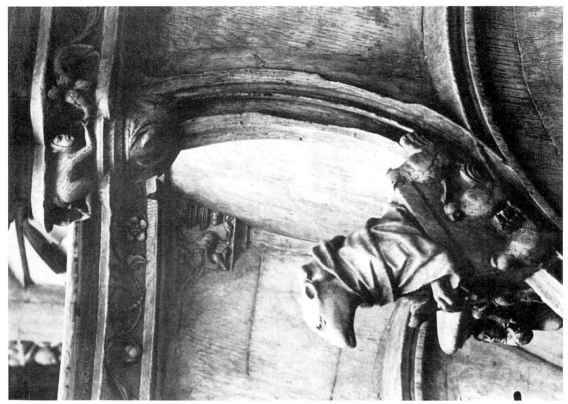

Amiens (Somme) Fable of Fox Preaching to the Birds XVIth Century

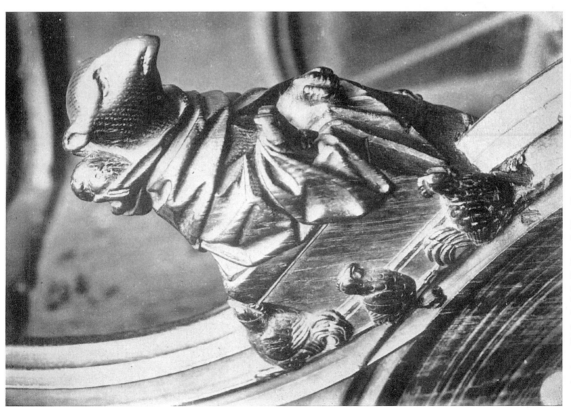

Amiens Cathedral Stall Detail Fox Preaching to Birds XVIth Century
Satire on Monks

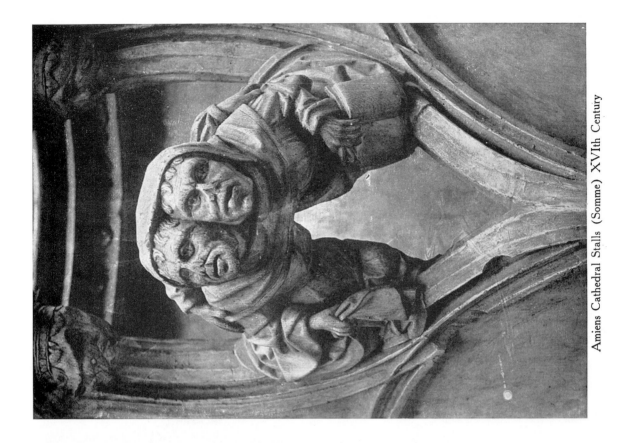

Amiens Cathedral Stalls (Somme) XVIth Century

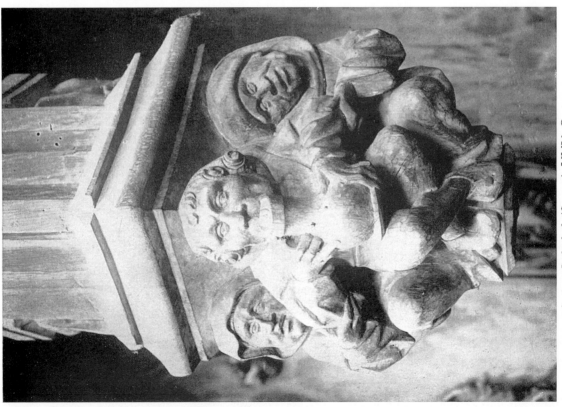

Amiens Cathedral (Somme) XVIth Century

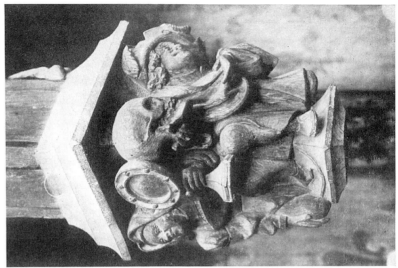

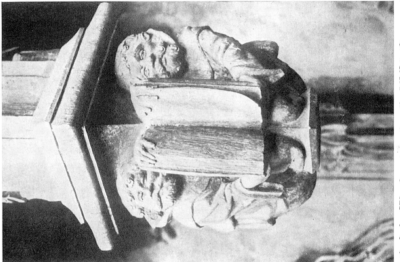

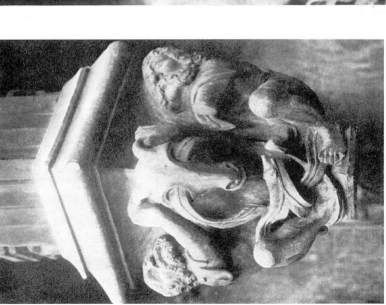

Amiens Cathedral—Woodcarving of stalls XVIth Century (Somme)

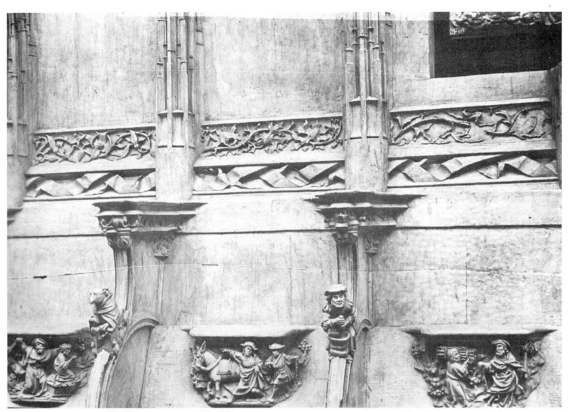

Amiens Cathedral (Somme) Stalls, Showing Position of Misericordes Under the
stall seats. (XVIth century)

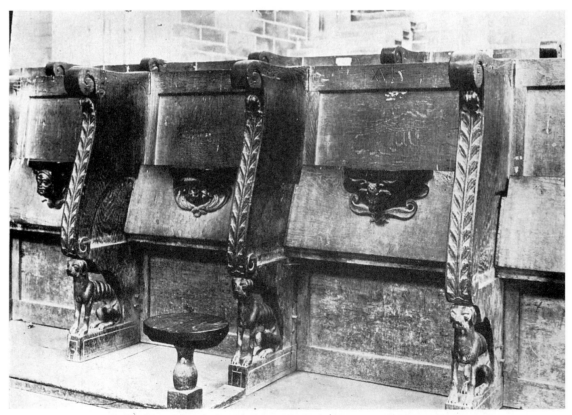

Vézelay (Yonne) La Madeleine Showing Position of Misericordes

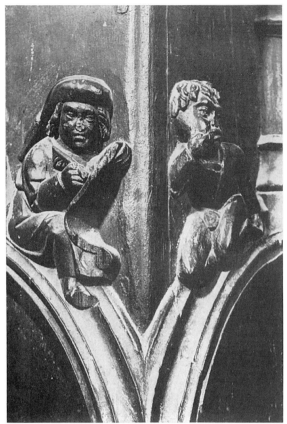

Champeaux (Seine et Marne) Stall Details, XVIth Century

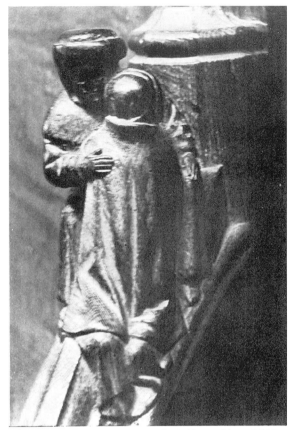

St. Pol de Léon (Finistère) Stall Detail Year 1512

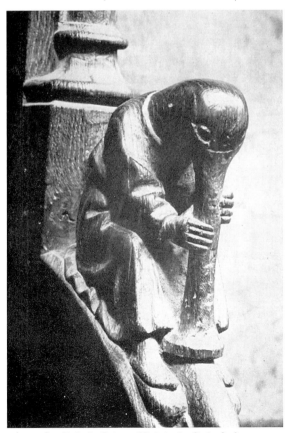

St. Pol de Léon (Finistère) Cathedral—
Stall Detail Year 1512

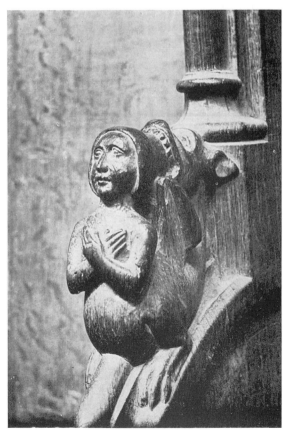

St. Pol de Léon—(Finistère) Cathedral—Year 1512

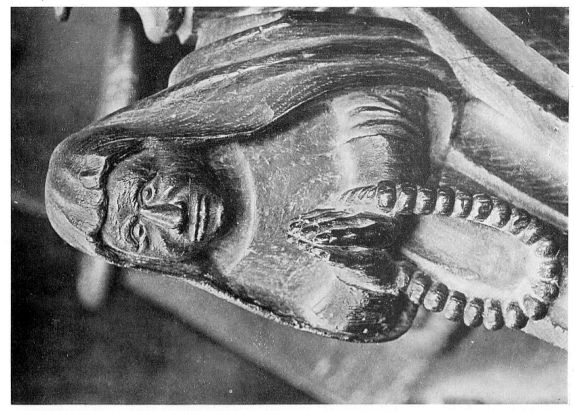

Vendôme (Loir et Cher) La Trinité XVth Century

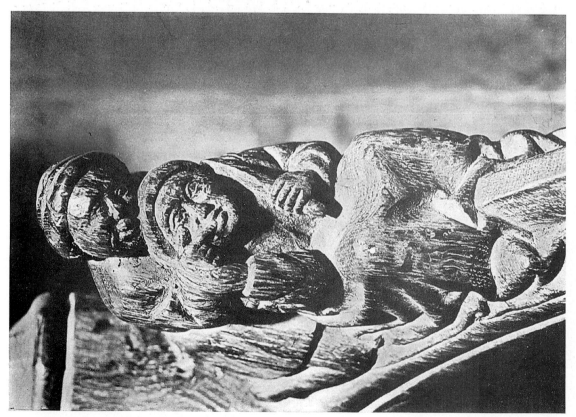

St. Pol de Léon (Finistère) Dentist; Year 1512

Poitiers (Vienne) (Misericorde) Note—Two Inverted Heads at Sides

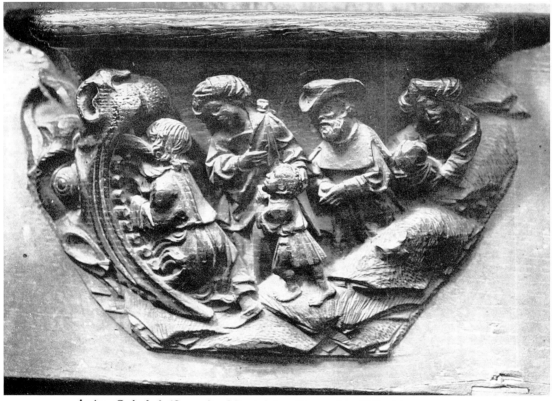

Amiens Cathedral (Somme)—Misericorde—Descent into Hell—Years 1508-1519

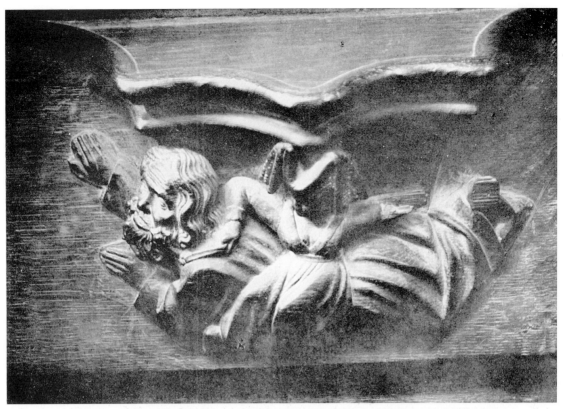

The Lay of Aristotle Rouen—Cathedral—Misericorde—(Seine-Inférieur) 1457-1469

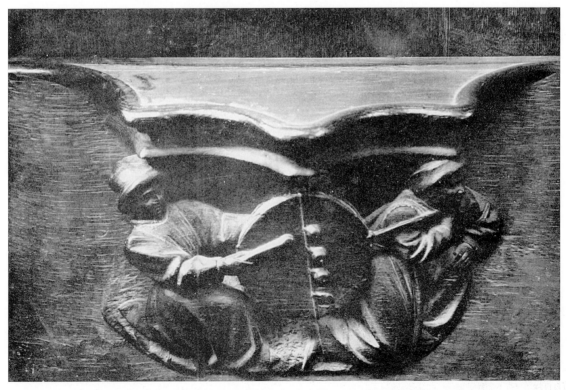

Beating a Drum for a Procession Rouen Cathedral (Seine Inférieur) Date—1457 to 1469

St. Pol de Léon (Finistère) Grotesque Face—Misericorde—Year 1512 AD

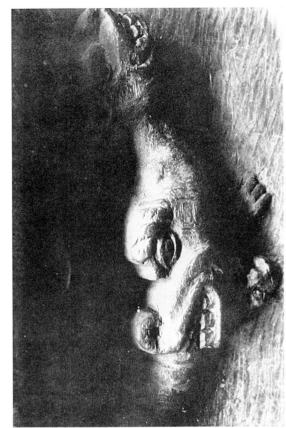

St. Pol de Léon—(Finistère) Chimeríçal Animals—Misericorde—Year 1512

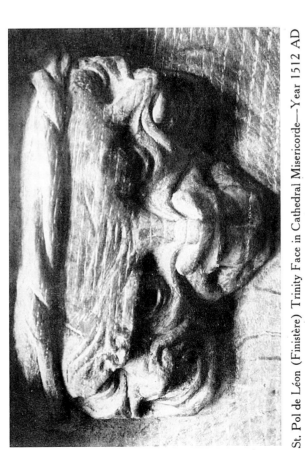

St. Pol de Léon (Finistère) Trinity Face in Cathedral Misericorde—Year 1512 AD

St. Pol de Léon (Finistère) Monkey Reading—Year 1512

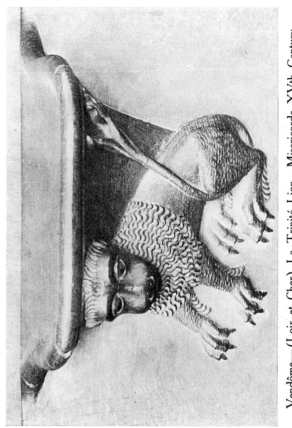

Vendôme—(Loir et Cher) La Trinité Lion—Misericorde XVth Century

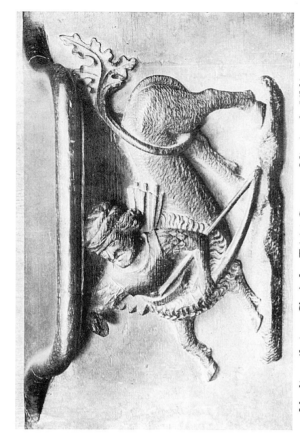

Vendôme (Loir et Cher) La Trinité Centaur—Misericorde XVth Century

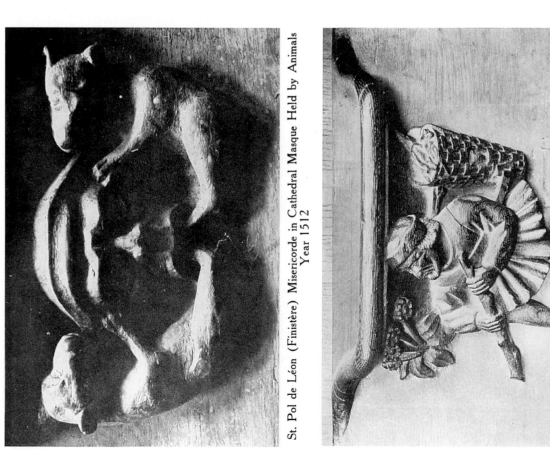

St. Pol de Léon (Finistère) Misericorde in Cathedral Masque Held by Animals
Year 1512

Vendôme (Loir et Cher) La Trinité Wood Gatherer—Misericorde XVth Century

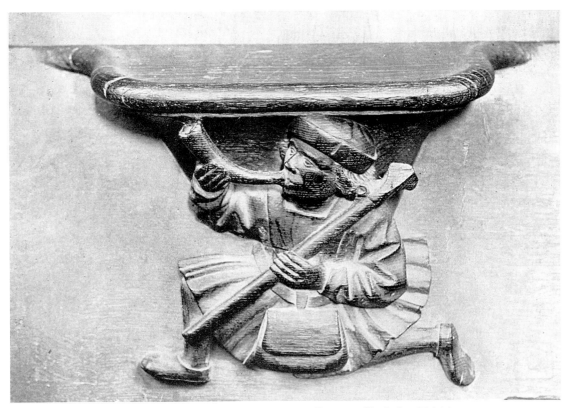

Huntsman Blowing Horn Vendôme—(Loir et Cher) La Trinité
XVth Century—Misericorde

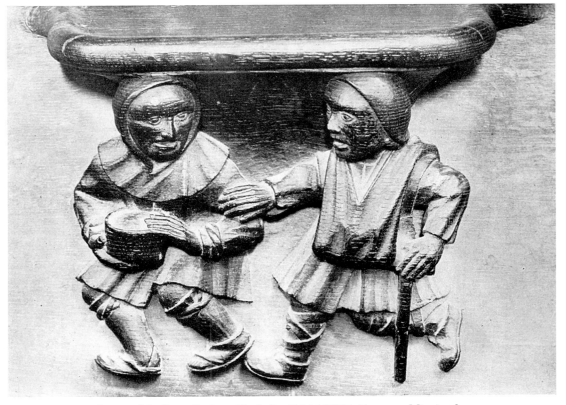

Beggars Vendôme (Loir et Cher) La Trinité XVth Century—Misericorde

Vendôme (Loir et Cher) La Trinité XVth Century—Misericorde

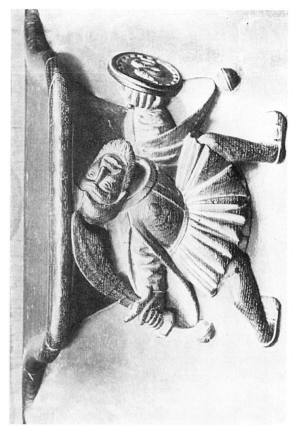

Vendôme (Loir et Cher) La Trinité Warrior—Misericorde, XVth Century

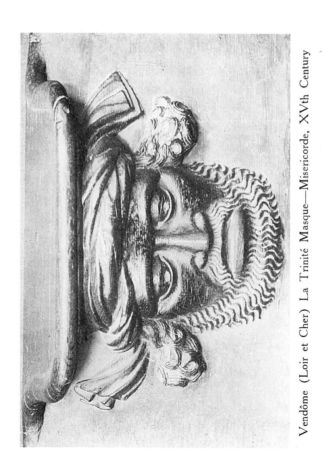

Vendôme (Loir et Cher) La Trinité Masque—Misericorde, XVth Century

Vendôme (Loir et Cher) La Trinité Face in The Foliage XVth Century, Misericorde

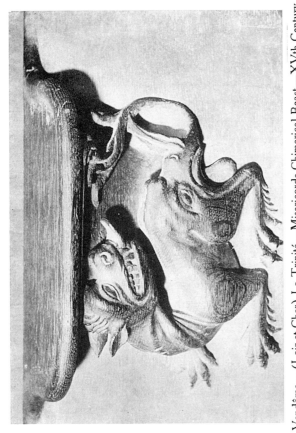

Vendôme—(Loir et Cher) La Trinité—Misericorde Chimerical Beast—XVth Century

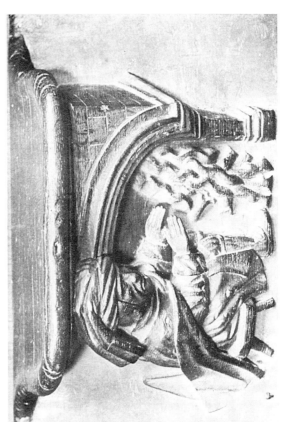

XVth Century—Misericorde Vendôme—(Loir et Cher) La Trinité Man Warming Himself

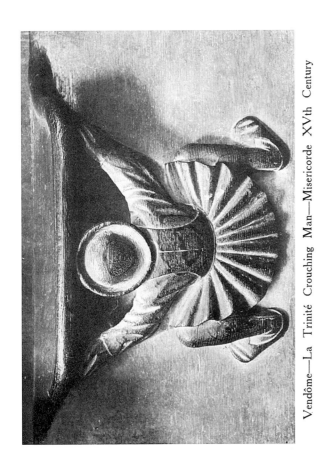

Vendôme—La Trinité Crouching Man—Misericorde XVth Century

Dogs Eating a Bone Vendôme—(Loir et Cher) La Trinité—Misericorde XVth Century

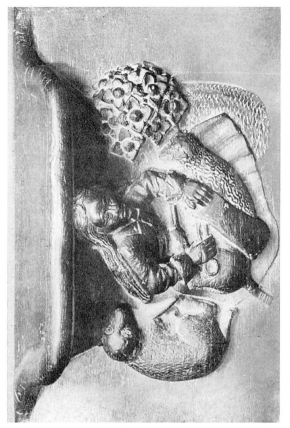

Sheep Shearing Vendôme (Loir et Cher) La Trinité XVth Century—Misericorde

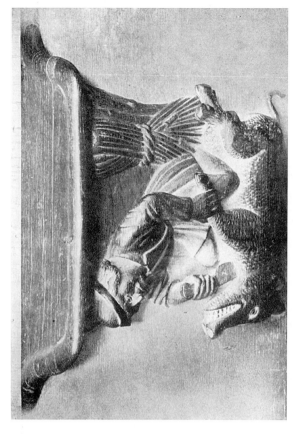

Farmer Kills His Pig Vendôme—(Loir et Cher) La Trinité XVth Century—Misericorde

Farmer Sowing Vendôme—(Loir et Cher) La Trinité XVth Century—Misericorde

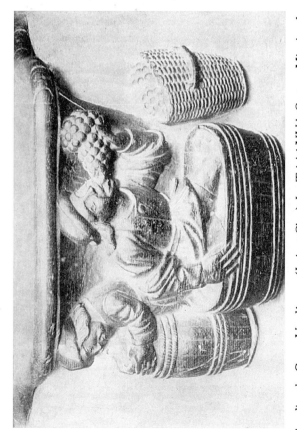

Treading the Grape Vendôme—(Loir et Cher) La Trinité XVth Century Misericorde

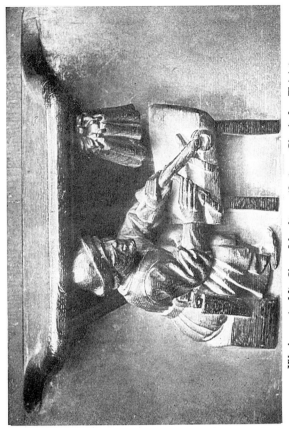

Workman in His Shop Vendôme (Loir et Cher) La Trinité
XVth Century Misericorde

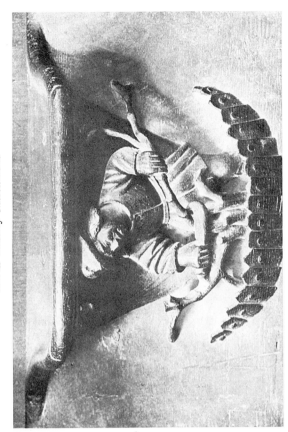

Man Gathering Dead Wood Vendôme (Loir et Cher) La Trinité
XVth Century—Misericorde

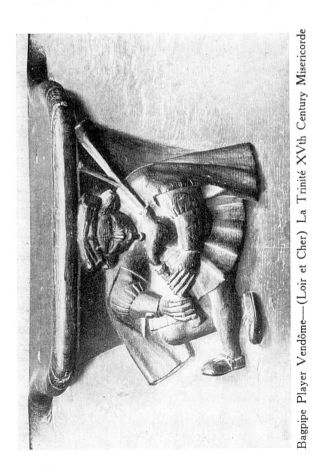

Bagpipe Player Vendôme—(Loir et Cher) La Trinité XVth Century Misericorde

Tavern Keeper Vendôme (Loir et Cher) La Trinité XVth Century Misericorde

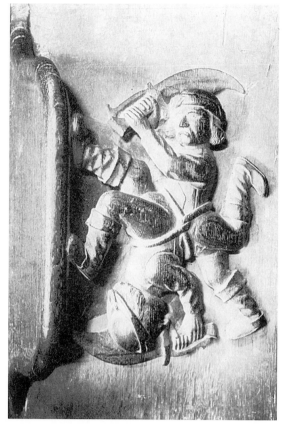

Vendôme (Loir et Cher) La Trinité Warriors in Battle
XVth Century—Misericorde

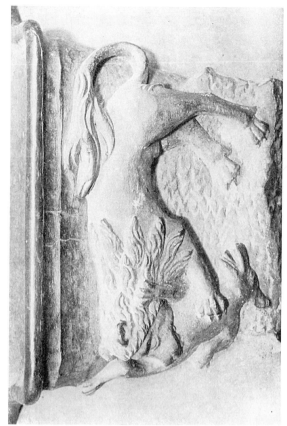

Champeaux (Seine et Marne) Lion Eating Animal—
Renaissance—Misericorde

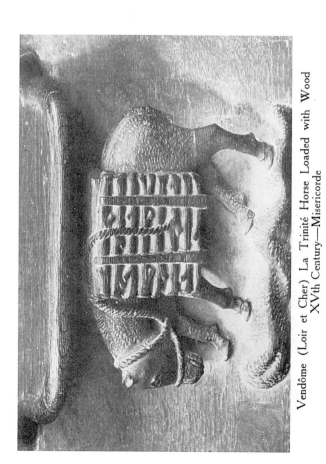

Vendôme (Loir et Cher) La Trinité Horse Loaded with Wood
XVth Century—Misericorde

Champeaux (Seine et Marne) A Derivation of The Lay of Aristotle
Renaissance Misericorde

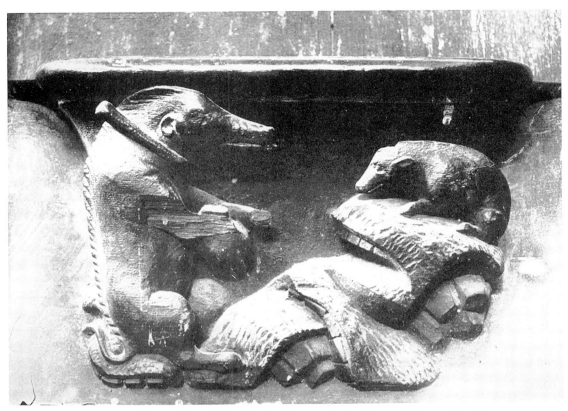

Champeaux (Seine et Marne) Sow Playing Bagpipe for Its Young—Satire on Musicians
of the Time (Misericorde) Renaissance

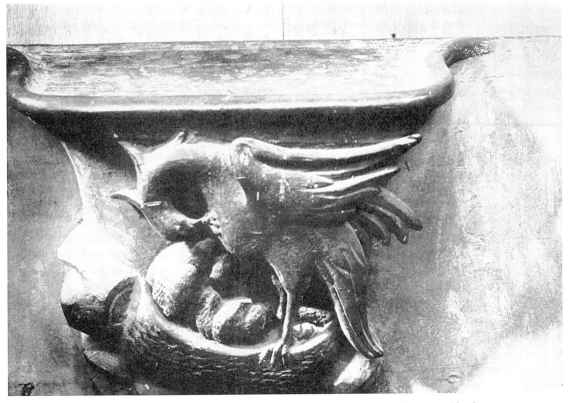

Champeaux (Seine et Marne) Pelican Feeding Young with Its Own Blood
Renaissance Misericorde

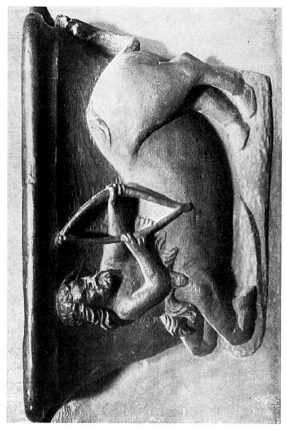

Champeaux (Seine et Marne) Centaur—(Misericorde) XVIth Century

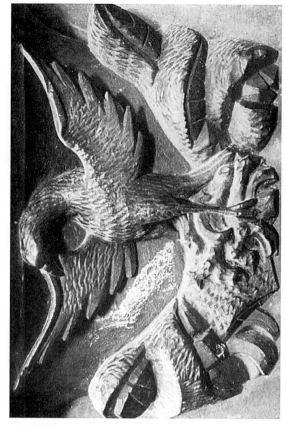

Champeaux (Seine et Marne) Phoenix Bird (Misericorde) XVIth Century

Champeaux (Seine et Marne) Centaur—Misericorde (Renaissance Type)

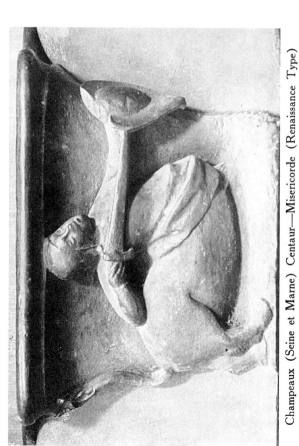

Champeaux (Seine et Marne) Dogs Gnawing Bone XVIth Century (Misericorde)

Champeaux (Seine et Marne) Man Riding Chimerical Beast
XVIth Century (Misericorde)

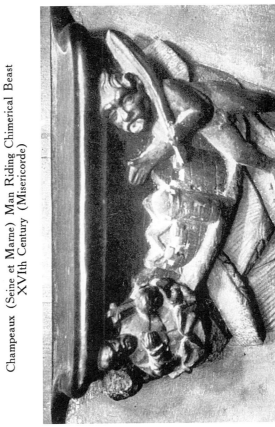

Champeaux (Seine et Marne) Devil Talking with Christ
XVIth Century—Misericorde

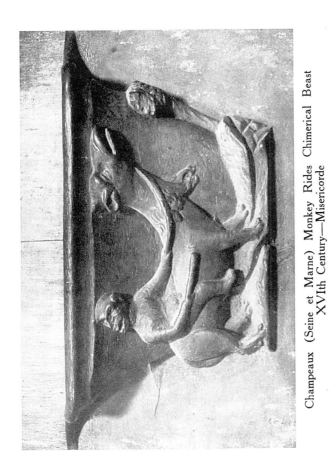

Champeaux (Seine et Marne) Monkey Rides Chimerical Beast
XVIth Century—Misericorde

Champeaux (Seine et Marne) Devils Boil in a Pot
XVIth Century (Misericorde)

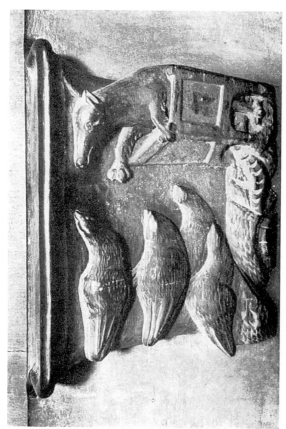

Champeaux (Seine et Marne) XVIth Century—Misericorde
Fox Preaching to the Birds

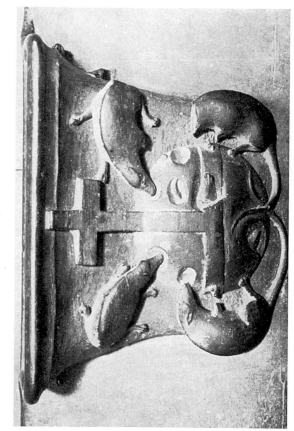

Champeaux (Seine et Marne) Misericorde—XVIth Century
The World is Eaten by Rats

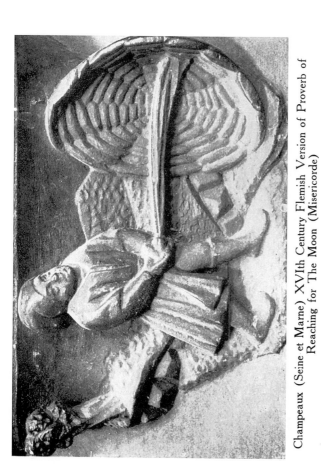

Champeaux (Seine et Marne) XVIth Century Flemish Version of Proverb of
Reaching for The Moon (Misericorde)

Champeaux (Seine et Marne) XVIth. Century Misericorde Man Fighting Dragon

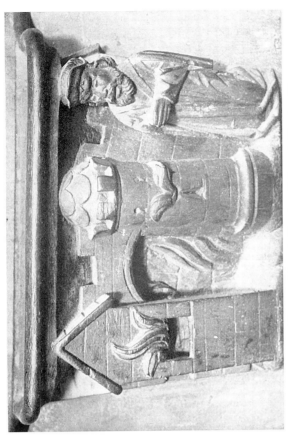

Champeaux (Seine et Marne) Prophet Before A Burning Town—
Misericorde XVIth Century

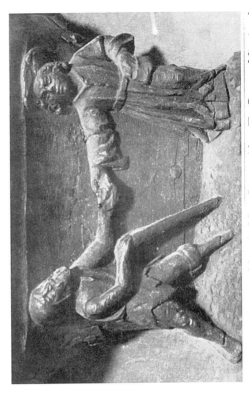

Champeaux (Seine et Marne) Man Giving Alms To Beggar Misericorde
XVIth Century

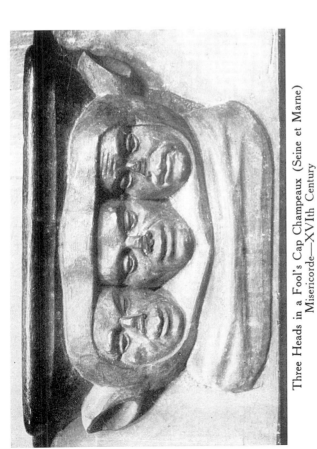

Three Heads in a Fool's Cap Champeaux (Seine et Marne)
Misericorde—XVIth Century

Buying Food Champeaux (Seine et Marne) Misericorde—XVIth Century

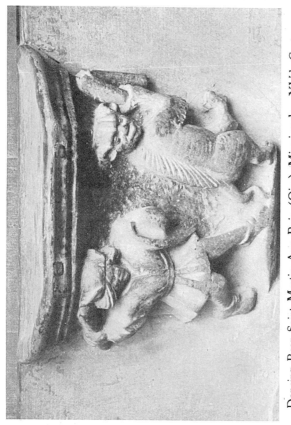

Dancing Bear Saint Martin Aux Bois (Oise) Misericorde—XVth Century

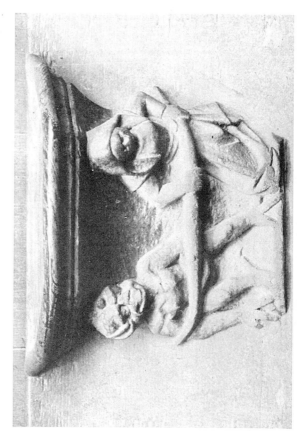

Devil and Woman Pulling a Yoke St. Martin Aux Bois (Oise) Misericorde—XVth Century

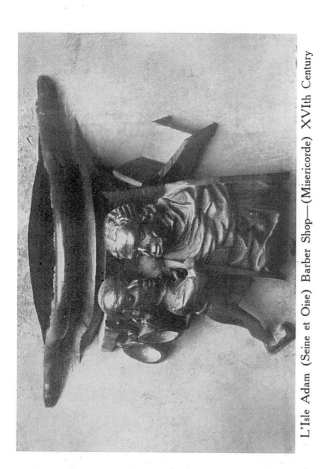

L'Isle Adam (Seine et Oise) Barber Shop—(Misericorde) XVIth Century

Saint Martin Aux Bois (Oise) Fool's Games Misericorde—XVth Century

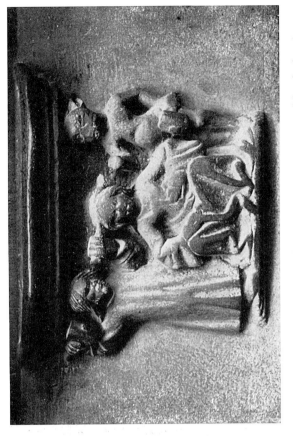

Saint Martin aux Bois—(Oise) Misericorde—XVth Century Man Sculpturing a Woman—It Takes the Help of the Devil to Make a Woman

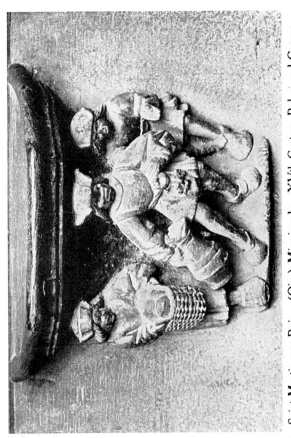

Saint Martin aux Bois—(Oise) Misericorde—XVth Century Baker and Grocer

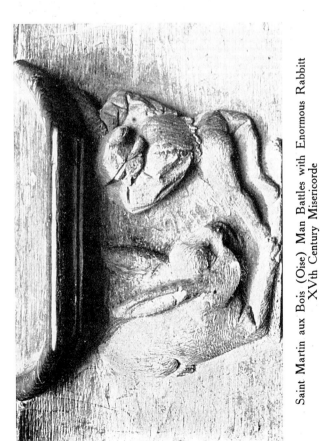

Saint Martin aux Bois (Oise) Man Battles with Enormous Rabbitt XVth Century Misericorde

Saint Martin aux Bois (Oise) Misericorde—XVth Century Bears Dancing

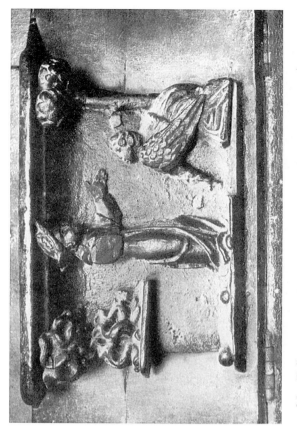

Man Talking with A Chimerical Bird in the Forest Fontenay—Lès—Louvres
(Seine et Oise) Misericorde—XVth Century

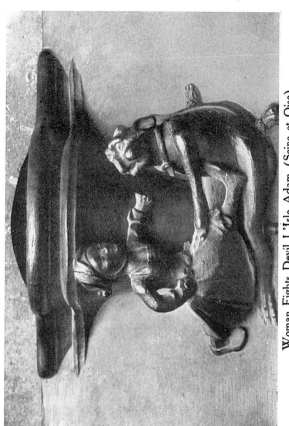

Woman Fights Devil L'Isle Adam (Seine et Oise)
Misericorde—XVIth Century

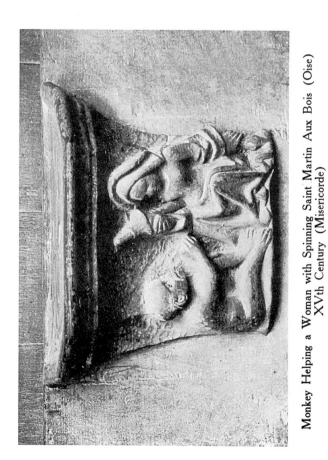

Monkey Helping a Woman with Spinning Saint Martin Aux Bois (Oise)
XVth Century (Misericorde)

Samson and The Lion L'Isle Adam (Seine et Oise)
Misericorde—XVth Century

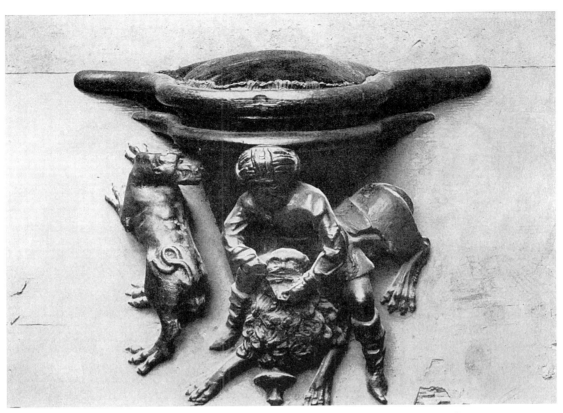

L'Isle Adam (Seine et Oise) Misericorde—XVIth Century Samson and The Lion

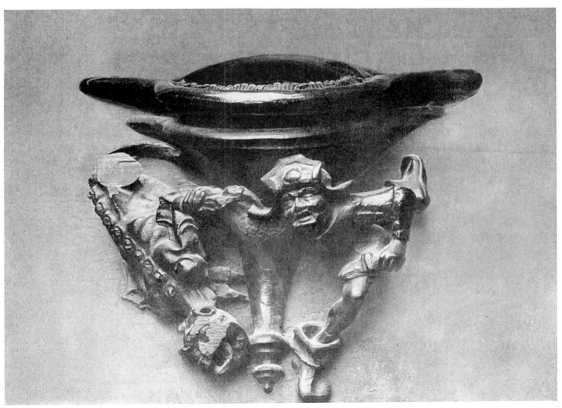

L'Isle Adam (Seine et Oise) Misericorde—XVIth Century
Knight Fighting Dragon

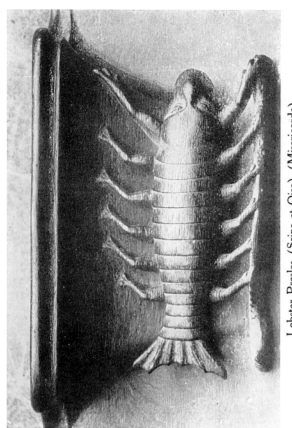

Lobster Presles (Seine et Oise) (Misericorde)
XVIth Century

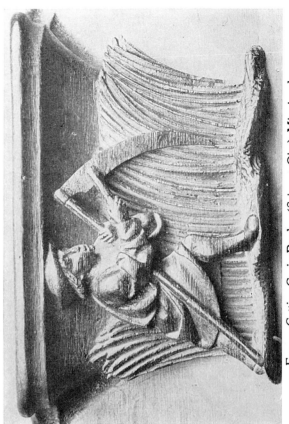

Farmer Cutting Grain Presles (Seine et Oise) Misericorde
XVIth Century

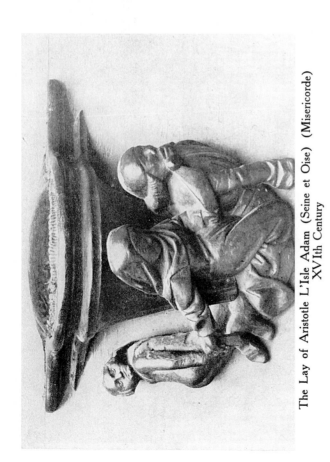

The Lay of Aristotle L'Isle Adam (Seine et Oise) (Misericorde)
XVIth Century

Carpenter in His Shop Presles (Seine et Oise) Misericorde
XVIth Century

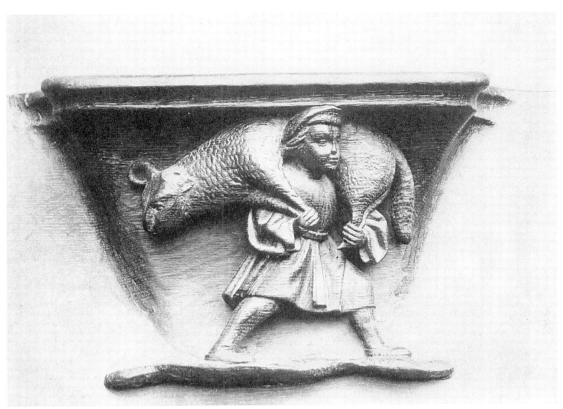

Farmer Carrying A Sheep From Market Presles (Seine et Oise) Misericorde—
XVIth Century

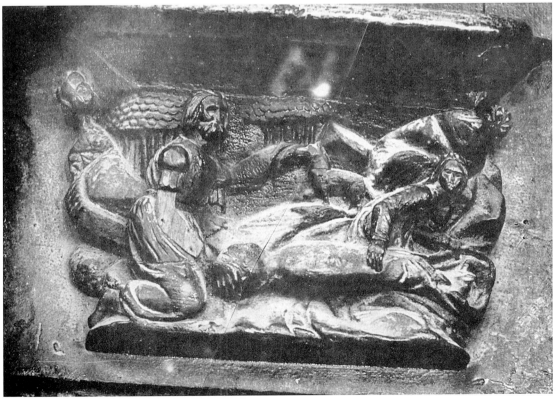

Burial of the Dead Fontenay—Lès Louvres (Seine et Oise) Misericorde—
XVIth Century

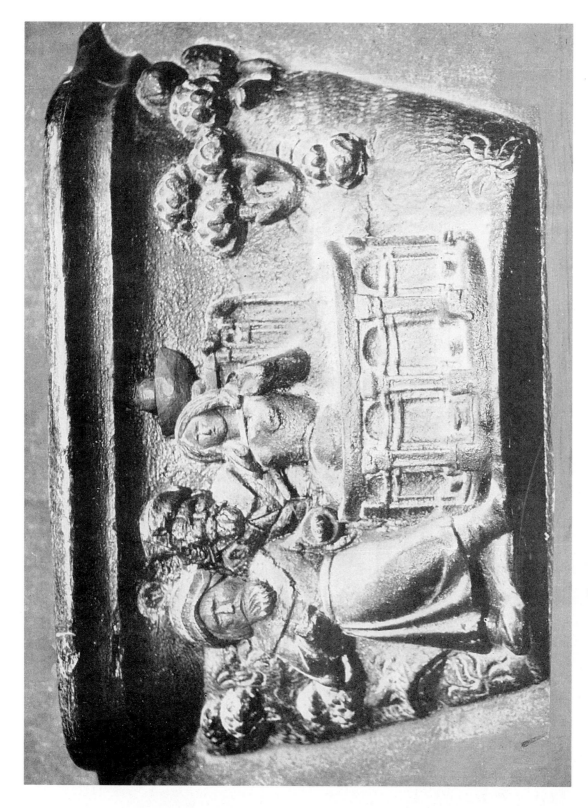

Fontenay—Lès—Louvres (Seine et Oise) Misericorde—XVIth Century
Suzanna and the Elders

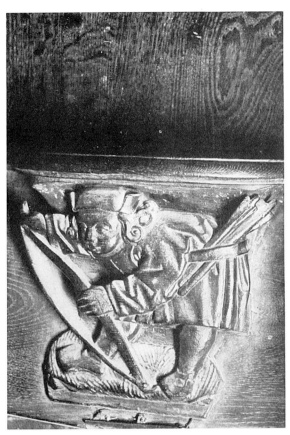

Routot (Eure) Bowman—(Misericorde)
XVIIth Century

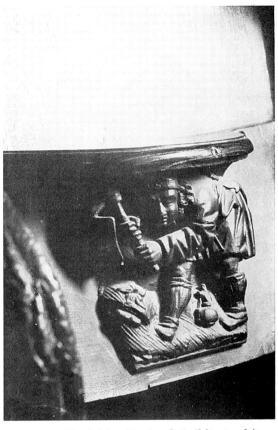

Routot (Eure) Man Turning Soil (Misericorde)
XVIIth Century

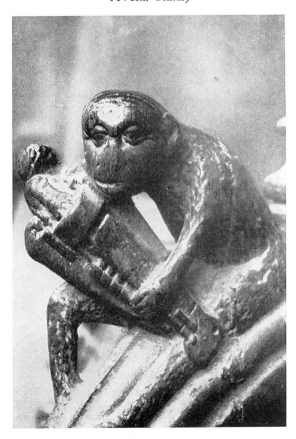

Saint Martin aux Bois (Oise) Monkey Musician
XVth Century

Wooden head from house in Lisieux (Calvados)
XVth Century

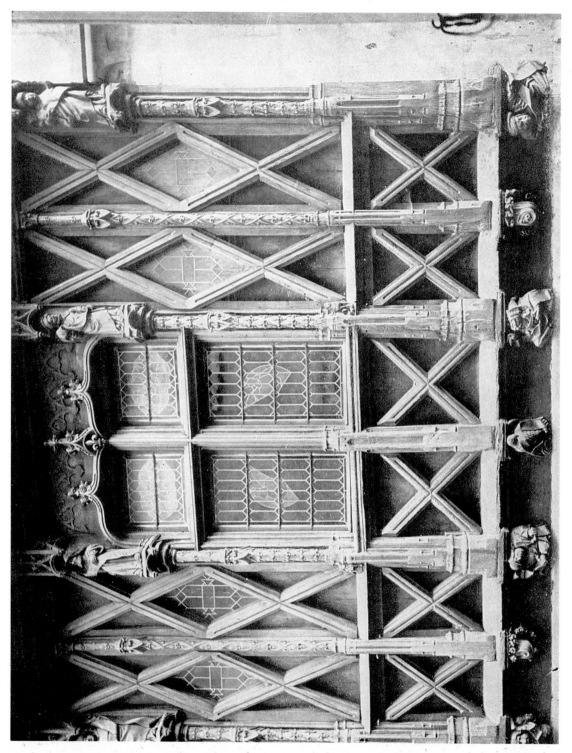

House of Reine Bérengère Le Mans (Sarthe) 1495

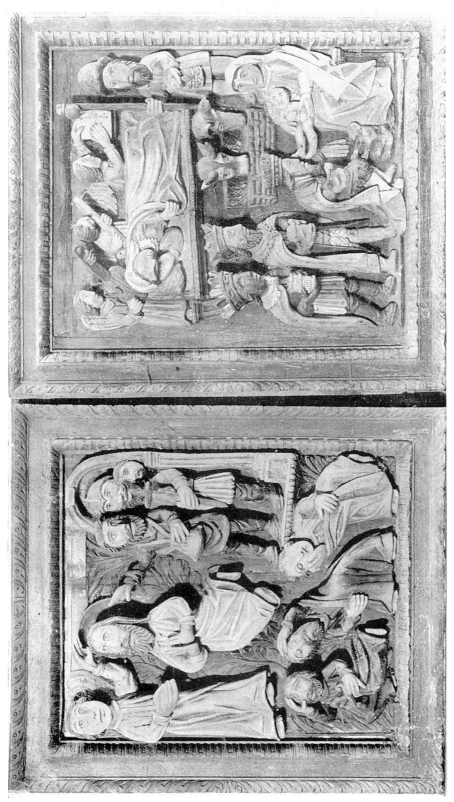

Caudan—(Morbihan) The Way of the Cross Chapelle de La Vénté

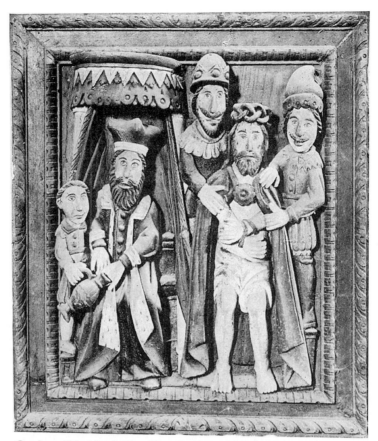

Caudan, (Morbihan), La Chapelle de la Vénté, Christ before Pilate

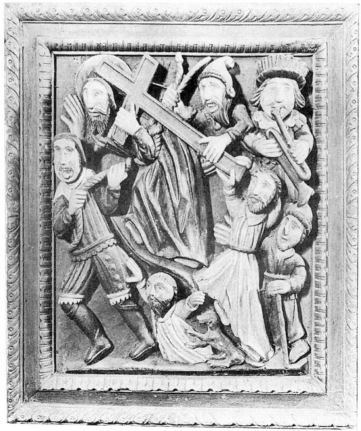

Caudan (Morbihan) Chapelle de la Vénté The Way of the Cross

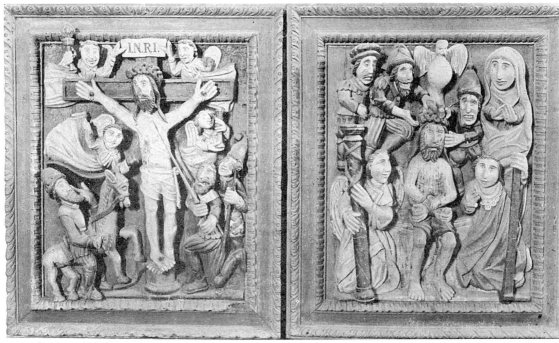

Caudan, (Morbihan) Chapelle de la Vénté,
The Crucifixion of Christ

Caudan, (Morbihan) Chapelle de la Vénté,
The Crown of Thorns

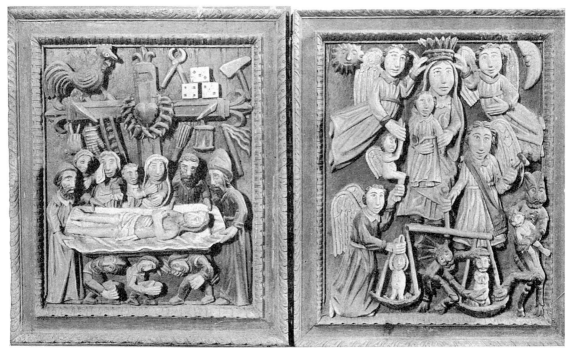

Caudan, (Morbihan), Chapelle de la Vénté,
The Burial of Christ

Caudan, (Morbihan), Chapelle de la Vénté,
the Weighing of Souls at the Last Judgment

Lisieux (Calvados) . . Francis the First House, XVth Century, showing the details of woodwork

BIBLIOGRAPHY

(1) ADELINE, (Jules) Les Sculptures Grotesques et Symboliques, (Rouen et Environs), préface par Champfleury, 1878, Rouen (E. Augé, 36 Rue Grosse Horloge.)

(2) AUBER, (Abbé Charles Auguste) Histoire et Théorie du Symbolisme Religieux. Paris 1870—1871 (A. Franck 67 Rue Richelieu).

(3) AUBERT, (Marcel) La Cathédrale Notre Dame de Paris, Paris, 1909 (D. A. Longuet, 250 Faubourg St. Martin.)

(4) BABEAU, (Albert) Saint Urbain de Troyes, 1891, In-8; Troyes, (Dufour-Bouquot, 41 Rue Notre Dame.)

(5) DE BAUDOT, (A) La Sculpture Francaise au Moyen Age et à la Renaissance. In Fol. 1884 Ière Edition Paris (Librairie Central D'Architecture, des Fossez et Cie Editeurs, 13 Rue Bonaparte).

(6) BELLEMERE, (J) La Cathédrale D'Amiens, Amiens (Roger Léveillard 1921) Abbeville Impr. F. Paillart.

(7) BOND, (Francis) English Wood Carving, (1) Misericordes, 1910, Humphrey Milford, Oxford University Press.

(8) BOINET, (Amédée) Les Stalles de la Cathédrale de Poitiers, Caen, 1914 (Henri Delesques, 34 Rue Demolombe).

(9) BOUXIN, (Abbé Auguste) La Cathédrale Notre Dame de Laon, 2e Edition, Laon (Imprimerie du Journal de L'Aisne. 22 Rue Serurier 1902).

(10) BREHIER, (Louis) La Cathédrale de Reims, 1916 Paris (Henri Laurens, 6 Rue de Tournon).

(11) BULLETIN ARCHEOLOGIQUE DU COMITE DES TRAVAUX HISTORIQUES ET SCIENTIFIQUES, Année 1912, 2e Livraison, Paris (Imprimerie Nationale, Ernest Leroux, Editeur, 28 Rue Bonaparte).

(12) CHAMPFLEURY, (J.F.F.) Histoire de La Caricature Au Moyen Age. 2e édition 1875 Paris (E. Dentu, Librairie de la Société des gens de lettres, Palais Royal, 17 Galerie D'Orléans).

(13) CUSHMAN, (L.W.) The Devil and the Vice in the English Dramatic Literature before Shakespeare. Halle a S. M. Niemeyer, 1900.

(14) DESCUNS (Francois) Notice Historique sur la Ville de Mirepoix. 1902. Mirepoix. J. Cassé.

BIBLIOGRAPHY (cont'd)

(15) DURAND, (Georges) Monographie de L'Eglise Notre Dame Cathédrale d'Amiens, Tome I Histoire; Tome II, Mobilier et Accessoires; Tome III Atlas. Amiens 1901-1903. 3 volumes (Impr. Yvert et Tellier, Paris, A. Picard, 82 Rue Bonaparte).

(16) ENLART, (Camille) Manuel d'Archéologie Française Depuis les Temps Mérovingiens Jusqu'à la Renaissance. Paris, 1924. 2e Edition (Auguste Picard 82 Rue Bonaparte).

(17) EVANS, (E. P.) The Criminal Prosecution and Capital Punishment of Animals, London, 1906, Wm. Heinemann.

(18) EVANS, (E. P.) Animal Symbolism in Ecclesiastical Architecture. London 1888.

(19) FOSSEY, (Jules) Monographie de la Cathédrale D'Evreux. (Imprimerie de L'Eure 1908).

(20) FRASER, (J. G.) The Golden Bough, MacMillan and Co. London 1920 12 Vols.

(21) FYOT, (Eugene) L'Eglise Notre Dame de Dijon. 1910. Dijon, Felix Rey, Editeur, 26 Rue de la Liberte.

(22) GASTE, (A) Les Drames Liturgiques de la Cathédrale de Rouen. Evreux (Imprimerie de L'Eure 1893 in-8.)

(23) HARAUCOURT, (ED.) L'Histoire de la France expliquée au Musée de Cluny, guide annoté par salles et par séries. Impr. de Librairie Larousse, 13 Rue du Montparnasse 1922.

(24) HOURTICQ, (Louis) Ars Una Species Mille; France, 1911, Librairie Hachette (Histoire Générale de L'Art—France).

(25) JOHNTON, (Dr. O. D.) [(pseud. de Joanneton (Henry)] Gargouilles (Imprimerie de G. Frémont, 1910, Troyes) (Aube).

(26) LeCLERT, (Louis) Troyes-Les Anciennes Maisons de Bois. L'Election. La Maison dite de L'Election. Ses anciens proprietaires, son épi, (Troyes Paul Nouel 41 Rue Notre Dame 1905 In-8).

(27) Le FALHER, (Jules) Josselin, Son Pélerinage son Château, (Vannes Lib. Lafolye Frères 1909).

(28) LEFEVRE-PONTALIS, (Eugène) Histoire de la Cathédrale de Noyon, Paris 1900 (Extrait de la Bibliothèque de L'Ecole des Chartes, Année 1900 Tome LXI (Nogent le Rotron, imp. de Daupeley-Gouverneur 1900).

(29) LeMERCIER, (E.) Monographie de L'Eglise Notre Dame de Louviers. Evreux, Imp. Ch. Hérissey, 4 Rue de la Banque, 1906.

BIBLIOGRAPHY (cont'd)

(30) MAETERLINCK, (Louis) Péchés Primitifs. 1912 (Mercure de France, 26 Rue de Condé, Paris).

(31) MAETERLINCK, (Louis) Le Genre Satirique, Fantastique, et Liciencieux dans la Sculpture Flamande et Wallonne. Les Miséricordes de stalles, art et folklore. Paris Jean Schemit, 52 Rue Laffitte, 1910.

(32) MALE, (Emile) L'Art Religieux du XIIe Siècle en France, Paris 1922, Armand Colin, 103 Boul. Saint Michel.

(33) MALE, (Emile) L'Art Religieux du XIIIe Siècle en France, Paris 1923, E. Leroux.

(34) MALE, (Emile) L'Art Religieux de la Fin du Moyen Age en France. 1920 Armand Colin, 103 Boul. Saint Michel.

(35) METIVET, (Lucien) Contribution à l'Etude de la Caricature, La Physionomie Humaine Comparée à la Physionomie des Animaux (D'Apres les Dessins de le Brun) (Henri Laurens, 6 Rue de Tournon, Paris 1917).

(36) MICHEL, (Wilhelm) Das Teuflische und Groteske in der Kunst, 1919 (R. Piper & Co. München).

(37) NICOLAYSEN, (N). The Viking Ship Discovered at Gokstad in Norway. Christiania 1882, Alb. Cammermeyer.

(38) PILLION, (Melle Louise) Les Portails Latéraux de la Cathédrale de Rouen, (Alphonse Picard, 82 Rue Bonaparte, Paris 1907).

(39) POITIERS, Congrès Archéologique de Poitiers, 16-23 Juin 1903, Imprimerie L. Danel, 1903, Lille.

(40) RAGUENET, (A). Matériaux et Documents D'Architecture: Gargouilles, Chimères (R. Ducher, Editeur, 3 Rue des Poitevins, Paris).

(41) SOYEZ, (Edmund) La Procession du Saint Sacrement et les Processions Générales à Amiens. Amiens, (Yvert et Tellier, 64 Rue des Trois Cailloux, 1896).

(42) THIERS, (Puy de Dôme) Capitale de la Coutellerie, par le Syndicat D'Initiative de Thiers, (Thiers Imprimerie Favye).

(43) TRIGER, (Robert) Un Rhinocéros Gallo-Romain Au Mans. LeMans (A. De St. Denis, Place St. Nicolas 1914).

(44) VALTON, (Edmond) Les Monstres dans L'Art. Paris 1905 (Ernest Flammarion, 26 Rue Racine).

BIBLIOGRAPHY (cont'd)

(45) VILLETARD, (H. L'Abbé) Remarques sur la Fête des Fous au Moyen-Age, à propos d'un Livre récent. (Paris, A. Picard, 82 Rue Bonaparte) 1911.

(46) VIOLLET-LE-DUC, (E. F.) Dictionnaire Raisonné de L'Architecture Française du XIe au XVIe Siècle, (Paris, Lib. Imp. Réunies 10 Vols.).

(47) VIOLLET-LE-DUC, (E. F.) Dessin Inedits de Viollet Le Duc, par A. de Baudot et J. Roussel. (Armand Guerinet, éditeur, 140 Rue Faubourg St. Martin. Archives de la Commission des Monuments Historiques).

(48) WITKOWSKI, (Dr. G. J.) Les Licences de L'Art Chretien. Paris 1920 (Bibliothèque des Curieux, 4 Rue Furstenberg.)

(49) WRIGHT, (Thomas) A History of Caricature and Grotesque in Literature and Art, (London, Chatto and Windus, Piccadilly, 1875).